COLUMBUS
NEIGHBORHOODS

A GUIDE TO THE LANDMARKS OF
**FRANKLINTON, GERMAN VILLAGE,
KING-LINCOLN, OLDE TOWN EAST, SHORT
NORTH & THE UNIVERSITY DISTRICT**

TOM BETTI, ED LENTZ
& DOREEN UHAS SAUER

THE
History
PRESS

Published by The History Press
Charleston, SC 29403
www.historypress.net

All images appear courtesy of Tom Betti, Columbus Metropolitan Library Collection,
Franklinton Historical Society and Doreen Uhas-Sauer.

First published 2013

Manufactured in the United States

ISBN 978.1.60949.669.2

Library of Congress Cataloging-in-Publication Data

Betti, Tom.
Columbus neighborhoods : a guide to the landmarks of Franklinton, German Village,
King-Lincoln, Olde Town East, Short North and the University District / Tom Betti,
Doreen Uhas Sauer and Ed Lentz.
pages cm
ISBN 978-1-60949-669-2
1. Columbus (Ohio)--History. 2. Neighborhoods--Ohio--Columbus--History. 3. Columbus
(Ohio)--Buildings, structures, etc. I. Sauer, Doreen Uhas. II. Lentz, Ed. III. Title.
F499.C76A22 2013
977.1'57--dc23
2013037053

The concept of a community-written "encyclopedia" was encouraged, funded and supported by the United Partnership Grant of the Columbus Foundation and the United Way of Central Ohio, along with their partnerships with the Bob Evans Restaurants, PNC Banks and the Osteopathic Heritage Foundation. In addition, support came from Chris Zacher and the Humanities House at the Ohio State University. Thank you.

More than any other project of Columbus's bicentennial year celebration in 2012, the award-winning WOSU Neighborhood Series video series of six neighborhoods created an awakening in each community to learn more about their history. To be featured in an hour-long documentary and work with the expertise and professionalism of the WOSU staff allowed each neighborhood to see that its historic roots and its living stories educated young people, attracted others to explore their streets and honored the neighborhood elders. Thank you.

The staff members of the Columbus Metropolitan Library have expertise, wit, humor and patience for the many workshops on their resources, inquiries (one more time—"Where can I find…..?") and ability to find an obscure clipping in an antiquated but lovely old card catalog, thereby proving there is still much to be found on paper as online. Thank you.

CONTENTS

Acknowledgements 7
Introduction 9

Franklinton 13
Short North: Victorian and Italian Villages, Harrison West 49
University District 73
German Village 112
Near East Side, King-Lincoln, Bronzeville and Olde Town East 145

List of Sites Within Neighborhoods 185
About the Authors 191

ACKNOWLEDGEMENTS

The following authors and researchers contributed anecdotal information, history, memories, research and pictures. In many cases, their own investigations into local history have become bodies of work that they generously share with others. As people who love neighborhoods and treasure the city, they, above all, understand the importance of landmarks. Thank you to this community of authors and researchers:

Sandy Andromedia
Cathy Appel
Al Berhold
David Binkovitz
Leslie Blankenship
Lela Boykin
Lee Brown
Willis Brown
Bruce Dooley
Brenda Dutton
Tim and Sue Gall
Seth Golding
Pasquale Grado
Barbara Hackman

Laurie Hernance-Moore
Conrade Hinds
Stu Koblentz-Headley
C.L. Miller
Dana Moessmer
Bea Murphy
Cathy Nelson
Teresa Nolan
Ed Quickert
Walt and Lois Reiner
Ann Seren
Terry Sherburn
Carol Stewart
Bruce and Jan Warner

INTRODUCTION

When is a building, a stone, a balcony, a brick, a sign, a wall, a park, an empty lot, an artifact or a phosphate soda a landmark?

In December 1964, Miss Fern Zetty, the descendant of a founding family (Vogl) in Franklinton, the first "neighborhood" of Columbus, was trying to convince others, mostly the city parks commission, that the first brick home in old Franklinton was worth saving as a historical landmark. The Sisters of Good Shepherd, who had resided in the home for over one hundred years, had already accepted $195,000 in "damages" when the new Sandusky Expressway took off a strip of their property, and they had also been awarded $535,000 from a federal grant to build a new hospital and convent in Mifflin Township to continue their work with troubled girls.

Miss Zetty knew that many supported the concept of retaining the old mansion as the center of a park. Several park commissioners found her ideas excellent in principle but expressed reservations about how much this would cost the city. The Franklin County Historical Society did not have the money to purchase the building.

Already there was the nagging little problem of the Alfred Kelly mansion on East Broad Street, an 1840s Greek Revival home and a landmark for both its architectural merit and its significance in Ohio history. Despite efforts to save that landmark by Dixie Sayre Miller, who took the issue to the state of Ohio, the disassembled stones were lying among weeds in Wolfe Park, and the donor money to rebuild was insufficient. The governor, with an eye to the budget, rejected the idea that the state should spend money to save Ohio history.

Eventually, the stones were numbered and sent to the Hale Farm in northern Ohio to be kept in anticipation of reconstruction. Never reassembled, the stones were finally released from their state of purgatory by Ms. Miller before her death, and the stones no longer are there. The Hale Farm was free to sell or dispense them as they saw fit.

The Sullivant home was torn down. The iron balcony that a Sullivant son had hung so proudly from the front of the house was saved and placed in the showroom of the Graham Ford dealership nearby. The dealership has been closed for a number of years, and the balcony remains inside.

A plaque marks the Sullivant mansion's site, but as Miss Zetty said in a newspaper article, "Once you tear down a place such as the Sullivant home, it's gone. They put up a plaque. But what is a plaque? Nobody stops to read it." And indeed, the plaque is perched over the busy highway below and close to the busier West Broad Street traffic on a prairie of concrete.

From 1928 to 1936, the Centenary Methodist Episcopal church (established 1900) had the largest African American congregation on the near east side at the time, and they struggled in the midst of the Great Migration and the Great Depression to find money to finish their building on East Long and Eighteenth Streets and also to feed people in the neighborhood. Their priority was the need of the community. The partially constructed roof was put under temporary cover with no idea as to when or how the church would be finished. The congregation continued to meet in the basement. Rain or snow did not stop them.

Their grand vision eventually completed, the massive brick church with a five-story Gothic style bell tower reigned over East Long Street for six decades. It came down in 2011, despite neighborhood attempts to save it.

This is a book not about lost landmarks or the lack of money to preserve them—because Columbus has been able to preserve, restore and reuse many historic structures and neighborhoods. It is the result of a discussion with neighborhood people about the concept of a landmark.

What is a landmark? Is a landmark always a monumental building or a historic structure?

The compiled writings of a "community of authors and researchers" indeed do confirm that "landmarks" are the churches, the parks and the historic houses, but, just as importantly, they are the places shaped by geography and by memory.

The WOSU Neighborhood Series presented an opportunity to consider a landmark in a much broader definition—isn't a landmark literally "a marker" in the landscape? Does it have to be old? Does it live as long as the

memory of it lives? Landmarks can be fine old Victorian homes, but are they also ice cream stands that have served four generations?

Schiller Park is a landmark to some because of the statue of Schiller, the old trees and the well-manicured perennial flower beds and a landmark to others as a reminder of anticipated third-grade May outings when lemonade was dished out into little tin cups, and the St. Mary's nuns rolled up their sleeves to play softball.

The Blue Danube restaurant is a landmark to some because of the blue mural of Budapest, the funky painted 1970s ceiling tiles and the round blue mirrors, and it is a landmark to others who remember (realizing only later) that it was the location of their first real grown-up conversation about the meaning of life or where the guy in the next booth proposed marriage to his girlfriend and spent the money for the bottle of champagne and the White Castle burgers listed on the menu.

Bryden Road is a landmark to some because of the over-the-top architecture of the homes once occupied by some of Columbus's wealthiest families, and it is a landmark to others because it is a walk along the diversity of a street with rainbow flags, where Jewish temples stood near African American churches and where the historic homes of water colorists and sculptors are again the homes of contemporary artists.

The Garden Theater on North High Street is a landmark to some because of its refurbished façade, newly re-lit neon sign and the promise of more musical theater in a popular neighborhood. It is a landmark to others who went to the burlesque to see the pole dances in its discreetly walled-off balcony while the "naughty" movies were shown in the auditorium.

Lemmons' Drugstore at Mount Vernon and Taylor Avenues is a landmark because to some, it is the extraordinarily large and unmarked building remaining in a neighborhood of vacant lots whose fate was sealed by economic downturns and failed government policies and a landmark to others who vividly remember the drugstore's fountain soda counter and the lemon-lime phosphates.

Perhaps a landmark may be defined by neighborhood people as the geographic marker that signifies when you are almost home. A landmark lets you know when you are near your street. It is also a marker in the geography of your head where memories (happy, sad, commemorative or cultural) reside. Who has not driven back to a place or a site to more fully remember a significant event or to relive a poignant moment? A space remembered by generations of people, each of whom has different memories, is a landmark.

When the eighteenth-century French philosopher Denis Diderot compiled his famous encyclopedia of ideas and political thought, despite years of working on it, he knew it was not complete. An encyclopedia is a process that tries to give a democratic order to information. A recent movement in humanities circles and public history has encouraged even the smallest organization of "history gatherers" to begin to create "a work of comprehension" (as Diderot would have described it). This book is arranged alphabetically by entry (very democratic) within a neighborhood—a snapshot in time. The entries were submitted by current community writers to note their thoughts about neighborhood landmarks and to supplement or document places from the WOSU television series on Columbus neighborhoods.

Unlike Diderot, who was persecuted by his enemies for his encyclopedia because his enemies thought it was seditious and threatening to the governing classes of France, this modest compilation of entries marries "landmark" with "memory" and is anticipated only to encourage more "history gatherings."

—Doreen Uhas Sauer

FRANKLINTON

ANTHONY THOMAS CANDY COMPANY (1160 WEST BROAD STREET)

The Anthony Thomas Candy Company, started over one hundred years ago by Greek immigrant Anthony Zanetos, is a landmark in Franklinton not only for its present physical location but also for the story of how the Zanetoses' family business endured and prospered while keeping its roots in the neighborhood.

Anthony Zanetos emigrated from Greece in 1907 to Columbus, serving as an apprentice to a candy maker. In 1916, deciding to go into business for himself, he opened Coop Dairy at the corner of West Broad and Chicago Avenue with a small candy stove, a copper kettle, a marble slab, a showcase and a wooden cigar box for a register. His peanut brittle, fudge, caramel corn and sugarcoated peanuts were so popular that he sold candy to other immigrants for their downtown pushcarts. In 1926, he opened a candy shop in the Union Station, the Union Depot Candy Kitchen, and opened a third location near Ohio State University, State Confectionary, in 1930, but that location closed because of the Depression.

When his son Tom returned from World War II in 1945, together they started Anthony's Confectionary. Though sugar was still rationed in 1945, veterans (like Tom) could get a thirty-thousand-pound annual allotment if they were in the confectionary business. Milk and bread trucks sold their fudge; the business grew by word of mouth. Father and son opened the Crystal Fountain Restaurant in 1947 (1022 West Broad

Street), adding ice cream, a soda fountain and a lunch counter to the growing candy business.

In 1952, they switched to candy making and renamed the company, combining their first names, to the Anthony Thomas Candy Company. In 1970, the business moved to 1160 West Broad Street into a large building that once housed a car dealership, where several Willis Overland Jeeps had been left on the second floor. They were auctioned off to get them out of the building. Because the site was located within the one-hundred-year flood plain and the floodwall was not yet constructed, Anthony Thomas and other business were forbidden by FEMA regulations to build or expand. After almost one hundred years in Franklinton, the company needed to build its new factory on an eleven-acre site on Arlington Lane in 1995.

The company does, however, remain a presence in Franklinton, and many members of the Franklinton Board of Trade have fond memories of meeting in its boardroom on occasion where the smell of chocolate was in the air and plates of milk and dark chocolate-covered graham crackers fresh from the candy line filled plates on the table. Each year before Easter, the company donated a thirty-five-pound chocolate rabbit with a chocolate basket of jelly beans to begin fundraising for the community. Bidding was fast and furious.

A third-generation of Zanetos brothers (Joe, Greg and Tim) lead the operations at this writing and produce fifty thousand pounds of chocolate daily. They also build and repair their own equipment, have developed their own caramel and nut machine to make "turtles" and once spent eight months developing a peanut butter that could be pumped while keeping the consistency of fudge. Cocoa Manor is the name of the mansion owned by a Zanetos brother and is listed as a landmark in another neighborhood.

ATER'S SANDWICH SHOP (924 WEST BROAD STREET)

ATER'S DRIVE IN (914 WEST BROAD STREET)

TOMMY'S DINER (914 WEST BROAD STREET)

Ater's Sandwich Shop opened on the corner of West Broad and Jones in April 1946 and sold jumbo hamburgers for fifteen cents. Charles G. Ater, originally from New Holland, Ohio, was the owner, convincing his friend Gordon Dunkel to leave Kroger's and work with him. Gordon was there for more than forty years. The restaurant moved eastward to 914 West Broad and became

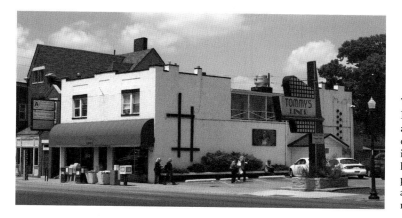

Tommy's Diner has a fun 1950s decor and is a popular hangout for politicians and neighbors.

Ater's Drive In in 1955. By 1982, burgers cost eighty cents. Ater's was mainly an eat-in restaurant though it was called a drive-in and served T-bone steaks, burgers, fries and, every Friday, potato soup. Space was leased from Louis Schlezinger until Sandra S. Sells purchased the building in February 1993.

Chuck Ater was active in the community as a member of the Sunshine Recreation Advisory Board and West Side Board of Trade. He was killed in a car accident on September 17, 1967. The business continued under co-ownership by his sister Geraldine Ater Sells and Gordon Dunkel until 1986. The restaurant was leased briefly to William and Ann Fernandez as the Tick Tock Restaurant until it was sold in 1989 to the Pappas family, who opened Tommy's Diner in July 1989. Kathy Meek Newman Church was Ater's last carhop. She remembered, "Chuck Ater was great for kids in the neighborhood. He tried to keep them busy by doing odd jobs for him. I also remember when I received my first pay. Chuck took me to the bank and opened a savings account for me. He died way too young."

Tommy's Diner has a fun 1950s décor, quick service, good food and a lively coziness for the really early breakfast and lunch bunch (closing at 3:00 p.m.). Tony and Kathy Pappas came to Columbus in 1977 from Greece, where Tony worked for Trans World Airlines, supervising food loaded onto planes. He worked at bars and Jolly Roger Donut stores across Columbus and, in 1989, rented the restaurant site from Geraldine Ater Sells. The rent was $300, the walls were green with stuffed fish on them, the booths were orange and the ceiling was different colors. The Pappas family agreed to a six-month trial basis and bought paint. When the Broad Street Bridge was closed for replacement, business in Franklinton slowed, but by being open on Sundays, the Pappas family made enough to pay the rent and utilities.

Business boomed when the new Discovery Bridge opened in 1992. During the second week in January 1997, the restaurant set at a record volume of more than $14,000 (especially notable when the average check was $6.50). The family bought the business from Mrs. Sells and the building from daughter Sandra Sells, completely remodeling it.

Kathy Pappas took over the kitchen, making pastries for the weeklong Greek Festival each September and for son Louis's restaurant, Milo's Deli and Café, a block west. When asked what has contributed to his success, Tommy Pappas said an ability to remember names and numbers, belief in himself and Columbus, the national attention the restaurant has generated (see the walls) and the good advice from restaurant critic Doral Chenoweth, the Grumpy Gourmet, who said, "Stay here and make your restaurant a landmark."

B&T METALS COMPANY
(425–435 WEST TOWN STREET AT LUCAS STREET)

What would become the B&T Metals Company in Franklinton began as B&T Floor Coverings in 1930 by William Bonnell and William Thompson on the corner of Front and West Long Streets. In 1932, Lyman Kilgore purchased the business, making it one of the first African American–owned factories in the United States. The focus of production shifted from floor coverings to the aluminum pieces used to hold carpet and linoleum to the floor, weather stripping and door frames. The company was renamed B&T Metals, and Bonnell stayed on as president of the company, though by 1943 Kilgore had taken over the day-to-day operations.

The current building was purchased in 1940, and over the next few years, other properties around the building were added. With the business now relocated in Franklinton on West Town Street, B&T Metals Company began another era in its life—as part of the top-secret Manhattan Project during World War II, beginning in March 1943 and operating for eight to ten months. Workers did not know they were working on the project that developed the first atomic bomb. There were more than thirty sites in the United States, Canada and the United Kingdom working on portions of the Manhattan Project, with Dupont Chemical acting as the agent for the Manhattan Engineer District.

The Franklinton site worked on extruding rods (forcing them through a die) of uranium metal pellets for the reactor in Hanford, Washington. The

work was done in the northwestern corner of the main building. (The eastern portion of the buildings was demolished in May 2011.) Twelve men stretched uranium into long rods, cut the rods into twenty-one- to twenty-four-inch lengths and ground them on a lathe until they were seven to eight inches in diameter. Approximately fifty tons of extruded uranium was produced under the watchful eyes of guards and removed from the plant under armed guard. However, workers had no safety equipment, though the government required physicals every week and a monthly visit to one of four doctors.

Beginning in 1973, the owner was David Tolbert, whose father had been in company management in the early years. During these years, there was continued cleanup and decontamination on the site. A 1996 survey of the site released the facility for use without radiological restrictions in 2001. By 2005, there were four employees who made aluminum parts for cars, electronics and chalkboard frames. Much of the roof of the main building collapsed in 2005, and the City of Columbus condemned the deteriorated building.

The site was purchased April 20, 2011, by the Manhattan Project LLC (also known as Urban Smart Growth, Brick Investment Corporation and Lance Robbins). Robbins, a Los Angeles developer, had worked with the City of Columbus on a two-phase environmental site assessment since 2004. Possibilities for the area include artist studios, condos, apartments, galleries, retail spaces and a small theater. Columbus City Council authorized preparation of the East Franklinton Creative Community District Plan to guide revitalization in the area beginning in July 2011.

BURGER BOY FOOD-O-RAMA
(1380 WEST MOUND STREET AT CENTER AVENUE)

It was at the first Burger Boy Food-O-Rama (BBF) at 1380 West Mound Street in Franklinton in 1961 where the concept of the fifteen-cent hamburger originated in Columbus. The distinctive whirling satellite sign and glass-enclosed service area designed by architects Eiselt&Eisselt made it easy to spot. Co-owners Milton Lustnauer and Roy Tuggle created the idea while on a fishing trip and were successful in making the restaurant family friendly and cost effective.

By 1964, there were nineteen BBFs across Columbus and Ohio—with thirty-five more planned. Their business philosophy was to be "bigger, better, faster" than their main competitor, McDonald's restaurants. BBFs

were open seven days a week, staffed by neighborhood people and locally produced supplies. Windows were washed twice daily. Milton Lustnauer and Ohio governor James Rhodes started the "Sale of Champions" at the Ohio State Fair, where Lustnauer often made the top bid. Company-owned restaurants were under the supervision of General Manager Jim Near. In later years, the Franklinton BBF building became a Sisters Chicken and Biscuits and then Viereck the Florist. A coupon in the July 1963 *Columbus Dispatch* advertised a 79-cent chicken-in-a-basket dinner regularly priced at $1.19. It included "4 full sized pieces of country fried chicken, crisp salted French fries with ketchup, creamy cole slaw and a hot buttered bun."

CENTENNIAL ROCK
(EUREKA AVENUE TO THE WALKING PATH ON DRY RUN CREEK)

Centennial Rock was a popular photo-op site of the 1897 celebration of the founding of Franklinton. It was the largest glacial erratic (rocks pushed south by glaciers during the Ice Age that remain behind once the ice melts) in Franklin County. The rock was taller than a person and measured fifty-one feet in circumference at the base. The Columbus celebration of the Franklinton centennial was September 14–16, 1897, staged on two hundred acres of Sullivant's Hill where West Broad Street begins to rise, and the rock was center stage, so to speak. The land was owned by William Sullivant, first son of Lucas and Sarah Sullivant, founders of Franklinton. The celebrations included parades, historic tableaux, mock battles, balloon ascensions and speeches.

To find the Centennial Rock, go west on West Broad, turn right at Lechner Avenue, pass both state office buildings and continue until the road ends, continuing left to the pathway along the fence. Follow the path to the rock. An alternative route is to turn right on Eureka Avenue to the walking path by Dry Run Creek, and follow the walking path to the rock.

CENTER OF SCIENCE AND INDUSTRY
(COSI)/CENTRAL HIGH SCHOOL (333 WEST BROAD)

The bend in the Scioto River, first seen by Lucas Sullivant in the 1790s, who marveled at the corn growing there, is the historic landmark that marks the

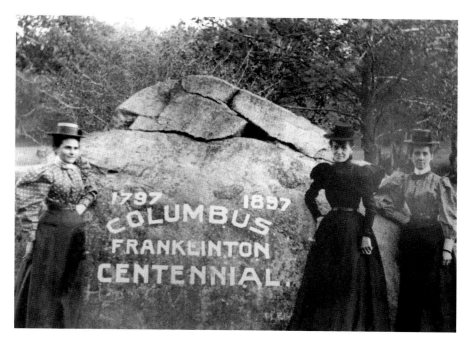

Centennial Rock was taller than a person, measuring fifty-one feet in circumference at the base.

beginning of Franklinton, the oldest settlement in Central Ohio and the oldest neighborhood in Columbus. (See Lucas Sullivant statue entry.)

The site is also the landmark first building of the Columbus Civic Center that rebuilt downtown after the devastating 1913 flood. The Civic Center was part of the City Beautiful Movement (that also built on earlier plans from 1908). The civic center project was spearheaded by noted Columbus architect Frank Packard, who wrangled together a consortium of architects called Allied Architects. It was fitting that the jewel of the civic center be based on the completion of a high school, originally to be called Washington Gladden High School, and was saved and continued to be used for educational purposes.

Central High, designed by W.B. Ittner, an architect from St. Louis, functioned as a high school from 1925 until the 1980s with an evening adult school. Its sunken courtyard gardens, classrooms designed with natural light and interior touches such as Arts-and-Crafts tiles inspired a movement to put the building on a city referendum to save it from possible destruction.

Its reuse was championed in 1989 by Schooley Caldwell Architects, which repurposed the building for Son of Heaven, a large exhibition of Chinese

art sponsored by the Columbus Art Museum. The event helped to swing the opinion that the building could be saved, though the auditorium was removed. The Burkhart Works Progress Administration (WPA) mural was saved (see Emerson Burkhart home entry). In 1999, the Center for Science and Industry moved from its previous location at the old Memorial Hall on East Broad into a greatly expanded building that included a contemporary elliptical addition.

CENTRAL POINT SHOPPING CENTER
(INTERSECTION OF HARRISBURG PIKE AND WEST MOUND STREET)

Central Point Shopping Center was developed as a local retail node by developer Don Casto in the 1950s. He also developed Graceland, Great Eastern, Great Southern, Great Western, Northern Lights, Town and Country and University City. Milton Lustnauer, owner of Green Gables Drive-In and developer of BBF Burger Boy Food-O-Rama chain, was a major force in promoting events for the Casto shopping centers, especially the Dollar Days sales concept in the 1960s.

CELEBRATION OF LIFE STATUE (300 WEST BROAD STREET)

Celebration of Life is also known locally as the Arthur Boke/Sarah Sullivant statue. Noted Columbus sculptor Alfred Tibor created the nine-foot-tall bronze statue to honor the story of Arthur Boke, the first known black child born in Franklinton, and Sarah Sullivant, wife of Franklinton's founder, Lucas Sullivant. Arthur's mother was a black servant (although it is also speculated she was a fugitive slave who may have been fleeing Ohio), and his father was a white surveyor who worked for Sullivant. When Arthur was abandoned, Sarah, who had been raised on Kentucky plantations in a slave economy, did the unthinkable in the nineteenth century, raising him as her own with her new firstborn son, William (born 1803). Arthur remained with the Sullivant family his entire life and was buried in the family plot in Franklinton Cemetery. (The plots were moved to Green Lawn Cemetery in the 1840s.)

In 1996, Bea Murphy, a local historian with a passion for African American history, rediscovered Boke's tombstone in the Sullivant plot. It was restored as a Franklinton bicentennial project in 1997. Through her research, the amazing life and story of Boke and Sullivant emerged, and she convinced Tibor to donate his time for the sculpture. The project began with support from the Franklinton Historical Society, the Hilltop Historical Society and the Greater Hilltop Community Development Corporation and was completed through the generosity of M/I Homes and the Schottenstein Stores.

DEARDURFF HOUSE AND FRANKLINTON'S FIRST POST OFFICE (72 SOUTH GIFT STREET)

Franklinton was founded in 1797. One of the original families was the Deardurffs who came from Pennsylvania in 1798. Abraham and his thirteenth-year old son, David, arrived with trade goods and bartered for ten acres of land. They were given a free lot on Gift Street by Lucas Sullivant. After planting the corn, Abraham left to bring the rest of his family to Franklinton. David stayed to tend the corn, cut trees and hew the logs.

On October 5, 1789 Abraham returned with his wife, Katharine; daughters, Polly and Elizabeth; three younger sons, Samuel, Daniel and Joseph; a cow; a bulldog; and a wagon. By late November, their log house off the southwest corner of Gift and Sixth (now Culbertson) Streets was finished, but this was not the post office. By 1807, David built his own home opposite his parents' on the southeast corner of Gift and Sixth (Culbertson) Streets. That structure, made of heavy walnut logs with oak woodwork and horsehair plaster, remains and is the oldest known structure in Franklinton on its original foundation. Franklinton's first post office was established in the west room of the house. Adam Hosack secured the first mail contract and became the first postmaster. Thirteen-year-old Andrew McElvain was the first post carrier. He left each Friday, stayed overnight at Markley's Mill on Darby Creek, made it to Chillicothe on Saturday, then went on to Thompson's on Deer Creek and returned to Franklinton on Sunday. Twice in the first year he had to swim the Darby and Deer Creeks with the mailbag on his shoulders. Other postmasters in Franklinton included: Henry Brown (1811); Joseph Grate (1812); James B. Gardiner (1813), who edited the *Freeman's Chronicle*; Jacob Keller (1815); Joseph McDowell (1819); William Lusk (1820); and W. Risley (1831).

Mail was picked up at the post office, and postage was paid by the person receiving it. Until 1816, the rate depended on distance. One piece of paper folder into a letter cost eight cents if delivered within a distance of under forty miles, ten cents for under ninety miles and so on, up to twenty-five cents for distances over five hundred miles.

Abraham Deardurff made frequent trips carrying mail and securing goods. On a trip in 1815, he was robbed and killed. His horse, having traveled the route many times, returned to Franklinton without its rider. When a bridge tollgate was built on the west bank of the Scioto River in 1816, Katherine and Daniel "kept" the gate. David built a house for his mother where she lived until 1820 when she moved to Urbana to life in a log house on her son Daniel's farm (she died in 1844). One of the brothers had a tavern at the corner of Skidmore and Broad Streets, and Samuel ran a blacksmith shop. Descendants of the Deardurff family continued to have major roles in the community's development.

The David Deardurff house has not been lived in since the 1950s, but restoration is being conducted through the efforts of owners Walter and Lois Reiner and the City of Columbus. In 2010, an archaeological dig of areas outside the house and in the basement uncovered a brass plate about five inches in diameter, animal bone fragments, pieces of pottery and brick, nails and a clay marble. Over the years, many modifications were made to the house.

In the summer of 2011 the house was lifted, the foundation rebuilt and raised two and a half feet from ground level, a copper cap was put on the stones to keep moisture from the logs, and a new sill and floor joist logs were installed. Drilled samples of wood sill and floor joist logs were sent to a laboratory for dendrochronology dating to determine what years the trees were cut. Based on samples from the basement, first floor and attic, the house was determined to have been constructed over a period of years.

FLORENTINE RESTAURANT (907 WEST BROAD STREET)

One of Franklinton's continuously operating restaurants has long been a place of first dates, graduation parties, wedding dinners, class reunions and special family events, both happy and sad. Staff members tend to be there for years and enjoy watching families grow up. The Florentine Restaurant was founded by Tony Penzone, who arrived in the United States in 1921. His father, a railroad worker, immigrated in 1914 and worked for seven years to be able to bring his family to the United States.

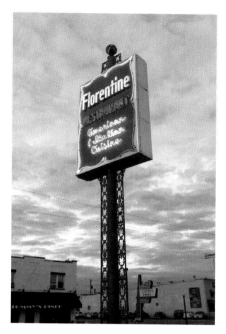

The Florentine opened in 1945 and has been a popular Italian American restaurant for over six decades.

Tony grew up in Messina, Sicily, and served in World War II as a cook in the armed forces. He opened the Florentine Restaurant in 1945. Tony's wife, Adelaide, and her brother, Joe Scuro—both born in Forli, Italy—worked in the restaurant. Joe quickly became known as "Uncle Joe" in the restaurant, and he gave bags of candy to children as they left the restaurant. The tradition continues today, with "Love, Uncle Joe" stamped on each bag.

In the mid-1950s, the restaurant was a large room with tables and folding chairs. The back wall was covered with a large mural by Ivan Pusecker, and when the Sorrento Room was remodeled, the arches were built over the mural.

Tony Penzone adapted old family recipes for homemade pastas and sauces. Tony's oldest son, Joe, began working in the restaurant while he was in grade school. He managed the restaurant from 1976 until his death in 1998. His expertise was refining the old recipes and creating new Italian and American dishes. Joe's two sons, Peter and Nick, are the third generation to run the business. Peter started cooking in the restaurant when he was a teenager. In April 2011, State Representative Michael Stinziano gave the family and the restaurant a commendation for their longevity in the community and unwavering attention to a quality family atmosphere.

FRANKLINTON BRANCH LIBRARY (1061 WEST TOWN STREET)

The eighth branch of the Columbus Public Library system opened in a rented storefront at 840 Sullivant Avenue on June 11, 1943, with a collection of 2,500 books. It would be the first of three buildings for the library, and each one was the center of neighborhood activism for over two decades. Since

June 11 was a Friday, it was decided that the actual checkout of books would begin the following Monday with Miss Virginia Case in charge, assisted by Mrs. Mary Piper, Mrs. Gladys Anderson and Mrs. Sophia Damach.

The 1959 flood closed the library for several weeks to repair damage and rewire the furnace. In 1964, Sally Kessler was head librarian who also supervised a "new" library of more than three thousand books deposited at the Senior Citizens Recreation Center, 275 McDowell Street, the first federally subsidized public housing senior citizen recreation center complex in the country and the first facility of its kind to have a public library collection on its site. When the Columbus Public Library system decided to close the Franklinton branches and three others for financial reasons in 1974, the community rallied. The church extended the lease, and legal counsel for the community suggested that remaining funds from the John M. Lewis bequest could be used to keep the Franklinton branch open until tax money to the library system could be used. The library could be safe for two years; however, in 1976, as the storefront lease was running out, and a much larger library was needed, the library director proposed a combined Franklinton and Hilltop branch library.

The community responded with a resounding, "No." The second Franklinton library opened in the former Cranfill Dental Lab, formerly a grocery, at 1061 West Town. Totally renovated in 1983, the branch was the first merchandised location in the system with books grouped by topics and displayed with covers facing out. It was nicknamed the "paperback branch" because it had more soft-cover titles than other branches. Painted a light blue both inside and out, the Franklinton branch was also called "the Little Blue Library." Before the library moved into its third building, it had acquired a gray library cat, Smoke, who celebrated a birthday each June 14 in time to kick off summer reading clubs. Feasting on tuna and cat treats brought by young library patrons, Smoke enjoyed his delicacies while children had cake. Smoke also made a cameo appearance in a movie about library cats, and then he retired to the Crago household in 1995 before the move to the third library.

Franklinton's library was not permitted to be built until the Franklinton floodwall was completed. The site was next to the existing library with additional lots purchased. Plans took into account the location on the one-hundred-year flood plain, creating a flood-proof library located on a second floor with special concrete, pounded fill dirt and flood louvers in the foundation and parking underneath and next to the building. The library opened on January 23, 1995, retaining its original address, though technically this is the address of the parking lot.

FRANKLINTON CEMETERY AND THE FIRST PRESBYTERIAN CHURCH (SOUDER AVENUE AND RIVER STREET)

As the oldest settlement in Central Ohio, Franklinton also has the oldest cemetery, established in 1799. Sometimes called the Old Franklinton Cemetery or the Pioneer Burying Ground, it was near the Sullivant Mill (later Rickly Mill) in a locust grove on the west bank of the Scioto River. Franklinton's first church, First Presbyterian, was built by Lucas Sullivant in 1811 within the cemetery.

More than one hundred graves remain with far fewer headstones. At the present time, volunteer Gary Royer is caring for and researching the cemetery, finding additional stones and records of stones. The cemetery was prone to flooding, as was the entire community. Once Green Lawn Cemetery (founded in 1848) opened, many families moved the remains of loved ones there. Joseph Sullivant, youngest son of Lucas and Sarah Sullivant, helped to plan Green Lawn, and in doing so, he moved the family plot to the higher ground of Green Lawn.

Over the years, changes were made to the cemetery. The 1930s Works Progress Administration (WPA) built the stone wall surrounding the cemetery. The West Side Board of Trade erected a twenty-six-foot granite obelisk monument in the center of the cemetery in 1931, honoring the memory of Lucas Sullivant, early settlers and First Presbyterian Church. A historical marker was erected by the Franklin County Historical Society for the city's sesquicentennial in 1962. In 1992, new grave markers were added for Revolutionary War veterans Samuel McElvain, Seth Noble and Robert Culbertson and Civil War veteran Samuel Scott Jr. In 1997, many of the mature trees along the river were removed for the construction of the Franklinton floodwall, and in 2005, the Franklinton Historical Society erected a replacement cemetery marker on the Souder Avenue side of the cemetery.

First Presbyterian Church was organized in 1806 by Robert G. Wilson, but within the year, Reverend James Hoge, on a missionary pilgrimage from Virginia, came to Franklinton and became the pastor in 1807. The church was built in 1811. During the War of 1812, the congregation agreed to allow grain to be stored in the building by the army's quartermaster. When a storm damaged the roof in 1813, rain caused all the grain to expand, causing the church walls to fall. In 2009, Dr. Jared Burkes of Ohio Valley Archaeology, Inc. did a radar and magnetic scan of the graveyard, finding evidence of a past structure where historians had surmised the church to be based on print and picture records.

In 1814, the church had moved across the river to the emerging city of Columbus, occupying a log cabin at Spring and Third Streets. Dr. Hoge and his wife, Jane Woods Hoge, were active in the community, establishing the first Sabbath school in their home, advocating for free public education, starting schools for the deaf and blind and a hospital for the insane and helping found the Columbus Female Benevolent Society to care for survivors of the cholera epidemic in 1835.

FRANKLINTON FIREHOUSES (540 WEST BROAD, 1096 WEST BROAD, 1080 WEST BROAD STREETS)

Ask for directions to something in Franklinton, and part of the answer is often, "It's before/after the firehouse." That is not surprising since Franklinton retains a number of firehouses, and the oldest (#10) is 116 years old. Firehouse #6 was built in 1880 at 540 West Broad and Mill Streets. It was rebuilt in 1882 to house a steam engine and was motorized in 1912. Late in 1934, it became home to the first emergency squad in the city; however, the site was abandoned as a firehouse in 1966 and was purchased by Jimmy Rae Electronics Inc.

Until 2008, Fire Station #10, home of the nicknamed River Rats, was the oldest active station in Columbus, built in 1896 and opened in February 1897. At the time, #10 had the latest in modern equipment—all powered by the station's six horses. The northern half of the station was originally a stable with hayloft above. The equipment was motorized in 1913, meaning each apparatus had a gasoline-powered tractor especially made to convert the wagons to engine power. The horse barn was converted into space for firefighters that included a kitchen. The hayloft became a recreation room. The two interior brass poles that enabled speedy access from the second floor to the trucks were used routinely. Cost for the firehouse, including horses, was $22,139.

Firehouses #6 and #10 were placed in proximity because horses pulling heavy equipment could run only so far at a full gallop. When that distance was measured, a new firehouse was built. New station #10 is the city's first LEED-certified station. Opened in 2008, it is one story, and its 21,428 square feet is more than twice the size of the old #10. Four apparatus bays house the engine, ladder and medic companies.

FRANKLINTON MURAL (33 NORTH GRUBB STREET)

The Franklinton mural is on the west façade of the Homeless Families Foundation Dowd Education Center at 33 North Grubb Street but is visible from Route 315 at West Broad Street and best viewed from Green Street, west of Route 315 or the West Broad overpass. The mural depicts Franklinton's beginning in 1797 to the present—founder Lucas Sullivant, early river activity, prominence in the War of 1812, railroad and vehicular transportation and its important role on the National Road, the 1913 flood, businesses, art and major landmarks. The Franklinton Branch Library, at 1061 West Town Street, has a small model. The mural was commissioned by the Columbus Compact Corporation as part of a series of streetscape improvements. Well-known muralist Greg Ackers (International Murals and Graphics Enterprises, Inc.) began the mural in August 2006 and finished the 165- by 30-foot graphic in November 2007. Akers said, "I think BIG...If you're in preservation of history, you have to think big because history is very big in our lives."

FRANKLINTON SCULPTURE SIGN
(NORTHWEST CORNER OF WEST BROAD STREET AND ROUTE 315 EXIT)

The Franklinton Streetscape Committee worked with the Neighborhood Design Center on a four-part project that included community directories, location markers (metal signs at street level), a sculpture at Broad Street and Route 315 exit and railroad overpass graphic designs that became the Franklinton mural. One of the main objects of the Columbus Compact, which funded the project, was to identify neighborhoods within the city. The metal sculpture spelling "Franklinton" was created by Baker Welding and installed in spring 2006 in the historic heart of the community. East of the sign was the site of the Franklin County Courthouse until 1824, and across West Broad Street was the home of Lucas and Sarah Sullivant. The letters are in a favorite shade of blue, adopted by the Franklinton community, and the red-and-blue abstract portion of the graphic represents the community's transportation heritage.

FRANKLINTON WAR OF 1812 LANDMARKS

Few books on the War of 1812 mention Franklinton. Yet all the able-bodied men in the area fought in the campaign, and their names are recorded on the War of 1812 plaque at Veterans Memorial. The community served as a supply depot for the Northwest Army under Quartermaster Lyne Starling, brother of Sarah Starling Sullivant. General William Henry Harrison was regularly in Franklinton, and thousands of troops passed through the settlement.

The Sullivants personally knew many of the troops from Kentucky and allowed them to camp on the yard around their home (the current site of the Graham Ford dealership). Sarah Sullivant nursed the soldiers and contracted typhus, or "cold plague" as it was called in 1814. She died on April 28, and her young daughter, Sarah Anne, died May 12, 1814, from typhus.

In the early nineteenth century, Franklinton was a tiny spot in the wilderness, and the residents lived in great fear of an attack by Native Americans, especially one that might be prompted by the tribes' siding with the British in the War of 1812. Already, the 1795 Treaty of Greenville, only seventeen years earlier, opened the Ohio lands for settlement, and the Ohio tribes were not happy about settlements appearing in their farming and hunting areas. American general Hull's surrender of Detroit and all of the Michigan Territory to British commander-in-chief General Brock on August 16, 1812, was reported in the local Franklinton newspaper, *Freeman's Chronicle*, on September 5. Franklinton residents were alarmed.

Tribes openly opposed the frontier settlements, encouraged by the early British victory and bounties for scalps paid for by the British. Settlers lived in constant fear of attack, burned houses and scalping. Alarms were frequent. Terrified settlers from Darby Creek and Sell's settlement on the Scioto (now Dublin, Ohio), Delaware and Worthington often came to Franklinton for safety in numbers. A ditch and a stockade were built around the Franklin County Courthouse in Franklinton, and Lucas Sullivant kept two scouts on duty as far north as the village of Zanesfield in Logan County to give warning of potential attacks. Ohio governor Meigs called for a militia, and General Harrison came through Ohio, gathering troops, rescuing Fort Wayne from siege and returning to Franklinton to be commander of the Northwestern Army and prepare supplies for the expected winter campaign. General William Henry Harrison would establish his military career that helped his successful run for the presidency of the United States on the frontier border of Ohio and in Franklinton.

Many consider Harrison House to be the headquarters of General William Henry Harrison during the War of 1812.

Throughout the war, the general was often in Franklinton, and houses on Franklin Street (now West Broad) were used by the general and his men. Harrison House, also known as the Overdier House (570 West Broad Street at North Gift Street) is presumed to have been the general's headquarters.

Due to an 1872 stereograph of "Gen'l Harrison's Headquarters, Franklinton, War of 1812," many consider a house between Foos and Davis Streets on the north side of West Broad Street to be the most likely headquarters of General Harrison.

Beginning in 1974, a campaign to save the Jacob Overdier home at 570 West Broad identified that home as the Harrison House. Built in 1807, most likely by Robert Culvertson, who bought the property in 1805, the sturdy house has hewn black walnut beams (still visible in the basement). Jacob Overdier purchased it from Michael Sullivant, son of Lucas Sullivant, in 1832.

From 1863 to 1973, the house was owned by the Kuhn family, and in 1974, Charles P. Conrad bought the house with plans to restore it with help from the Franklin County Historical Society. Though that effort was unsuccessful, within two years, the Columbus Society for Preservation of the Harrison House, Inc. raised funds, secured federal grants and received over $100,000 from the Columbus building trades union in labor and materials and funding from community development monies. In 1980, the Columbus Parks and Recreation Department purchased the property with federal and local funds; donated labor by Cardinal Industries secured the restoration.

The decorative black stars on the outside of the building cover steel reinforcement rods placed in the second floor at an earlier period. The building was leased from 1985 to 2009 by the Franklin County Genealogical Society and is currently leased by Holy Family Catholic Church, located next door, and used as a small conference center.

Behind the house is the Sullivant Land Office at 25 North Gift Street. Moved to its current site from 714 West Gay Street, the office was built by Lucas Sullivant in 1822. When Sullivant died in 1824, William, his eldest son, used the building after taking over his father's businesses.

Though much of the heart of Franklinton was lost in the twentieth century to the Sandusky interchange of I-71/Route 315, important neighborhood landmarks, in truth, were eroded earlier by modernization, widening of West Broad Street and the 1913 flood.

On April 30, 1911, the *Columbus Dispatch* carried a picture and article about the demolition of Fort Franklinton, a modest log structure later covered by clapboards. It was located off Sandusky Street near Green and River Streets. The stockade that surrounded the building was gone by 1911; arrowheads were found in the logs. The clapboards were removed with a plan to reconstruct the original cherry-and-walnut log structure as a summer cottage at Buckeye Lake. The building has remained a mystery—not only what happened to it but also how it originated. Supposedly built in 1800, the building may have been older, erected by French traders in the 1750s. The fort is said to have housed the first mayor of Franklinton; however, Franklinton was never a town or city and had no mayor. The mention of a "fort" eluded most early recorded histories, even the Sullivant family history, yet the building was there and showed signs of a hostile attack.

The Tarhe-Harrison Peace Council Monument is located at the intersection of Martin Avenue and West State Street, an unexpected surprise and important neighborhood landmark in a quiet residential area. The Columbus Chapter of the Daughters of the American Revolution erected a simple stone monument on June 21, 1904, to mark an event of great importance in the War of 1812 and Franklinton. Fear of attack by hostile Native Americans kept local men from joining the militia. General William Henry Harrison called a council of local tribes, needing to know if they were friendly to the Americans or the British.

Fifty chiefs and men arrived, and since there was no building large enough to accommodate the crowd, the council was held outside under a tree on the Sullivant property. The monument plaque reads simply: "Near this spot June 21, 1813 was held a council between William Henry Harrison and the Indians comprising the Wyandots, Delawares, Shawnees and Senecas with Tarhe

the Crane as spokesman resulting in permanent peace with the Indians of Ohio." Assured their families were safe, the men joined the war effort. Many warriors also joined and marched with other American soldiers to Fort Meigs in northern Ohio, fighting at the Battle of the Thames River in Canada where Tecumseh, the Shawnee chief who sided with the British, was killed.

The Peace Council is commemorated on the base of the Lucas Sullivant statue near the Scioto River.

GLADDEN COMMUNITY HOUSE (183 HAWKES AVENUE)

Since its founding in 1905 as the First Church Settlement/West Side Social Center, the Gladden Community House in the Franklinton neighborhood has been the place to go for help. Originally the outreach program was started by Washington Gladden, First Congregational Church's well-known minister and leader of the nationally known social gospel movement, and Mrs. Celia Jeffrey of the Jeffrey Manufacturing and Mining Industry family. Volunteers provided clubs, classes, a library and reading room, social gathering spaces, camps and sports, milk stations and well-baby clinics to benefit the neighborhood and to support the needs of immigrants.

Officially named Gladden Community House in 1921, the settlement house became an independent nonprofit welfare agency in 1923. Over the years, Gladden Community Center evolved from a social organization to one addressing social needs. *The Franklinton News*, a community newspaper, began at Gladden House in 1972. The Near West Side Community Council originated there and established the Near West Side Area Commission (today the Franklinton Area Commission). Since 1954, Gladden has been at the corner of Hawkes and West Town, and it greatly expanded in 1994, still serving the needs of a changing community.

GREEN GABLES DRIVE-IN (619 HARRISBURG PIKE)

Green Gables was the cruise-in place to be seen and to enjoy burgers, fries and shakes for three decades of Columbus residents. Located at Central Points Shopping Center, it was opened in 1948 after Milton Lustnauer borrowed $10,000 to open a six-stool restaurant in a leased building at the intersection of Harrisburg Pike and Mound Street. Business boomed and

expanded. Ten years later, a remodeled Green Gables also made its own buns and strawberry pies (fondly recalled by many) in a basement kitchen. As Lustnauer became more involved with developing the Burger Boy Food-O-Rama chain, Dick Norris took over in 1961. The restaurant was demolished in 1979, and McDonald's now occupies that corner. Starting in 2007, local Green Gables fans often hold an August reunion at Darby Dan. Central Point Shopping Center, developed by Don Casto, was behind Green Gables.

GREEN LAWN ABBEY (700 GREENLAWN AVENUE)

Green Lawn Abbey is the final resting place for magician Howard Thurston.

The majestic building on top of a hill, classically designed with a gray granite exterior and columned second-floor portico, was built to impress. It still does. Green Lawn Abbey is a private community mausoleum built in 1927 by the Columbus Mausoleum Company and was once the finest resting place in the city. Though nearby, the abbey is not part of the Green Lawn Cemetery that was established in 1848.

In the nineteenth century, cities were closing early burying grounds within city limits. Park-like cemeteries in rural areas, like Green Lawn Cemetery, were opening. The wealthy often built aboveground mausoleums within cemeteries. Private community mausoleums appeared in the 1920s.

Green Lawn Abbey was the largest with 654 crypts, one-and-a-half-foot-thick walls, marble floors, a central chapel and foyer area and stained-glass windows. When it opened, four crypts cost approximately $2,500, with

second-floor "family rooms" considerably more. Some families had special statues designed for these rooms. The Columbus Mausoleum Company bought land near cemeteries, sold crypts, built the structure and then turned it over to a local board of trustees to maintain.

With the stock market collapse of 1929 and the Great Depression that followed, the concept of perpetual care ended. Originally the mausoleum had a grand entrance at the intersection of Harmon and Greenlawn Avenues, but gradually land was sold to raise money, and by 1960, there was little left to maintain. The mausoleum fell into serious disrepair. County Commissioner Dewey Stokes prevented the sale of more land in front of the structure. The Columbus Cemetery Association board was reactivated in 2011 with additional members to help with compliance issues, marketing and fundraising. One descendant from the original board of trustees remains: Chip Aschinger, the great-grandson of W.F. Aschinger, founder of Columbus Showcase Company.

Janice Loebbaka, a volunteer with Columbus Landmarks Foundation, first saw the abbey on a Columbus Landmarks tour in 2005 and was saddened by its condition and convened a work crew to clean up the first floor in time for the next tour. She created an informational website to bring the plight of the abbey to the attention of the community, gathered volunteers and worked to place the structure on the National Register for Historic Places in 2007 in order to apply for grants for planning and the restoration of the building. The roof has been replaced and entry doors and previously vandalized stained-glass windows repaired.

Green Lawn Abbey Preservation Association (GLAPA) was convened in 2009. Historic cemetery consultants were secured, a business plan emerged and GLAPA engaged McGill Smith Pushon, Inc. in 2010 to develop plans for a landscaped park and memorial gardens. Willet Hauer Architectural Glass of Winona, Minnesota, created a restoration plan for the sixty windows in the abbey, possibly the largest collection of stained glass in the world from the former Rossbach Art Glass Studios (101–111 West Broad Street), estimated at $250,000. Special programming (often centered on famous abbey resident and magician Howard Thurston) helps to fund restoration efforts.

Green Lawn Cemetery (1000 Greenlawn Avenue)

Architect Howard Daniels, who designed Spring Grove Cemetery in Cincinnati and the Greek Revival Montgomery County Court House in Dayton, helped to create Columbus's preeminent Victorian cemetery during

the era influenced by the "cemetery beautiful" movement that started in Mount Auburn Cemetery in Boston, Massachusetts. The movement emphasized keeping the beauty of the natural environment; enhancing it only with natural plantings, creation of pathways and carriage steps; and encouraging monuments of beauty that are today associated with Victorian cemeteries. With urbanization, water pollution and railroad expansion, the city stopped burials within city limits in the later nineteenth century.

In March 1848, the Ohio legislature incorporated a cemetery association to provide a large cemetery, Green Lawn, outside city limits. Land was purchased in Franklin Township in 1849—forty acres from Judge Gerhom Peters and forty-four acres from William Miner—along Harrisburg Pike. Mary Minor Wharton gave the county the right of way through her land, and by May 1849, a "pic-nic" was held to enlist volunteers to begin cleanup. Green Lawn was dedicated July 11, 1849.

The first burials included an infant and Dr. Benjamin Gard, a victim of cholera. Within three months, a cholera epidemic was responsible for 162 burials from the city and 116 from the Ohio Penitentiary (including 3 doctors). In 1864, Green Lawn offered lots to inter the remains from the now abandoned North Graveyard (see North Market entry). Due to litigation over the Kerr tract at North Graveyard, the moves were not finished until 1881. By January 1, 1858, there were 1,079 burials, of which 247 were removals from other burying grounds.

Local architect Frank Packard designed the chapel, created in 1902, and the Hayden and Packard mausoleums. The chapel's stained-glass windows and mosaic artwork were done by Tiffany studios in New York and paid for by banker Pelitiah Huntington. Huntington Bank today supports the restoration efforts of the chapel-turned-mausoleum (1960s). Many of the early families of Columbus are buried near the Brown Road entrance, the original road into Green Lawn.

Today the cemetery covers 360 acres, has approximately 150,000 internments, maintains six distinct areas for war veterans, contains a butterfly preserve and is recognized as an important birding area by the National Audubon Society.

HARLEY-DAVIDSON MOTOR CO./ A.D. FARROW COMPANY HARLEY-DAVIDSON (491 WEST BROAD STREET)

A number of businesses in the Franklinton area have existed for fifty, seventy-five and one hundred years. While A.D. Farrow was not founded at

this location, the company settled on this site in 1941, becoming the oldest Harley-Davidson dealership in America. It was 1912 when twenty-three-year-old Alfred Dale Farrow sold his first Harley-Davidson motorcycle in his new dealership in Nelsonville, Ohio. After he died in 1927, his wife, Lillian, continued the business, becoming the only female owner of a dealership at a time when that was not sanctioned by the company.

A.D. Farrows Company has always been a family business. Daughter Jane worked in the shop and at the track, as did a cousin who lived with them. Grandfather uncrated the motorcycles, and Aunt Jo, who also lived in Nelsonville, delivered the mail on a Harley instead of a horse. In 1924, the business took over the Columbus dealership of P.I. Hayes and Company, located at 425 North Fourth Street, and moved to 844 East Main Street the following year. The Farrows did not own a car and in 1927 created the Buckeye Motorcycle Club, promoting weekend trips and sponsoring club activities and charities. Grandparents Emma and Charles Matheny also moved to Columbus when Alfred died to help take care of the children, Jane, Donald and Robert.

During the Depression and World War II, the company survived on service contracts with the Columbus Police Department motorcycle unit, funeral escort services and businesses using motorcycles for deliveries. The shop bought the building housing Cassady's Motors on West Broad in 1841 from Orville Cassady. Lillian and her second husband, H.B. Kinnel, ran the shop until retiring in the late 1940s, when son Don, a national hill climber champ, and his wife, Dorothy, took over. Sister Jane and her husband, Bill Langley, created Harley-Davidson on Parsons Avenue, and Jane joined Motor Maids, an organization promoting female riders. Annually the Motor Maids did a parade lap around the Columbus track in their uniforms—blue shirts, gray pants and white gloves—before the Charity Newsies Race. In 1970, Don's son, Bobby Farrow, took over.

Alan and Pat Doerman purchased the dealership in 1983, expanding the building next door and refurbishing the original building. They also started HOG (Harley Owners Group) to revive the Buckeye Motorcycle Club, reviving old traditions and runs and promoting new charities and sponsorships. The original Nelsonville shop was refashioned as A.D. Farrow Museum, with an ice cream parlor added in 1997. When the Doermans retired, Bob Althoff purchased the dealership in 2002, celebrating the 100th anniversary of Harley-Davidson in 2003 with a permanent exhibit and continuing an involvement of family members. Bob's daughter runs the riding school, introducing a new generation of riders to the open road.

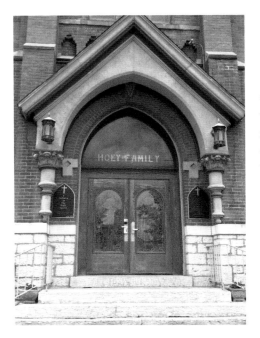

The Holy Family Catholic Church has done outreach in the Franklinton neighborhood since the nineteenth century.

HOLY FAMILY CATHOLIC CHURCH (584 WEST BROAD STREET)

Catholic families in Franklinton were served by traveling missionaries in the early nineteenth century. After 1865, Catholics on the west side of the Scioto River attended a small chapel for the Sisters of the Good Shepherd Convent, located in the former Sullivant home at West Broad and Sandusky Streets. Opposite the convent on Sandusky Street was an old ecclesiastical seminary building that closed in 1876.

At the request of Bishop Rosecrans, the Sisters of St. Joseph of Ebensburg, Pennsylvania, opened a day and boarding school for young men in 1871. Reverend R.C. Christy, a former army chaplain who also came from Ebensburg, started using a barn on the seminary property for church services until acquiring the United Brethren Church on Sandusky and Shepherd Streets. It was remodeled and blessed on June 8, 1877, as Holy Family Church. Reverend Christy resigned due to poor health. Because of a flaw in the title to the property, the church was sold to satisfy mortgage claims by the former owner.

A lot off the corner of West Broad Street and Skidmore Avenue was purchased to begin again. Two years passed, and by 1885, only the basement was completed, with two windows added to create a temporary chapel and a few classrooms. Four years later, the completed church was dedicated by Bishop Watterson on June 2, 1889.

The Gothic-style church can seat one thousand. Stained-glass artists from Munich, Germany, created the windows. A convent for the teaching sisters was added in 1887 and enlarged in 1912 and 1917. The pump organ, pumped by waterpower, was added in 1890 but replaced in 1981. A new school on Sandusky Street was completed in time to weather the 1913 flood. The basement flooded, but the upper floors were used to provide flood relief,

opening a year later for students and run by eight Sisters of Mercy from Louisville, Kentucky.

The high school closed in 1962, but the elementary school that opened in 1941 lasted until 1973. Today the school building at 57 South Grubb Street houses the Holy Family Soup Kitchen and became the Jubilee Museum 2000. As part of Franklinton's bicentennial in 1997, the church steeple was lighted.

JOSIE'S PIZZA (952 WEST BROAD STREET)

Since August 1959, generations of west siders have enjoyed the best pizza in Franklinton in the small shop operated by the Catalfina family, who know most customers by name. It was named "Josie's" after Josephine Catalfina Placid, who, with her husband, established the business (and Kelly's bar next door) after purchasing the building from owner Lillie Caito. Josie's has the original tin ceiling and walls that are three layers deep of brick. Placid's family immigrated to the United States from Sicily when he was twelve years of age. They moved to Columbus after living in New York and Cleveland, opening the shop and developing their own blend of cheeses, dough and sauces that are still used today.

By the 1970s, sons Phillip, Anthony and John bought the business from their parents. Anthony and John ran Josie's, and Phillip ran Kelly's (closed later). Always a family business, the shop is staffed by relatives and their children, and a niece and nephew are in the pizza business in two other locations. At this writing, Josie's operates from late afternoon through late night and, though remodeled in the 1980s, is being updated as part of the Franklinton Board of Trade's Façade Renovation Affordability Made Easy program (FRAME).

MAGGIE FAGER MEMORIAL LIBRARY (969 WEST BROAD STREET)

The Maggie Fager Memorial Library, the Franklinton Branch Library, the Hilltop Branch Library and the Main Library of the Columbus Metropolitan Library are joined by a tale of library intrigue. It starts with grocery store owners Frank and Maggie Fager, who operated their store from 1894 to 1905 from their house at 969 West Broad Street.

After he retired, Frank Fager continued to live in half of the duplex, and the other half was rented as a grocery, confectionary shop, upholstery store, barbershop and real estate office for the next thirteen years. Maggie Fager died in 1897, and her husband, acting on advice from friends, established a library in her name. Since there was no library in the Franklinton area, Frank Fager decided to "establish a reading room for the public with shelves and tables of books that people could take home" in his 1916 will. The will further stipulated that the trustees must raise $300 for the library among the residents of the neighborhood. With Frank's death in 1917, funds and time were donated to add a new front of brick and glass to the former duplex, becoming the start of the west side's library. Books circulated for ten days for free, and borrowers could check out as many books as they wished.

One resident, Michele Finneran Williams, said, "My first experience with libraries was at Maggie Fagers. We used to make a tent out of bed blankets over the clothesline in our back yard, collect pop bottles from the neighbors and go to Bob Shultz's IGA on Hawkes to pick out penny candy and other snacks. Then go to Maggie Fagers and get some books and read them in the tent. Great times." Frank Fager's will was probated by John Morgan Lewis, a lawyer whose sister Sarah was a teacher. A library board of trustees administered the estate of $3,000 and $10,000 in realty. The Maggie Fager Memorial Library opened October 2, 1918 with fifty books. Lewis asked his sister to staff the library, and she agreed to a two-week term. Thirty-two years later in 1950, she retired from the job after her eighty-fourth birthday. Sarah Lewis is honored on the plaque at the base of the Lucas Sullivant statue. One of Sarah's favorite young patrons was a neighborhood boy, Howard ("Hopalong") Cassady of Ohio State football fame and a 1955 Heisman Trophy winner. John Morgan Lewis died in 1954, and his estate passed to Sarah, who died in 1966, living to the age of one hundred.

Neither John nor Sarah married, and their estate passed to the Columbus Public Library to build the Lewis Memorial Community Center on West Broad Street, between Sandusky and Central Avenues. However, the site became the Sandusky exit from Route 315, and the money from the estate was held by the City of Columbus for six years. Within the same decade, Creth D. Irwin, one of the library trustees, died in 1973, and his daughter, Jeanne Irwin Scott, who had worked at the library as a child, owned the building from 1977 to 1980.

But the library could no longer be supported by money from apartment rents and bequests. There were plans to move the books and reestablish the library at another location, but the library ceased to exist, and remaining books were

given to the Boys Club or sold to the public in 1978. By 1972, the $84,000 held by the city was not enough to build a community center and/or a library. The funds were used to establish the Columbus and Ohio Room at the Main Library and purchase county histories valuable for genealogy work. In 1996, the John Morgan Lewis meeting room was dedicated at the newly constructed Hilltop Branch Library (511 Hague Avenue) to honor his philanthropy.

Today, the sign for the library on West Broad Street is still visible from the corner of Meek Avenue.

MARINA RESTAURANT
(ORIGINALLY 1421 SULLIVANT AVENUE; 697 HARRISBURG PIKE)

When Central Point Shopping Center opened in November 1952, Marina was one of the new restaurants, and it was the last of the original stores when it closed in 2008. Starting in 1942, Ralph Presutti had a restaurant at 1421 Sullivant Avenue next door to the five-and-ten-cent store, into which his business eventually expanded. Joseph J. Polina, a cook, became an owner. By 1980, Dong and Joon Lee bought it and continued the Italian restaurant. After Dong Lee's death, his wife and daughter, Suzie Tipton, continued the tradition of using the original recipes of the Marina's original owners. Joon made Italian meatballs daily, and pasta was made on site. The last people connected with the restaurant were Keith and Kyong Tipton, relatives of Suzie Tipton, but the origin of the name "Marina" remains a mystery.

MILO'S DELI AND CAFÉ (980 WEST BROAD STREET)

For many people, their introduction to Milo's came with the box lunch they received in a long meeting. The food was great and the brownies divine. In a short time, chocoholics everywhere were suggesting Milo's as a new caterer for their meetings. While the deli was new, opening on November 23, 1998, the owners creating the business were pros. Kathy Pappas, wife of Tommy's restaurant owner, Tom Pappas, and her sister Demetra Stefanidis, created Milo's from the former Mowery's Food Town.

The building was a former Atlantic & Pacific (A&P) neighborhood grocery store. Louie Pappas, son of Kathy and Tom Pappas, was ready to

strike out on his own. His deli, named for the Pappas sons, Michael and Louie, is two thousand square feet, originally employing twelve workers. Today, employees number twenty. All soups and meats are cooked on premises. The kitchen has expanded, and apartments upstairs are now sales offices. Milo's recently became the operator of the Capital Café in the lower level of the Ohio statehouse, but it still maintains forty seats in the deli on West Broad Street.

MOUNT CALVARY CEMETERY AND JEWISH CEMETERY (518 MOUNT CALVARY AVENUE)

Mount Calvary, established in 1865, is the second Catholic cemetery in Columbus and the oldest surviving Catholic cemetery in the city. When laid out, it was outside the city limits near the Harrisburg turnpike and not far from Green Lawn Cemetery. The original area was twenty-five acres with several later purchases that added fifteen more acres.

Consecrated by Bishop Rosecrans, the first bishop in Columbus, on November 2, 1874, there were, prior to his blessing, 1,400 internments. Bodies were moved from St. Patrick's Cemetery (now the location of Columbus State University) and from St. Jacob Cemetery (also called Frey Cemetery), once located near East Broad Street and Stanwood Road.

German Catholics took the north half of the cemetery, named Holy Cross, and the English Catholics took the southern half, named Cathedral. The dividing line between the two sections is the Priest's Circle (also called the Bishop's Circle) for burial of Catholic clergy. There is also a section for nuns from various orders—Sisters of the Holy Cross, who ran Hawkes Hospital (now Mount Carmel), and Sisters of the Good Shepherd, who cared for women during the Civil War at the convent in Franklinton (originally Sullivant's Mansion, now the site of the vacant Graham Ford dealership).

There have been approximately forty thousand burials at this writing, and only those who hold deeds can be buried at Mount Calvary. The cemetery is maintained by St. Joseph's Cemetery, the current Catholic cemetery in Columbus located on South High.

Next to the southeast corner of Mount Calvary Cemetery is a small Jewish cemetery purchased in 1874. In 1881, one hundred graves were moved from the East Graveyard at Meadow Lane and East Livingston Avenue (currently the front of Nationwide Children's Hospital) when the city prohibited burials

inside city limits. During the 1913 flood, the Jewish Cemetery records were destroyed and many tombstones were lost. The burial site is closed, but it is also maintained by St. Joseph's Cemetery for Temple Israel.

MOUNT CARMEL HOSPITAL AND HAWKES HOSPITAL OF MOUNT CARMEL (793 WEST STATE STREET) AND MOUNT CARMEL COLLEGE OF NURSING MURAL (127 SOUTH DAVIS AVENUE)

Today Mount Carmel Health serves all of Franklin County with several hospitals, surgery centers and outreach vans, but the hospital has long been associated with Franklinton as both a landmark and major employer.

The hospital began in the late 1880s as Hawkes Hospital of Mount Carmel, and Dr. William Hawkes was a physician who invested well in transportation and land development to keep the hospital financially secure. Hawkes was a wealthy man who donated four acres at the corner of West State Street and Souder Avenue for the hospital and $10,000 of government bonds to the Columbus Medical College to secure the building of the hospital. When Hawkes died, he left Dr. Hamilton to raise more funds and to supervise the construction of a four-story building.

With the help of the Sisters of the Holy Cross of Notre Dame in Indiana, Dr. Hamilton opened the hospital in 1886 on the Feast Day of Our Lady of Mount Carmel. The plaster on the walls was still wet, and there was no furniture. However, Mother Angela had experience in working in military hospitals (she was a cousin of General Sherman). Mother Angela and five other nuns raised awareness and funds. The City of Columbus provided free water for the hospital with eighteen private rooms, two wards, a kitchen and an operating floor and amphitheater. In 1887, the sisters bought the adjourning property to the east, and in 1891, a foundation for a hospital with seventy rooms, three wards and surgical facilities began.

The training school for nurses opened in 1903 with additions in 1906. In 1921, additional classrooms, a library and a recreation hall were added for nursing students. Mount Carmel was the first accredited nursing program in the United States.

During the 1913 flood, flood victims were housed in the building for a week. In the 1930s, families and children were able to eat because the Mount Carmel kitchen staff put out buckets of food for hungry people. The seal in the entrance of the original building is now in the Medical Records Bureau.

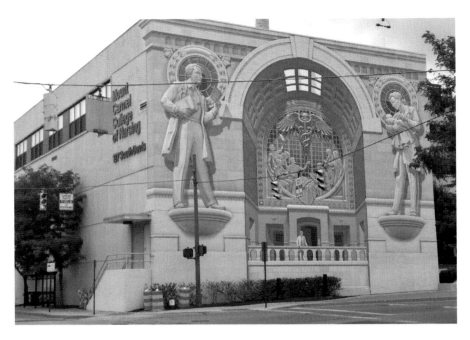

Mount Carmel Hospital's mural is entitled *Honoring Every Soul with Loving Service.*

Sister Barbara Hahl, who directs community outreach for the hospital, is the last sister living from the order of the Sisters of the Holy Cross.

Honoring Every Soul with Loving Service is the title of the fifty- by fifty-eight-foot mural by Eric Grohe on the west façade of Mount Carmel College of Nursing. The *trompe l'oeil* mural often confuses people who assume the porch is real and there is an entrance on that side of the building, and the faux arch frames a group of caregivers attending a patient. The mural pays tribute to the dedicated educators, physicians, nurses, employees and volunteers who have made up the century-old Mount Carmel staff. The doctor on the porch is modeled after an employee.

NATIONAL ROAD (ROUTE 40)

Route 40 is the original seven-hundred-mile National Road that ran from Maryland to Illinois, opening the Midwest to settlers in the mid-nineteenth century. It was the first federally planned and funded highway in the country.

An oversized replica of a National Road marker is on West Broad Street in front of the veterans' memorial.

Running through nine Ohio counties, this historic landmark road helped establish many "pike towns" throughout Ohio and helped establish Columbus as a major crossroads city. The National Road also affected many Columbus neighborhoods and was responsible for the settlement patterns along East Broad Street, Drexel Avenue, East Main Street, South High Street and West Broad Street.

The less-than-straight road through Columbus occurred because wealthy families on East Broad Street did not want traffic through their residential area, but the merchants of East Main Street (the old Hub business district) welcomed the traffic. The road contributed to the demise of many nineteenth- and early twentieth-century landmark buildings in favor of gasoline stations in the automobile age. Historic mileage markers still mark the road; however, the one by Veterans' Memorial Building is oversized and considered more public art than reproduction.

PHILLIP'S ORIGINAL CONEY ISLAND (450 WEST BROAD STREET)

Phillip's Original Coney Island celebrated 100 years of tasty traditions in January 2012. Great-grandfather Phillip Manus emigrated from Greece to the United States and opened Phillip's Coney Island on North High Street, selling Coney hotdogs for five cents. Within three years, and following the 1913 flood that devastated the west side, the store moved to 1244 West Broad, but this location closed after Phillip Manus's death in 1959.

His son, George, opened Phillip's Son Coney Island at Buttles and North High Streets, but that restaurant was sold in 1948 upon George's death.

Phillip's other son, William (Bill), also opened a shop at West Broad Street and Wilson Avenue. Other restaurants opened at 847 West Mound Street (1963–81) and 450 West Broad Street (1981–present); the latter was opened by Bill's son, Jim, and his sons, Nick and Demetrios, worked at the restaurant while still in school.

On the retirement of his father, Nick took over the management when he was only twenty-two years old. As a fourth-generation "Coney Man," he succeeded, redoing the décor at 450 West Broad Street and keeping the family recipes for quality, simple food, including bean soup, chili, ham sandwiches and, of course, Coney sauce.

PILOT DOGS INC. (625 WEST TOWN STREET)

Regardless of the weather—hot, cold, rain or snow—people will be walking dogs on Franklinton's streets. At each intersection, trainer and dog stop and learn to proceed safely because these working dogs are in training. The mission of Pilot Dogs Inc. is simple: "To provide the finest guide dogs to the qualified sightless."

Pilot Dogs Inc. started when Columbus man Stanley Doran moved to Michigan to be a student trainer at a guide-dog school. Doran had had a vision impairment since he was twelve years old. Returning to Columbus in 1946, he started a school in a rented home and paid $600 for four dogs. The first class of four students was housed in the home of the Harold Fawcett family near Ohio State University. In three years, Doran trained fifteen dogs, at $500 per dog, but the demand for the trained dogs grew. Most applicants to receive a dog were sponsored by civic or labor groups.

Pilot Dogs Inc. was incorporated in 1950, and in 1952, the Chicago-based Pilot Guide Dog Foundation helped to provide guide dogs to the blind at no cost, screened applicants, paid airfare for students to get to Columbus and paid the school's operating expenses. By 1956, the school moved from near Ohio State University to the present location. After years of acquiring surrounding properties, a new expanded facility opened in 2004 and included an Alumni Park set up like a street with steps, bridges, walkways and other traffic impediments. Training a dog and owner costs $8,500, but where there was previously only room to train 4 students at a time, now 150 students per year are trained, each needing three to four months to complete the program. Puppies for training come from

families, a 4-H puppy pilot program and prisons, where they learn simple commands and are socialized.

SULLIVANT STATUE (WASHINGTON BOULEVARD)

The Lucas Sullivant statue is on the west bank of the Scioto River on Washington Boulevard at the east façade of COSI, south of the Broad Street Bridge. Dedicated on May 6, 2000, the statue is very near where Franklinton was founded by pioneer Lucas Sullivant in 1797. Twelve descendants from four generations of the Sullivant family attended the ceremony.

The bronze figure is twelve feet tall and sits atop a five-foot, 11,500-pound Columbus limestone base. The limestone was from the same vein near the original Sullivant quarry (now under the I-70 freeway) and was reopened by the North Shore Stone Company to repair the statehouse. Artist Michael Anthony Foley designed Lucas Sullivant in a modernized classic Greco-Roman style to reflect the heroic stature of the man who created the first settlement in what later became Franklin County and was instrumental in the creation of Columbus as the capital of Ohio.

After working closely with the Lucas Sullivant Statue Committee on historical details and portrayal, Foley began wax sculpting in 1998, using as a studio the buildings provided by GFS Chemical Company, which were in an area where Sullivant had his mill and built the first church. The House Bronze Fine Art Foundry in Lubbock, Texas, made rubber molds and cast the bronze pieces. After being transported by a flatbed truck across the country, the statue was assembled on site by the artist. Columbus Art Memorial and Old World Stone Carving designed the base.

The statue's base has three commemorative plaques designed by Paul Foley, the artist's brother. They commemorate early women of Franklinton, the devastation of the 1913 flood and the meeting of Chief Tarhe the Crane and General William Henry Harrison in June 1813.

SUNSHINE PARK/DODGE PARK (667 SULLIVANT AVENUE)

The land on which Sunshine Park is located (later renamed Dodge Park after long-time Recreation and Parks Department director Mel Dodge)

has a long and curious history. No one knows why the term "Sunshine" was used, but accumulating the land for a park began as early as 1852 and 1853, culminating in the purchase of the Keller tract at Sandusky Street and Sullivant Avenue in 1915.

Historic records give clues to what the land had been used for, since some of the names were "Workhouse," "Riverside Park," "Circus Grounds" and "Gravel Lot." The gravel lot was platted by the city in 1884 as the Riverside Addition, but no lots were ever sold. Close by at 515 Sullivant Avenue at McDowell Street was the city's workhouse, once used as police headquarters in the 1920s until a tornado destroyed the building. Tunnels under the jail were used for furniture storage, but these collapsed when nearby highways were built.

The park officially opened as Sunshine Field on September 3, 1921. By 1925, it had a playground and baseball diamonds. A stone building, a WPA project, was completed in 1935. In 1947, a Sunshine Kindergarten and Sunshine Shelter House were popular, and a pool was added in 1964 on the site of the former workhouse.

Local businesses and residents supported all the parks projects. The Seely family (Seely's Hardware) served in all positions on the park board. O.D. King, a retired policeman, helped build soapbox derby cars, and Al George, a lightweight boxing champ, taught Golden Glove Boxing. If the park was not attraction enough, a nearby slaughterhouse, David Davies, Inc. or David Davies Baby Beef, at 1616 West Mound Street, provided a window in the back of the plant where the entire slaughtering process could be watched from the park (not for the faint of heart).

When Mel Dodge retired from over thirty years of service in the city's Recreation and Parks Department, the park was renamed for him because he had started his career as a playground leader at Sunshine while just out of college. In 1990, a skateboard park was added, designed by Frank Hawk, father of master skateboarder Tony Hawk, and it contains three interconnected concrete bowls with gradual drop-in chutes. Though the park has been the site of many historic reenactments and much city programming due to its proximity to downtown, most residents remember the landmark park for its West Side Jubilee that started in the 1950s and continued through the 1980s. The weeklong event kicked off the summer season with the Gooding Amusement Company attractions, bands and choirs and themed evening events, like variety shows, ballet companies, novelty acts and tumbling exhibitions, cake walks and many giveaways for gift certificates.

The Dutch Uncles Club sponsored boys from the West Side Boys Club, giving away tickets for rides and food. Local businesses sponsored potential

"queen" candidates. Girls from Starling Junior High and Central High School became Miss Stith Radiator, Miss Pat Wood Tires, Miss Ater's Drive-In or Miss Josie's Pizza, among others. They competed in formal and swimsuit events to be judged as the Queen of the West Side Jubilee at the end of the week.

In a revival of the event in the 1990s, a Franklinton baseball team faced the Ohio Historical Society Muffins for nineteenth-century baseball, and Nathan Neeley won the pie-eating contest by consuming seven pies donated by the Mountain Top Frozen Pie Company.

TOLEDO AND OHIO CENTRAL DEPOT/FIREFIGHTERS UNION (379 WEST BROAD STREET) AND FRANKLINTON RAILROADS

Since 1850, Columbus has been a hub of rail transportation for freight and passengers. Franklinton made a major contribution with the first railroad and passenger station. By 1897, Franklinton could boast an impressive assemblage of tracks that can still be seen today.

The Toledo and Ohio Central Depot was designed by noted architect Frank Packard.

On February 22, 1850, an experimental trip was made from Columbus to Xenia (fifty-four miles in three hours). The completion of a wooden bridge over the Scioto River allowed the train service into Columbus. In 1851, the second rail reached Columbus on the Cleveland Columbus and Cincinnati Railroad, but it was not until two more bridges were erected that rail service came through Franklinton. The third railroad to reach Franklinton was organized in 1864 to operate between Athens and Columbus, and the name Mineral Railroad Company was changed to Columbus and Hocking Valley. This railroad

brought the needed coal for every home in Columbus. A fourth and fifth line entered Franklinton in the 1880s and 1890s.

The Hocking Valley passenger train utilized the Toledo and Ohio Central Depot, a Chinese-pagoda structure designed by Yost and Packard architects, known for their spectacular buildings. The tracks were level with the street, and a porte-cochere or roofed structure provided a sheltered east entrance. The T&O Railroad Depot opened on April 18, 1896, to throngs of people who wanted to visit the elegant station. It served as a station from 1896 until 1930, surviving two devastating fires in 1910 and in 1975. The Macklin Hotel, various restaurants and barbershops were nearby. In 1952, the last train to the station arrived, and in 1955, the last restaurant associated with the Macklin, the Keystone, was torn down. The T&O Railroad Depot was leased and then sold to the Volunteers of America, which was an excellent caretaker of the building until it sold in 2004 to the City of Columbus and became the headquarters of the Local 67 Firefighters Union. Union members used their own time and craftsmanship to restore the historic building.

SHORT NORTH

VICTORIAN AND ITALIAN VILLAGES, HARRISON WEST

AL G. FIELD HOUSE (29 WEST THIRD AVENUE)

Alfred Griffith Field was the impresario of Al G. Field's Greater Minstrels. The first performance of his troupe was on October 6, 1886, at Marion, Ohio, yet he had produced and managed minstrels and circuses for twenty-five years prior to this. The troupe traveled the United States and garnered top repute because the shows were new every season. Field bought his home at 29 West Third Avenue in 1899 and lived there until he died in 1921. His widow, Matilda, passed the house to a niece in 1929. When not living on West Third, Field relaxed and rehearsed new shows at his Maple Villa Farm, fourteen miles north of the city on Olentangy River Road.

ANNUNCIATION GREEK ORTHODOX CATHEDRAL (555 NORTH HIGH STREET)

The present Annunciation Greek Orthodox Cathedral was built in 1990, but the first Greek Orthodox congregation in Columbus was chartered in 1910. The permanent church edifice was opened at Park and Goodale Streets in 1922. Oral tradition in the congregation suggests the location was selected near the railroad depot for convenience to immigrating Greeks and for proximity to employment in businesses, both general and Greek-

The Annunciation Greek Orthodox Cathedral as seen behind the Cap.

owned. In the nineteenth century, Greek immigrants came to Columbus and settled near the Union Station and into Flytown, an immigrant and African American community west of current Victorian Village.

Flytown disappeared with 1960s urban renewal. The 1922 church was distinctive, with a large dome over the sanctuary and twin-domed towers. The adjacent freeway (later I-670) made the church a daily landmark for thousands. By the end of the 1980s, it was apparent that the Greek community wanted to expand their facilities, especially because the church membership and the large annual Greek festival were both growing. However, in order for the church to expand, it needed to buy the nineteenth-century commercial buildings on North High Street, some of which retained ornamental iron façades.

The possible loss of the ornamental, iron-façade buildings troubled preservationists, and one building had a popular business, Mellman's Bar. The controversy over how to keep the commercial buildings and how to keep the church on its historic site was even a topic of conversation on late-night national television. In the end, a gentlemen's agreement was reached. The demolition of the commercial buildings allowed the church to expand, but the church was to agree to an urban setting. There would be no long setback for parking in front of the cathedral, and the original 1922 church would be retained.

In 1990, a new sanctuary and congregational facility opened adjacent to the original, extending through to North High Street. Mr. George Kontogiannis, a parishioner, designed the edifice after St. Sophia in Istanbul, Turkey. Unique to this sanctuary are extensive mosaics covering the dome and the icon screen. They were installed over a ten-year period, having been produced in Venice, Italy, and installed here by the original artisan. The new spaces allowed the congregation to educate the city about Greek culture. The cathedral is set within a complex of classrooms and spaces that function almost like a small city. The magnificent cathedral with a Byzantine dome and interior exquisite mosaic work was completed in 1990; however, the 1922 church was replaced in 2008 by a new chapel and educational facilities, complementing the 1990 structure.

ASTON-TAYLOR-HOWE HOUSE (41 WEST THIRD AVENUE)

In 1871, adjacent North High Street land owners James C. Aston on the south and William Hershiser on the north each gave half of their land to create Third Avenue from North High west to Dennison Avenue. Aston built 41 West Third Avenue between 1873 and 1874 and lived there until 1884. Henry Howe rented the house from 1888 to 1892 and was famous for his *Historical Collections of Ohio*, published in 1846 and his 1889 revision, written while residing at the house.

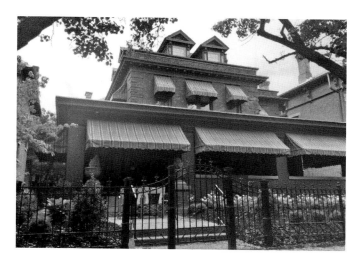

Historian Henry Howe lived in this house from 1888 to 1892 and revised his celebrated *History of Ohio*.

Dr. Clovis M. Taylor bought the house in 1902. He was an obstetrician and a professor at Ohio Medical University and its institutional successor, Starling-Ohio Medical College. Taylor was founder of Protestant Hospital, now Riverside Hospital. Early on, thought to be 1907, Taylor built new front rooms and a large porch onto the house. More interestingly, he built a garage that was approximately two and a half stories tall, with a plastered second floor and fitted out with a fireplace. It was said he entertained his auto-minded friends there. There was an auto-sized elevator, still extant in the 1990s, to take autos to the second floor for his tinkering in the winter months. The elevator consisted of four steel columns, supporting rigging to raise a hand-cranked, cable-supported platform. A 1903 photograph of Taylor and his friends in one of his cars became one of the most popular Franklin Park postcards. Dr. Taylor built the Garden Theater and managed it after retiring as a physician (see Garden Theater entry).

Christopher Columbus Square (134–136 block of Warren Street)

The smallest park in the city, the triangular park, was dedicated in 1976 with Mayor Tom Moody officiating and rededicated in 2004 with additional upgrades—brick paving, benches, planting beds and more. The sycamore tree in the center was originally planted by Louis Volpe, an Italian immigrant, in the early 1900s, and today the park is maintained by local residents who continue to add daffodils to the beds.

Cocoa Manor (76 Buttles Avenue)

In 1991, Greg Zanetos built a Georgian-style home on five vacant lots. The name of the house refers to the owner's occupation, chocolate entrepreneur of Anthony Thomas Candy Company (see Anthony Thomas Candy entry). The interior features an indoor swimming pool (filled with water, not chocolate, as some might have hoped).

ETHIOPIAN ORTHODOX TEWAHDO CHURCH/NEIL AVENUE UNITED METHODIST CHURCH (610 NEIL AVENUE)

Neil Chapel was founded in 1871 for Methodists working in the factories along the Olentangy River. Robert E. Neil donated two lots at Collins and Pennsylvania Avenues, and the chapel was dedicated in 1872. By 1888, the congregation was considering a move to Neil Avenue and Goodale Street to be more central and accessible to potential congregants. Columbus architect J.W. Yost made plans for the new chapel and sanctuary, with a spire for each. The chapel was begun in 1890. In 1914, the congregation finished the edifice but to different plans by the firm of Stribling and Lum. As the neighborhood changed, the congregation dwindled and then disbanded. Shortly after, in 1996, the building became the home of Ethiopian Orthodox Tewahdo Church.

GARDEN THEATER (1181–1189 NORTH HIGH STREET)

The building was begun in the summer of 1916 to house stores, apartments and a motion picture theater, situated in an expanding business cluster at North High Street and Fifth Avenue. When designed, it was to be one of the early neighborhood theaters—a real theater, with a balcony, as contrasted to movie houses set up in rooms built for stores. The three-story front was finished probably in late 1917, appearing in the City Directory the next spring. Auditorium construction was postponed, and its address at 1187 was listed as vacant through 1919.

The theater opened on Thanksgiving day in 1920. To accompany the silent films, there was a trio of violin, cello and piano seated in a "sunken garden" rather than an orchestra pit. Dr. Clovis Taylor, whose home and office were nearby, initiated the project. After retiring from medical practice in the early 1920s, Taylor personally managed the theater. It was sold in 1934 after Taylor's death.

With the death of another long-term owner, Evelyn Miles, in 1967, the Garden might best be remembered as a burlesque house, a landmark in itself since Columbus had so few. The theater closed as a movie house in 1975, having operated as both burlesque house and theater for a number of years. In the mid-1980s, the balcony was used for strip shows, having been walled off from the auditorium. Pole dancers, strippers and shady movies gave way

to sermons and Bibles at the Garden Worship Center, a local church for the last decade. Long neglected, the marquee fell to the sidewalk in the early 1990s, and a leaking roof ruined the auditorium ceiling.

Both the Garden sign and the building are landmarks of the Short North and have seen a wide variety of businesses—each attracting attention. The façade of the building is classic 1920s, but the back wall was originally from a preexisting stable building. Located near the busy intersection of Fifth Avenue and North High Street, the theater was the center of community life for the surrounding neighborhoods of the University District and what would become Victorian and Italian Villages.

In 2011, Short North Stage signed a long-term lease, returning the Garden back into theatrical life for musicals, cabarets, concerts and live performances. The famous Garden sign was relit in October 2011 and has given the vicinity an informal name of the Garden District. Currently, legitimate theater productions are staged there, and there is hope for the theater to again be a durable public venue.

The name "Garden" remains a bit of a mystery. The site is very near the old Philip's Gardens, a nursery and truck garden area that was one of the last sites along North High to remain undeveloped until before World War II. Ironically, a nearby neighborhood of the University District has been sporting the name of the Peach District. The other theory stems from within the Garden itself. It seems the original orchestra pit of the vaudeville theater was set off from the stage and audience by plantings of live boxwood bushes that were taken outside each day for a sunshine bath before they were returned to the theater for evening attractions. Across the street is another landmark business, the relocated PM Gallery, the first and oldest gallery in the district, which opened in 1984. Owners Maria Galloway and Michael Secrest were part of the first evening gallery events that later evolved into the monthly Short North Gallery Hop.

GOODALE PARK

In the 1840s, Lincoln Goodale bought land for the purpose of getting railroads into Columbus and to secure the right-of-way from those who might interfere for personal gain. After the railroads settled their locations, there was excess land. Late in 1851, Goodale gave 37 acres to the city for a park (33.4 acres), Park Street and Bond Street (Goodale Street). Goodale owned no land west or north of the park, and the remainder included merely one

An early 1890s photo of two friends posing with the bust of Lincoln Goodale.

block between Park and High Streets (not subdivided for sale) and land south of Goodale Street that was partly subdivided but pledged for rail access.

The park vicinity was undisturbed forest and outside the city's limits until 1862. Goodale Park was one of the first three American parks, all commissioned in 1851, to be a new kind—the pleasure ground, a place to go for pleasant activities. When the park opened in 1852, it was the second-largest municipal park in the country, just behind the Boston Commons at forty-five acres. Goodale Park was required by the deed to remain a grove. A carriage drive was finished in 1861. In 1862–63, the city engaged a local nursery owner trained in Prussian royal gardens to landscape the park in the manner of Andrew Jackson Downing, America's foremost landscape designer. Lincoln Goodale paid the cost of adding selected shrubs and ornamental trees. The pond awaited a water plant.

Unfocused managers of the park dragged the construction on from 1871 to 1875. A lake house was built in 1872 for refreshments and parties. A monument to Goodale was erected in 1888, with the bust done by J.Q.A. Ward and the pedestal by R.M. Hunt. From earliest times, opinions varied about what a park should be. About 1890, Goodale Park managers no longer saw the park

as a wooded grove and began embellishing Goodale Park with another lake and boathouse, bridge, grotto and three decorated gateways circa 1900. Play apparatus was installed in 1910, the first in a Columbus park. The Shelter House was built in 1912, incorporating a modern residence for a caretaker.

Some people view parks as vacant land awaiting some other use. For Goodale Park, a reverter clause in the deed secured the land for park use. In 1861, three city councilmen seized the park for their private room-and-board operation called Camp Jackson, a camp for Union soldiers. Goodale himself reminded city council that it risked losing the park. The occupation lasted only seven weeks, and photos show, contrary to popular opinion, few trees were cut. About 1900, the park was eyed as a site for Memorial Hall and for the Carnegie Library. In the 1930s, the Columbus Metropolitan Library, wanting to build a branch library, threatened to take the city to court for the right to build in Goodale Park. In the 1960s, a transit bus garage in the park was pressed by the mayor. From the 1950s through the 1980s, the effect of the park's management was to remove everything that required routine management. The "breathing space," envisioned by Goodale, was remade into "open space."

Since the 1980s, volunteers have partnered with the city to rejuvenate and restore the park with funds from the city, foundations and personal donations. The most notable new piece of public art is a fountain designed by sculptor Malcom Cochran, featuring elephants in a realistic but playful pose, to honor the history of the nearby Sells Mansion and to celebrate the park's public green space.

GRAYSTONE COURT (815–835 NORTH HIGH STREET)

Graystone Court, also known as "Fritter's Folly," is a monument to difficulties. The building was begun in 1903 by Dr. Lincoln Fritter of Lancaster, Ohio, to plans of architect Wilber Mills. It was slated to have fifty-six apartments with five to seven rooms each and was reported to be the largest and finest apartment building in Columbus. At the time, it was set in an area of residential homes, even though North High Street was changing. Constructed of sandstone, it was ahead of its time—fireproof materials, windows for light and fresh air for all units and seven entrances, eliminating long interior corridors and thus reducing, among other things, the spread of infections and diseases. Plans included a carriage driveway in the court, a rooftop garden and shops in the basement.

Moving Back Front of "Fritter's Folly"

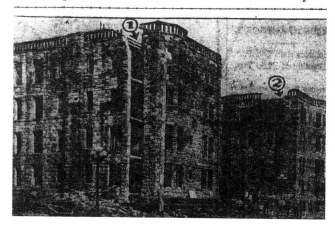

Graystone Court, also known as "Fritter's Folly," is a monument to difficulties, as illustrated by this 1922 clipping showing how sections of the old building would be moved.

Finances made progress fitful and slow, stopping with finished exterior walls, concrete floors, the roof and an auxiliary roof covering the entire roof garden. By 1907, Fritter was dead, and the project was in court. Dissatisfied creditors, lack of legal resolution and the complication of the land (which was leased) kept the building unfinished and the stone without glazing. In 1921–22, issues were resolved, and work resumed with plans from Charles Inscho, a noted Columbus architect who had been a draftsman on the original building.

The plans for the roof garden were deleted and the roof over it removed. There were to be sixty-four apartments of three to five rooms each with "iceless" central refrigeration and an incinerator for refuse. After being open for such a long time to the weather, the building hosted several Ohio State engineering classes, allowing students to observe and conduct tests to see how the building might be rehabilitated. However, a different problem was in the making.

High Street was being widened, and the stone curb would be only two feet from the building. Therefore, part of the 1922 work required removing ten-foot-wide vertical strips of stone on each side of both wings of the building, and the four-story façades (700,000 to 800,000 pounds each) were pushed back from the curb at two feet an hour. This remedy was chosen because the mortar had hardened to such a degree that the stone would have been destroyed trying to dissemble the wall. Muth Brothers of Columbus did the work.

In 1984, the building was acquired by Greystone Court Associates, which upgraded and rehabilitated the former Fritter's Folly in seventeen months for $1.5 million.

HUBBARD SCHOOL (104 WEST HUBBARD AVENUE)

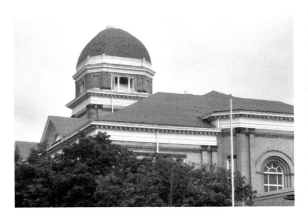

Hubbard School operated continuously as a neighborhood elementary school from 1894 until 2009.

The monumental tower of the Hubbard School is a landmark in the neighborhood that surrounds it and is easily seen from a distance. Built in 1894 and serving continuously as an elementary school until 2009, the school has most recently served as a "swing school" for students whose buildings are being renovated. The cost of the building in 1894 was almost $41,000, and the land was an additional $15,000.

By 1913, the school served over five hundred students with sixteen teachers. This was a high enrollment considering the number of schools on the north side, testimony to the rapid growth of neighborhoods along the streetcar lines north of downtown. In these early years, Hubbard was also housing a separate junior high with within the elementary school building.

The landmark central tower has a convex roof reminiscent of Second French Empire style, but the building also exhibits influences of Georgian Revival and neoclassical influences. Originally, nineteenth-century school buildings often had towers, which were intended to help draw in fresh air to the interior of the building. By the early twentieth century, as towers might have needed maintenance, the public became reluctant to finance what seemed like decorative extravagances in architecture.

MEDICAL SCIENCES BUILDING (CORNER NORTH HIGH STREET AND BUTTLES AVENUE, 9 BUTTLES AVENUE)

In 1892, Dr. J.W. Means bought the house at the southwest corner of North High Street and Buttles Avenue near the new Ohio Medical College, where he served as dean. He continued as dean of the successor institutions—

Starling Ohio Medical College (1907) and Ohio State University College of Medicine (1913). He helped organize the Protestant Hospital (now Riverside Hospital) in 1891 and served as chief of staff for fifteen years. About 1901, Dr. Means opened a small building next to his house for a few doctors, yet the demand for medical services space kept growing. In the early 1920s, the hospital facing Goodale Park was enlarged and renamed White Cross Hospital.

In 1928, the four-story Medical Sciences Building opened at a cost of $650,000. It had adaptable office space for seventy-five doctors and dentists. From the back of the building, a hallway over the alley connected the Medical Sciences Building to the hospital. The building was described as reflecting the "modern French influence." On North High Street, two of the three bays were built especially for the Citizens Trust and Savings Bank and the Wendt-Bristol Drug Company. Negotiations were underway for a restaurant, a barbershop and a beauty parlor. Around 1990, the owner secretly removed the monumental cast-iron torchieres from the North High Street façade, but the Victorian Village Commission required that they be reinstalled.

MICHAEL'S GOODY BOY DINER (1144 NORTH HIGH STREET)

Since 1937, Michael's Goody Boy Diner has been a North High Street landmark, primarily because of its large neon sign of a small boy on the verge of eating a hamburger. In a small building on a spacious drive-in lot, the diner was known for its counter seating, unchanged Formica-ish décor and pecan rolls hot off the grill. Owned by the Barricklow family until the 1990s, the diner was featured in the movie *The Calling*, which reportedly traced the life of Central Ohio's own faith-healing evangelist Reverend Leroy Jenkins, known for his miracle water drawn from a Delaware, Ohio well and his Elvis-styled hair. Faye Dunaway starred as Mae West in a scene shot at Michael's. Saved from possible destruction because of deteriorated conditions, Michael's has been remodeled and expanded and has an outdoor patio under the landmark sign. Across the street is another landmark sign, a 1950s retro-style neon—much newer—for Skully's Music Diner.

MONA LISA MURAL (742 PEARL STREET)

Though the Short North sports many murals and artworks, one of the landmarks is the Mona Lisa "on her side" mural on the side of the 1920s Mona Lisa Condominiums Building, a former auto body shop and later a former black box theater. Done by artist Brian Clemons, the mural is a delightful surprise to visitors who stray from North High Street and unexpectedly meet Mona at her most provocative.

NORTH MARKET/OLD NORTH GRAVEYARD (59 SPRUCE STREET)

The site of the North Market was (and probably still is) on the Old North Graveyard, running from Poplar Street to Goodale Park and east to the Convention Center. Though the graveyard officially closed in 1864, bodies continued to be buried there until land purchases by the Hocking Valley Railroad contributed to the decline of the cemetery's use.

In 1873, city council established a fund for the removal and relocation of all graves in the cemetery (though graves continued to be discovered even into the twenty-first century). The cemetery was given over entirely to private development. With the railroads and the establishment of Union Station, commercial enterprises sprang up along North High, and the first North Market, under the direction of architects Johnson and Kraemer, was constructed, opening in 1876. This frame structure was replaced with a brick market house in 1892, which burned down in 1948.

Merchants pooled resources in a World War II surplus Quonset hut for the next five decades. In 1995, the North Market was reborn in a former wallpaper warehouse near the site (the present parking lot was the site of the Quonset hut). While the city supported several market houses in the nineteenth and twentieth centuries on the east side, west side and the downtown Central Market, near South Fourth and Town Streets (and an earlier Central Market on South High Street), the North Market remains the only surviving public market. The North Market is the center of the commercial and warehouse structures that developed in the late nineteenth and early twentieth centuries.

SELLS "CIRCUS" HOUSE (755 DENNISON AVENUE)

Columbus architect Frank Packard has been credited with the design of the 1895 house for circus owner Peter Sells. This eclectic home is often called "Circus Gothic" because its expansive roof and Romanesque arched windows resemble a large "big top."

A published rendering of the house carries the signature of Yost & Packard, plus a second signature of Bulford Del (the addition of "del" indicates in Latin "he drew it"). However, a second signature is so rare that architect Bulford must have had a significant role beyond the sketch. Later Bulford was a partner in Richards, McCarty and Bulford, second only to the Packard firm for prominent society commissions.

Peter Sells, who owned Sells Brothers Circus with his brothers, traveled extensively, and he built the house to placate his bride, Mary, who sadly hated the circus. Mr. Sells seems to have left his young wife alone long enough for her to become attracted to wealthy and well-known bachelor William Bott, who owed Bott Brothers saloon and billiards (now the Elevator Brewery) with his brother. It was from the Sells Mansion that Mary's affairs and scandalous dalliance played out in Columbus's daily newspapers. The marriage eventually ended in divorce when Mr. Sells hired a detective who was able to gather incriminating evidence (Mr. Bott's new bicycle hidden in the bushes) as he had the couple under surveillance from the stone gate across the street.

The house ceased being a residence fairly early. The Columbus chapter of United Commercial Travelers was a good steward of the building, but later owners removed brick details on the front porch before 1965 and the

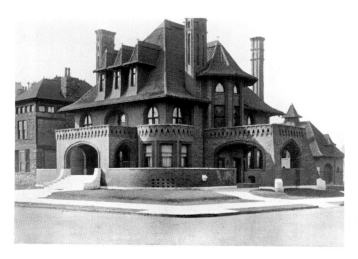

The Sells Mansion is sometimes referred to as "Circus Gothic" because of its resemblance to a circus tent and the occupation of its original owner.

triple dormers before 1973. Inside, the first-floor interior was devastated to accommodate a children's daycare. Fireplace mantels were still in the round parlors when a 1988 restoration began.

The Sells Mansion, now privately owned, is enjoying a full restoration. The Sells Circus winter headquarters in Columbus was on the west side of the Olentangy River (site of Lennox Center). Baby animals were sometimes brought to cages in the Sells Mansion. The Sells Circus, largest in the Midwest and owner of more elephants than any other circus, eventually was sold in 1906 to the Ringling brothers, whom the Sells boys contemptuously used to call the "Ding Dong Brothers."

St. Francis of Assisi Church (386 Buttles Avenue)

St. Francis Church was organized on June 12, 1892, by Bishop John Ambrose Watterson and held early services at Neil Chapel at Pennsylvania and Collins Avenues in a building used by Methodists before they moved to Neil Avenue. The two hundred congregants assumed the church would grow because the boundaries were enormous—the west side of North High Street to the Scioto River and the Pennsylvania Railroad to Delaware County.

The parish began building its permanent edifice in 1895, designed by Yost & Packard architects to be somewhat reminiscent of Northern Italian Romanesque churches. Only ninety feet of the church was built at the time, but because the church grew quickly, the planned additional fifty feet of frontage was built soon after the church opened. In 1893, a brick parsonage was built but was replaced by another in 1926. The school opened in 1907 under the supervision of the Sisters of St. Dominic in a large brick two-story building that contained eight classrooms and a large basement parish hall. The architect was David Riebel, who also designed many schools for Columbus Public Schools.

In 1902, the boundary between the parish of St. Francis and the parish of Sacred Heart was redrawn, and in 1905, with the building of Holy Name on Patterson Avenue, all the territory north of Eleventh Avenue was given to the jurisdiction of Holy Name. By World War I, the two-thousand-member congregation was made up of more than 50 percent Irish. The school provided classes until 1970. The present rectory was built in 1926, replacing the original from 1893.

ST. JOHN THE BAPTIST ITALIAN CATHOLIC CHURCH (720 HAMLET STREET)

Possibly the origin of the name "Italian Village," St. John the Baptist Italian Catholic Church was a prominent landmark in the neighborhoods that bordered the industrial area of the railroads, north of downtown. Jeffrey Manufacturing along North Fourth Street was a major employer in the area, with more than three thousand employees. Clark Grave Vault, Clark Auto Equipment, Berry Brothers Bolt Works, Case Crane, Smith Brothers Hardware, Radio Cab Company, Columbus Burlap Bag Company and Kilbourne and Jacobs provided an additional three thousand jobs.

Many of the Italians also had jobs on nearby Naghten Street, the heart of one of the former old Irish neighborhoods, in the many produce companies that unloaded the goods from the refrigerated railroad cars and onto peddlers' carts. Many of the houses around the church have fences and garden trellises made from the ten-foot wooden slats that once held the ice on the refrigerated cars.

The church was also the center of the devout Italian Catholic community that drew worshippers from Italian immigrant communities of St. Clair Avenue, Milo-Grogan and Flytown. Founded in 1896 and built in 1898, the church's mission was to help Italian immigrants keep their faith, language and customs alive. Though the area was always a mix of Greeks, Irish, Lebanese, German and Polish, the Italians were most visible because of the church and the nearby Sacred Heart School on First Avenue.

Weddings, celebrations and, especially, parades to honor the feast day of St. John the Baptist and other feast days made the Italian community very visible. Weddings at the church followed the custom of family members and friends throwing little *comfits* (Italian candies and almond nuts) and also coins (pennies, nickels, dimes and sometimes quarters). The altar boys would rush outside after the wedding Mass to collect the coins. Today the church is the home of the popular Italian festival, which draws Italian families, urban enthusiasts, foodies and meatball lovers who marvel at the cooking of the world's largest meatball.

SHORT NORTH GEOGRAPHICAL MARKERS:

"THE ARCHES"
(NORTH HIGH STREET FROM POPLAR STREET TO SMITH PLACE)

In the mid-1890s, High Street merchants from the courthouse to the depot paid to install arches (two to a block) and to pay half the electricity. After 1895, the new High Street viaduct reconnected the north side to downtown. The northern merchants wanted to capitalize on the retail area that would later be known as the Short North, and in 1902, they proposed seven arches from Vine Street to Buttles Avenue. It seems the arches were erected at Russell and Goodale, but their duration is uncertain.

In 1908, the merchants agreed to pay to erect the seven arches, remove all existing wooden wiring poles and maintain the arches—that is, to change the incandescent lamps. In return, the city agreed to install the feeder lines and pay for all electricity usage. The north side arches were lit on November 28, 1908.

Two years later, the merchants at Main and Fourth Streets installed "cluster lights" with five globes to a pole. The arrangement was attractive due to more frequently spaced lights, brighter illumination (more light on the sidewalks) and no overhead wiring. In 1911, downtown retail merchants petitioned city council to have cluster lights, offering to pay most of the cost for the system.

The north side merchants vehemently protested the new system but to no avail. The cluster lights were lit on August 25, 1912. Both systems illuminated the Columbus centennial celebration. The arch lights went out forever on September 4, 1912, and removal began quickly.

Today, the Short North arches are a landmark purposefully created by the merchants. Discussions about re-creating the historic arches started in 1995. Later, when the idea was moving forward, the city and the merchants agreed to split the estimated cost of $1.5 million. The city spent another $1 million to upgrade the power supply.

Seventeen arches were placed from Poplar Street to Smith Place. At Goodale Street, an arch was omitted because of complications posed by the jog in Goodale Street and the I-670 bridge. The arches are twenty-eight feet high, have sixty globes with variable color effects and were initially lit using optical fibers. They were illuminated on December 4, 2002, but because the application was innovative, lighting problems became intolerable within months. Globes were dim because the optical fibers entering the gloves had been curved too sharply. Erratic illumination and colors were caused by

the circuit boards in each post being flooded by water. Overheating caused halogen bulbs to expire at one year instead of three. This raised the lamp cost to $10,000 per year.

The solution took several years to litigate, experiment and resolve. LED lighting resolved the issue, and the arches were permanently lit on June 2, 2007, at a final cost of $3 million dollars. The modern arches are far bulkier than the original arches that were threatened only by a runaway beer wagon.

"THE CAP" (NORTH HIGH STREET BETWEEN POPLAR STREET AND GOODALE BOULEVARD)

Say "the Cap," and most any north side resident knows exactly what is meant—the Short North Cap that spans the I-670 highway that runs below and reconnects the Short North with the North Market and the Convention Center. To north siders, visitors and others in the city, "the Cap" means the southern boundary of the Short North, a term synonymous with art galleries, music, restaurants and creative retail.

The term "Short North" originally was used as a police term to indicate the location of trouble in the "short" (or closest to downtown) part of North High Street. The idea for a "cap" over High Street was discussed as early as the 1980s. By 1994, a cap was the top city proposal for state highway funding as part of the widening of I-670. This was to be a plaza with landscaping enhancements, one thousand feet long from east of North High Street to west of Park Street. The Ohio Department of Transportation estimated the cost at $8 million and chose not to fund it.

By early 1996, the concept had evolved to a smaller cap with buildings, possibly three stories tall, flanking High Street. Through unprecedented cooperation by developer Continental Real Estate Company, a city councilman and a state representative, state, city and private funding was orchestrated to create the Cap. The final plan would be three bridges—High Street Bridge, flanked by bridges to each side to support retail stores. The stores would be one story and thirty feet deep. The state integrated the additional foundations with the I-670 construction, and the city paid for the two flanking bridges. The developer built the retail space, all of it for a reported $7.2 million.

The retail portions for the Cap were designed by David Meleca to be reminiscent of the demolished Union Station arcade, the massive Daniel Burnham–designed train station that was located several blocks to the south

The Cap, over I-670, has stores and restaurants and reconnects the Short North with downtown.

of the Cap. Built in 1897, Union Station was the second of three depot stations and the only one of two Daniel Burnham creations in the city (the Wyandotte Building on West Broad is the other). Union Station was demolished in the middle of the night in 1977, touching off the historic preservation movement in Columbus. Federal judge George Smith and concerned citizens kept the last *beaux-arts* arch from being demolished, and Columbus Landmarks Foundation was founded later that year.

On October 12, 2004, the Cap officially opened at Union Station. Just as the 1897 railroad viaduct was flanked with stores that hid the rail yards from street view, the stores over I-670 hide the freeway trench and muffle the noise. The Cap created a commercial bridge of restaurants and coffee shops and a pedestrian-friendly walkway along North High where formerly there was only a bleak, windswept desert of concrete. From the demise of Union Station and for the following three years, Citizens for the Union State Arch secured public and private monies to re-erect the arch in a new Arch Park on Marconi Boulevard in 1980, but the arch moved again to its present location on McFerson Commons in the Arena District.

The over-seven-hundred-ton arch was moved to its third location in a slow, inch-by-inch journey that took three days and was under the supervision of the same company that moved the Cape Hatteras Lighthouse. The architecture of the Cap's commercial bridge, with its roofed walkways and large arches, is so reminiscent of the old Union Station that many are fooled into thinking that the Cap must be the façade of the former Union Station.

THE VIADUCT (NORTH HIGH STREET BETWEEN GOODALE AVENUE AND NATIONWIDE BOULEVARD)

The first train crossed North High Street in 1850 when the tracks were outside the city limit. By 1870, the city was anxious to grow north of the tracks, but trains hindered progress by blocking the street and sometimes colliding with city traffic. A better-located depot opened in 1875, and separately, the city and the railroads jointly paid for a tunnel under the tracks. The project began in 1875 and finished in 1876. Ramps descended to a double tunnel occupying half the width of High Street.

The tunnel was predicted to be unattractive to pedestrians and is reported to have been out of favor with regular vehicles. Streetcars used the tunnel until 1891 when electric cars were put on the line and could not pass through the tunnel. A viaduct over the tracks and a new depot were in the offing. For the interim, electric cars used a narrow, wooden viaduct erected in 1888 on depot property.

The final viaduct, spanning the full width of High Street, was completed in 1895, followed by construction of the new Union Station and stores flanking the viaduct. The east-side centerpiece was a grand arcade designed by Daniel Burnham of Chicago in a *beaux-arts* style in buff-colored brick to present a continuous, consistent façade to the street and to hide the rail yards from street view. (See the Cap entry.) The southeast-ramp stores were completed in 1897. The northeast-ramp stores were completed in 1910, and about that time, stores across the arcade were completed.

The arcade and the viaduct shops were demolished for the convention center in 1976. After a court-ordered halt to demolition, what little remained of Burnham's arcade was dismantled and now stands near the Nationwide Arena. The viaduct was rebuilt promptly. But Union Station, having outlived most rail services, was demolished in 1979.

THE WIDENING (NORTH HIGH FROM SPRUCE TO FIFTH AVENUE)

High Street, north of the depot, was once a rural turnpike merely sixty feet wide. From 1885, there was recurring agitation to widen the street to add a second streetcar track and yet have sufficient space on either side for regular traffic. The project was finally underway in 1914 with an intended widening of ten feet from Spruce to Buttles and eighteen feet from Buttles to Fifth

Avenues. South of Buttles Avenue, the ten feet was taken from the east side, and north of Buttles Avenue, the west curb was set back ten feet.

To retain the same sidewalk width, commercial buildings had to move their facades back. Most building owners demolished the old fronts and built new ones with "modern" styling. Some of the east-side buildings near Russell Street left the old foundation intact and even today have basements extending ten feet out under the sidewalk. At the southwest corner of North High Street and Fifth Avenue, a relatively new building was to be lifted whole and set back (see Graystone entry). Though much was accomplished in 1914 and 1915, completion of the widening was not declared done until 1922. However, the west curb between Spruce and Buttles Avenues was not set back. Likely, it was too costly to modify the nearly continuous front of three-story buildings. The same reason would apply to the west-side building between Buttles and Warren that, in the end, remained untouched. Therefore, the west side buildings south of Warren retained their original facades.

United Commercial Travelers Headquarters (632 Park Street)

The United Commercial Travelers (UCT) was organized formally in 1888 as a fraternal, social, charitable and beneficial organization for traveling salesmen at the Neil House Hotel by eight men. By 1975, the fraternity grew to a quarter-million-member international organization. Under the leadership of founder and general manager Charles Flagg, the UCT spread across the nation and Canada, with headquarters in downtown Columbus.

In 1903, UCT moved to 632 Park Street, the former Dennison-Peters mansion, built in 1874. In 1924, the old mansion was replaced by an appropriately stately office building that many have said bears a striking resemblance to a foreign embassy, especially because for many years, the UCT had both the United States and Canadian flags in front.

At this writing, the building is planned to become a cultural center to house the significant art collection of the Pizzui family, and it is part of a larger project that includes hotel, office, retail and parking space on this lot and two additional lots. UCT donated a monument to Charles Flagg to Goodale Park in 1907. UCT headquarters should not be confused with early quarters for the local chapter, Columbus Council # 1, at 24 Goodale Street nor with the early uses of the Sells mansion at 755 Dennison Avenue.

Home of the U. C. T. Dedicated This Week,
and Probable New Supreme Counselor

CHARLES C. GRIFFITH, Denver, Colo.

United Commercial Travelers was organized formally in 1888 by eight men with a plan to unite traveling salesmen.

WINDERS MOTOR SALES (783 NORTH HIGH STREET) AND THE AUTOMOBILE TRADE OF THE SHORT NORTH COMMERCIAL DISTRICT

Automotive firms located early along North High Street in the present-day Short North area for visibility to and from prosperous residential areas. They located north of Goodale Street because there was still considerable residential frontage available to advancing commerce, and zoning did not, for the most part, exist until the 1920s.

In 1909, the Columbus Auto Club established its quarters at Goodale and North High Streets. The Winders building is the most obvious relic of many nearby agencies. Winders Motor Sales was founded in 1914 and had several downtown locations before building at 783 North High Street in 1924. The site had never been built upon since it was part of the old Hubbard estate (once thirty acres). The giant vertical sign has been in existence since the 1930s. Winders Motor Sales was a prominent Chevrolet dealership until 1974. The following are less obvious buildings originally occupied by automotive agencies.

In 1907, Columbus Automobile Company opened at 691–695 North High in the south two-thirds of the building. The Mighty Michigan auto dealership built 780 North High Street in 1913. Next door, Ohio Auto Sales Company built in 1914, including a machine shop and a ramp to the second

Winders Motor Sales building, associated with the new automobiles of the 1920s, now houses popular new businesses in the Short North.

floor for used-car sales. At 879 North High Street at First Avenue, Farber Motor Sales opened in 1943. The last unit of the building was finished in 1948 to house the Tucker dealership.

At 989 North High Street, the Maize and Fritter Tire Company converted a 1925 building to drive-in service in 1933. In 1926, the Ellis-Overland Company moved into its new Overland and Willys-Knight dealership at 1037 North High. The Byers Company occupied the same building in 1932 for used cars sales and altered the front, at least to the extent of adding "Byers 1932" over the door.

At 1288 North High Street, in 1909, an architectural contract was announced for an automobile garage, and it opened under the name of Auto Inn Garage. During the Depression, several large, open-air, used car lots opened on North High between Price and Greenwood Avenues.

WONDER BREAD FACTORY SIGN (728 HAMLET STREET)

For lovers of commercial archaeology, urban freaks who thrive on neon in a nighttime skyline and covet industrial signs or those who remember the sweet smell of bread baking, the Wonder Bread factory sign still glows like a red

Wonder Bread Bakeries began in 1929, and its sign has become a recognized landmark.

beacon. It is THE landmark of Italian Village—rusty, iconic and filled with Columbus memories of the North Fourth manufacturing corridor. The Wonder Bread factory, however, started out as the Kinnear Manufacturing Company in 1901, became the Holland Bread Company in 1921, the Ward Brothers Bakery two years later and the Wonder Bread Bakeries in 1929. The factory closed in 2009 and, many plans later, will soon reemerge as apartments with retail spaces. The Wonder Bread factory sign, hopefully, will continue to light the night sky.

YUKON BUILDING (601–615 NORTH HIGH STREET)

The Yukon Building in the Short North was the "Portland Block" when it opened in 1887. It became a city landmark in 1912 after John Metcalf bought the property. Metcalf and George Donovan operated the Capitol Clothing Company that sold ready-to-wear men's clothing made by the company.

The store opened in 1895 at High and Russell, but the Portland Block would realize Metcalf's dream of building a replica of the U.S. Capitol dome atop his business. Mundane work entailed modernizing the first floor of brickwork, treating the upper bricks to match and adding foundations and interior steel pillars to support the dome. The base was 45 feet square, and twenty-three columns supported the dome rising 80 feet above the roof and 135 feet above the street. It was clad in sheet metal with pure gold leaf on the dome and column capitals. There were four clock faces and one thousand incandescent lamps outlining the dome and base. The cost was $10,000 at a time when a blue serge suit cost $13.50 from the Capitol Clothing Company.

Metcalf tirelessly promoted all businesses north of the viaduct through the North Side Chamber of Commerce. One triumph was to bring Theodore Roosevelt to speak on law and order during the 1910 streetcar strike. Of

Few passersby today know that the Yukon Building sported a huge dome when it was the Capitol Clothing Co., as seen in this 1914 ad.

course, the speech was delivered in Goodale Park, close to Union Station, since Roosevelt had been persuaded this would be a short whistle stop that would promote both law and order and recognize the Capitol dome of Metcalf's building with his presidential presence.

Capitol closed in 1945, and the dome disappeared. After years in a declining business district, the building reemerged as a gateway landmark to the Short North in 1978 when Functional Furnishings occupied the entire first floor as a visible economic engine in the renaissance of the business district.

UNIVERSITY DISTRICT

BETA THETA PHI FRATERNITY HOUSE (165 EAST FIFTEENTH AVENUE)

The house was the first chapter house built especially for a fraternity west of the Alleghany Mountains, but its landmark status may be based on a famous tenant. The commanding house on the corner of East Fifteenth and Indianola was the fraternity house of George Bellows, famous artist of the Ashcan School of Art, who entered Ohio State in 1901.

Surprisingly, he never graduated, walking away from final exams in 1903. George Bellows felt he needed to make the point to his father, George Bellows Sr., that he did not want to be an engineer. He wanted to be an artist. It was a classic standoff between the generations (the father was fifty years old when his son was born). George Bellows Sr. was a Victorian master architect of many notable buildings in Columbus. After his son's bold move in purposely foregoing final examinations, Bellows Sr. agreed to sponsor his son's venture to New York for one year. Bellows went on to be a famous realist artist. Original sketches of his were found in the attic of the fraternity a number of years ago and are now on permanent display, ironically, in the Alumni House.

Blue Danube Restaurant (2439 North High Street)

A longtime landmark in the University District, the Blue Danube Restaurant, affectionately known as the Blue Dube, has enjoyed a varied life, starting as a Piggly Wiggly store. Piggly Wiggly, long associated with grocery stores in the south, was headquartered in New Orleans. The first Piggly Wiggly opened in Columbus at 40 East Long Street on February 18, 1919, and it is believed that the Blue Danube building was the third store (after 246 East Main Street). Piggly Wiggly stores billed themselves as the original self-service grocery stores, stayed open on Saturday nights until 9:00 p.m. and encouraged parents to bring their children. By eliminating clerks and not trying to create specials for certain days, the stores could afford highly competitive prices, but by 1928, the Louisiana parent corporation severed its ties with the Columbus Piggly Wiggly, and all Piggy Wiggly stores in Ohio were transferred to the Kroger Grocery and Baking Company.

Originally a Piggly Wiggly store, the Blue Danube is a legendary restaurant for generations in the University District.

The building became a retail space for selling housewares and then automobiles, until it settled into what it has since been associated with—food. In the 1930s, the Blue Danube restaurant was a white-tablecloth Hungarian restaurant with music provided on a baby grand piano. Even when the owners changed, the name did not. For the past decades, the Blue Dube was owned by members of a Greek family, all named George, whom the patrons sometimes referred to as Daytime George, Nighttime George and Sometimes George.

The business has evolved (sort of). From the mural of Budapest on the exterior, the neon sign, the "memorial" painted tile squares on the ceiling done by patrons of decades past (one points to a booth indicating that a marriage proposal was made on that spot) and down to the vintage ladies' room door (graffiti but no working lock), the Blue Dube continues to endure. Food is legendary—both home-cooked bar food and more exotic offerings. One or two times a month, someone will order the French special: a bottle of champagne and White Castle hamburgers for $125.

CHIC HARLEY TERRA-COTTA SCULPTURE/UNIVERSITY THEATER (1980 NORTH HIGH STREET)

Chic Harley's image is to the left of the marquee.

Chic Harley was a three-time All American football player at Ohio State who drew record-breaking crowds to the Ohio Field in 1916, 1917 and 1919. His popularity was great enough that it became obvious that a larger place to play football needed to be found—the logical outcome resulted in the drive to fund the Ohio Stadium (see Ohio Stadium entry). Harley was a favorite of James Thurber, who had attended East High School with him prior to World War I.

In the 1940s, commercial property developer Leo Yassenoff, who was himself a 1915 Ohio State football player and another

ardent fan of Harley's, honored Harley by placing his likeness on the façade of his new University Theater. The theater sat directly across from the old Ohio Field on North High Street (a commemorative boulder marks the Ohio Field). The dedication of the terra-cotta sculpture drew a crowd of ten thousand.

Yassenoff built a number of theaters, drive-ins and the Ohio Stater Inn (hotel/restaurant) that is now a student residence. His love for football was so legendary that it is said when Coach Woody Hayes was agitated and he could not talk to the team at halftime, Yassenoff went into the locker room and gave the pep talk.

"Terra Cotta Chic" was recently liberated from behind a restaurant awning and is now free to kick a submarine sandwich football over a field he made famous (though he is still obscured by a seriously misplaced sign).

DICK'S DEN (2417 NORTH HIGH STREET)

Consistently rated as one of the best jazz venues in Columbus, Dick's Den has nightly live jazz (though there is a wonderful old jukebox in the corner) that lasts until 2:00 a.m. The bar is appropriately dark and unpretentious. The building started as a tailor shop in one storefront and a small grocery on the other side about 1912 and was part of the boom building era brought on by the streetcar lines heading north on North High Street (there was a major streetcar barn and turnaround a few blocks away at Arcadia Avenue). The street has a number of one- and two-story brick commercial buildings with interesting details and residential apartments above.

Dick's Den is in one of these, but perhaps what is not as obvious is the row of apartment flats behind Dick's Den and its neighbor, the Blue Dube. They have traditionally been home to students and others who enjoy the ambiance of the two bars. By the 1960s, Dick's Den was established but was occasionally a rough place where fights might break out over a game of billiards. The current owners (for the past fifty years) purchased the business from the original owner, Dick, who thought it was time to move on, having lost an eye from a billiard cue on such an occasion. The current owners met at Dick's Den when he poured a pitcher of beer over her head during a softball victory celebration. He thought it was just a fun thing to do to meet a perky young blonde, and she, recognizing the act for what it was, quickly determined he was marriage material and the act was, as she described it, a Polish love call (with all apologies to Poland). They have kept the bar as they found it, introduced jazz artists, and tamed down the spirit of the place. They no longer, in good conscience, encourage

Dick's Den has been a staple in the area and is owned by a longtime couple who originally met there as customers.

the famous Norwich Run, a beer-shot run from Dick's Den to a liquor store in Graceland Shopping Center about three miles north and back to Dick's. (They also knew people cheated and took cabs.)

FRATERNITY AND SORORITY ROW (EAST FIFTEENTH AVENUE FROM NORTH HIGH TO NORTH FOURTH STREETS)

Even though East Fifteenth Avenue was directly across from the main entrance of Ohio State in 1915, there were few indications that the street would one day be known for its many fraternity and sorority houses. There were, however, in the first block from North High Street in 1915, several names that, even today, are recognizable to Columbus residents. Dr. J.A. Van Fossen had an office here, and William Mills, curator of the Ohio Archaeological and Historical Society, and William Knauss, the former Union soldier who saved Camp Chase (the large Confederate cemetery on the west side), lived on the street. Indianola Presbyterian Church's first building was located here

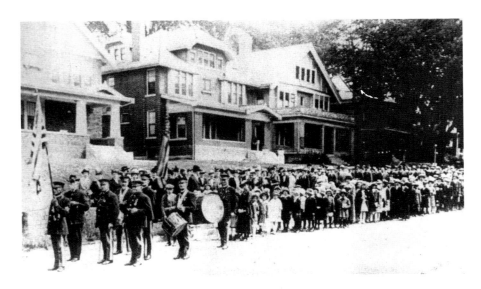

Members of the Indianola Presbyterian Church march down Fifteenth Avenue from their old home to a new church in 1918.

as well. Ohio State professors James Hagerty, Samuel Derby and George Knight had homes on East Fifteenth Street. Everyone wanted to live near the president of the university, who lived across the street (where Mershon and the Wexner Center are located). There were lawyers, judges, owners of major retail establishments and bankers. At this time, there was only one fraternity house (see Beta Theta Pi entry).

Before World War I, fraternities and sororities were throughout the neighborhood, often only renting at locations for a year (or perhaps only being offered by landlords to students for short periods of time). Of course, there were exceptions (see Kappa Sigma entry).

Starting in the 1920s, the Greek system grew, partly because fraternities and sororities were well-recognized social systems by which students could exercise networking skills (i.e. find a marriageable partner), but also because the students who attended college were wealthier. Starting in the 1930s, East Fifteenth Avenue homes attracted more of the fraternities and sororities because they were large mansion-like structures, and with a downturn in the economy, more became available for rent or purchase. By 1950, the situation had changed dramatically.

Within the first block of East Fifteenth, between North High and Pearl Streets, a few homes and commercial buildings (with residential space above) were now beauty and barbershops, sandwich shops and a Christian Science Reading Room.

Between Pearl and Summit Streets were twenty-four sororities or fraternities. In addition, the Westminster Hall (dormitories), a rooming house and the George Wells International House were established. The number of student-occupied homes outnumbered the eighteen residential homes. While some created spaces within the historic homes, others rebuilt the facades to modernize or add more entry space, and others were completely rebuilt so as to appear new.

The majority of the East Fifteenth Street houses were occupied by the sixteen sororities, with eight fraternities also located there. Another four sororities were close by on Indianola, Iuka or Seventeenth Avenues. Fraternities not on Fifteenth Avenue were also close by, for the most part, with sixteen on Indianola, Iuka and Waldeck Avenues, many just around the corner from Fifteenth Avenue. An additional twenty fraternities were scattered on Tenth, Twelfth, Thirteenth, Fourteenth, Sixteenth, Seventeenth, Eighteenth, Neil, Woodruff or Waldeck Avenues.

In January 1951, twenty-three fraternities had their social functions suspended by the university for significantly exceeding their entertainment budgets (five dollars per man per year), and fifteen other fraternities were just regaining their privileges for the same violation—almost all on Fraternity and Sorority Row. Though the term "row" was never an official designation for the street, it was clear that the university could take advantage of their clustering to keep an eye on them.

GLEN ECHO PARK (LOCATED ALONG INDIANOLA AVENUE, NORTH OF ARCADIA AVENUE, SOUTH OF PARKVIEW AVENUE)

The Glen Echo neighborhood began as a subdivision carved from the Shattuck farm, platted and marketed heavily by the Columbus Real Estate and Improvement Company, and located to the east of the popular Olentangy Park. It was the first planned subdivision outside the Columbus city limits (1909) and was a "streetcar community." In 1912, when Glen Echo did come into the city, the ravine park (formerly known as Slate Run) was dedicated as a public park. The area is rich in history—it was the site of the American Sewer Tile Company (see North High School entry), a Civil War camp was nearby (see Old North Columbus entry) and, for a brief time, it was a camp for children with tuberculosis. Later, the Open Air School was built for them to the west at Hudson and Neil Avenue to take advantage of the air of the Olentangy River. The ravine was considered, at one time, to

become a site for a new Protestant Hospital (now Riverside Hospital), and in the 1940s, the ravine enjoyed a spicy reputation for having a gambling shack owned by Pat Murnan. The shack was blown up by a disgruntled gambler.

The ravine has received loving and dedicated attention from neighbors who advocate for and preserve the plantings. Surrounding homes from 1910 to 1930 on Summit, Fourth, Cliffside, Glen Echo and Indianola Avenues may be Arts-and-Crafts bungalows, American Four-Squares or Craftsman homes with classical detailing. Most have the early twentieth-century charm of large front porches, stone and tile fireplaces and sleeping porches on the back of the houses. Many were financed originally by the Jeffrey Manufacturing and Mining Company (located to the south in present-day Italian Village) because many Jeffrey supervisors lived in the area, joining neighbors who were Ohio State faculty, real estate developers and self-made businessmen.

HENNICK HOME (1985 WALDECK AVENUE)

The unusual Tudor-style house across from Indianola Presbyterian Church was the home of Herb Hennick, the owner of Hennick's popular soda fountain and student hangout at Fifteenth Avenue and North High Street. The house was also home to the William Sweet family and the Columbus Women's Club

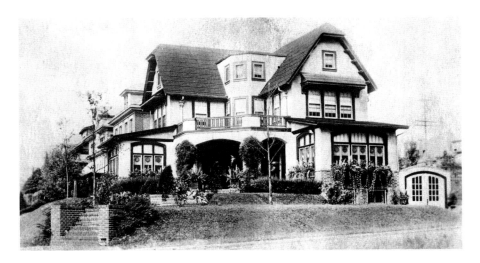

The Columbus Women's Club was founded in the Hennick Home.

(the latter being formed in the living room of Mrs. Sweet). Sweet's pharmacy business relocated from downtown to North Columbus on High Street. Here it occupied a six-story building that dwarfed the surrounding businesses in the vicinity of West Hudson and North High Streets. However, virtually no one recalls this building, which is now gone. Perhaps it is because the first floor became the Little Art Theater, showing "naughty" films.

INDIANOLA ELEMENTARY SCHOOL (140 EAST SIXTEENTH AVENUE), INDIANOLA JUNIOR HIGH SCHOOL (420 EAST NINETEENTH AVENUE) AND INDIANOLA PARK

The two Indianola schools, though separate buildings and only blocks from each other, share historic roots. Built in 1908, the Italianate and neoclassical Indianola Elementary was designed by prolific school architect David Rieble. The school is now the Graham Expeditionary Middle School, and the Indianola Informal Program, which started at the site and was the Columbus District's first alternative, lottery-based school (1975) has expanded into the former Crestview Middle School. The Indianola informal school approach featured a child-discovery curriculum. In September 1909, this building offered the nation's first junior high curriculum, created to lower school dropout rates by easing the transition to high school. The elementary grades shared space with the junior high students, although overcrowding meant many classes met in temporary structures on the playground.

The junior high movement (grades seven, eight and nine) was a collaborative brainchild of Superintendent Shawan of the Columbus Schools and Ohio State president William Oxley Thompson. Because of the school's proximity to the university, college life and neighborhood concerns were always interwoven. In the decades before World War I, many children dropped out of school after eighth grade and began working. Only wealthy families pushed for high school graduation. The families of the area were certainly wealthy enough to encourage high school, but Shawan and Thompson felt such a new idea would receive better reception from these "education-minded" families who lived near the university.

Success was certain; now it needed a building. The Indianola School was very overcrowded by the late 1920s, and a building needed to be used exclusively by grades seven through nine. Indianola Junior High was built in 1929 on a ten-acre park that had once been part of Indianola Park and

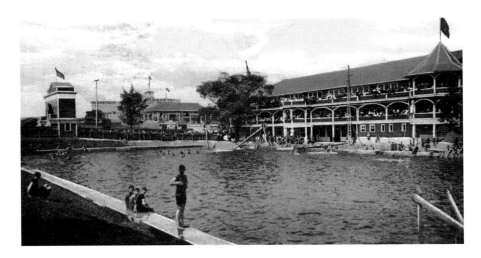

The pavilion of Indianola Park, as seen in the background of this early postcard, is now a church.

Smith's Roller Rink. It was the first junior high in the country dedicated to an innovative curriculum, allowing high school credits to begin before entering high school. Students began to help plan the building, which mimicked high school buildings by having rooms designed specifically for art, domestic science and industrial arts. It even had a domestic science "apartment" modeled after the one at North High School.

Howard Dwight Smith, architect for the university and creator of the Ohio Stadium, designed the building, and there are many exterior details that are identical to buildings he designed on campus. Edwin Frey, sculptor of the William Oxley Thompson statue in front of the Main Library on campus, designed the animal and floral exterior Arts-and-Crafts tiles, created the stylized animals surrounding the doorway and designed Chief Tahgajute over the front of the building.

Students suggested the image on the building should be one with historical reference, choosing Tahgajute, a Mingo chief better known as Chief Logan. In the 1980s, the stone carving was chosen to be the symbol of the University community.

Indianola Junior High was built on land obtained from the old Indianola (amusement) Park, which had opened in 1904. Amusement parks were streetcar lures to bring people into undeveloped parts of the city. Indianola Park featured a sizeable dance pavilion (still there) and the largest swimming pool in the state of Ohio, fed by three artesian wells. Though the park closed

in the 1920s, the pool remained until World War II and is still under the parking lot of the former shopping center. The dance pavilion is now the Vineyard Church. The informal approach to education designed in the 1970s at Indianola Elementary School became a successful model and continues. The butterfly sculpture at the front walk at Indianola Elementary was designed by D'Lynn Stinziano when she attended the school.

INDIANOLA PRESBYTERIAN CHURCH (1970 WALDECK AVENUE)

Dr. William Oxley Thompson, president of Ohio State University from 1899 to 1925, was a member of the Presbyterian clergy and helped to found the church. He took to preaching from the small outdoor pulpit built into the church by architect Charles Inscho. Charles Inscho was known for his association with the American Arts and Crafts movement, designing several buildings in the Iuka Ravine area, where he was also a resident.

Dr. William Oxley Thompson, president of OSU, would give sermons to the congregation from this unusual outdoor pulpit.

KAPPA SIGMA FRATERNITY/NEIL MANSION (1842 INDIANOLA AVENUE) IUKA RAVINE, INDIANOLA FOREST

Robert Neil built his mansion in 1856 on an Indian mound overlooking the Olentangy River valley that would, in one hundred years, become Fraternity and Sorority Row. His parents' home was located farther west on the present site of the William Oxley Thompson Library. By the 1860s, their farm would be sold to become a small land-grant college, later known as Ohio State University. Henry, Robert's brother, inherited the house in 1870. Henry was the first Ohioan to "officially" enlist for the Union during the Civil War, and upon inheriting the house, he named the house and spacious grounds around it "Indianola." A main drive on the land was named "Iuka," in commemoration of his having been wounded at the Battle of Iuka, near Indianola, Mississippi. Today, the driveway is Iuka Avenue, the first street in the city planned on a diagonal that broke with the usual grid plan. The Iuka Ravine and Indianola Forest (all part of the original Neil estate) were platted by King Thompson (founders of Upper Arlington) and Charles Johnson. Though some homes in the area were built for fraternities, the majority of the homes were originally owned by prominent local businessmen more so than university faculty, who preferred to be closer to Ohio State.

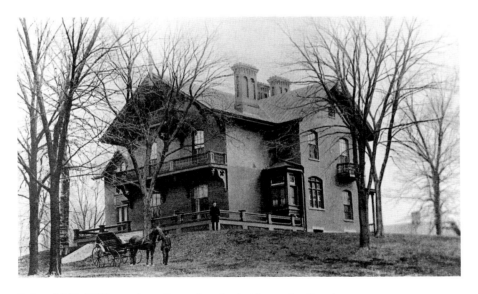

Robert Neil's 1852 mansion still stands today but is greatly altered.

Though the Kappa Sigma Fraternity had been at Ohio State since 1895, it had no permanent home (see Fraternity and Sorority Row entry). It was a chance encounter with a real estate leasing agent that led to the Kappa Sigma fraternity acquiring the house. Several fraternity members assisted the vulnerable and intoxicated agent after he was robbed, seeing him home safely. The agent leased the vacant Neil home to the fraternity in 1908, and the organization purchased it in 1918. For the next two decades, the exterior retained its original appearance: a large, dark brick home with a balcony across the front and a wing to the north. In the 1930s, 1950s and 1960s, the exterior took on the appearance of a large white plantation and an additional wing to the south. However, original staircases and fireplaces remain.

KING AVENUE METHODIST CHURCH (299 KING AVENUE), DENNISON PLACE AND "THE CIRCLES"

The church was started by a small group of neighbors who lived in the area of King and Neil Avenues in the late 1880s, worshipping in a small frame home on Henry Street (now Sixth Avenue) above a bakery. They purchased a lot that is now the present site of the church and built a small stone chapel, but the growth of the congregation necessitated a much larger church and required the large congregation to build a temporary structure next to the chapel that they jokingly called "The Wigwam."

In 1904, a large stone church was erected. This was the era of growth and prestige for the nearby Ohio State University, and the neighborhoods around the church were enjoying social prominence, from the southern portion of the district to the northern section of Indianola Heights Addition and Indianola Park. The Dennison Place Addition and the E.J. McMillan neighborhoods were attracting upper middle-class families and university faculty. Both Dennison Place and E.J. McMillan refer to the daughters of William Neil, Columbus's "stagecoach king," who once owned land on which the university and the state fairgrounds stand today. Neil's own house sat where the William Oxley Thompson Library is (see Long Walk entry). Neil's sons, Robert and Henry, occupied a mansion at Indianola and Fifteenth Avenues (see Kappa Sigma Fraternity entry), and Neil's daughters, Anne Dennison and Elizabeth McMillan, were bequeathed land in what is today the southern portion of the University District. McMillan actively

When King Avenue Methodist Church opened, it was considered to be the most technologically modern church in Columbus.

developed her parcels of land. She was a studied landscape architect who worked with Frederick Olmsted, creator of New York's Central Park, but she was never licensed because she was a woman. Her work, however, can be seen in her creation, the designed lots of the Circles Neighborhoods, near the King Avenue Methodist Church.

The 1904 King Avenue Methodist Church was originally designed to have two-story turrets on either side of the main doors, like the Castle in Buda (Budapest, Hungary), but fate intervened with a devastating fire that destroyed all but the exterior walls. In 1922, the present church was built and had, according to local newspapers, the most up-to-date technology of all Columbus churches (a speaker system) and extraordinary stained-glass windows that honored lives lost in World War I.

Over the years, the church has continued to model the spirit of the 1904 progressive era that surrounded the university. The church, with help from retired pastor Reverend Atha Gray and current pastor Reverend John Keeny, made the deliberate decision to openly welcome gay worshippers. Gray and his wife hosted more than one thousand people to their home over a six-year period to eat dinner and talk about the issue of openly welcoming gays into the church membership. Invitees included people on both sides of the issue, but in 1998, a church committee that had been studying the issue recommended that the church be inclusive to all.

Larry's Bar (2040 North High Street)

Established in the 1920s, Larry's Bar recently ended its run as a unique gathering place where one could grab a beer and spin a poem. The recipient of a number of humanities grants, Larry's held readings and published folios of poems. The bar had started as a white-tablecloth restaurant on High Street and was still owned by the Paoletti family when it closed. It had a bowling alley in the basement, esoteric graffiti on the restroom walls ("How many pins can you stick in the head of an angel?") and lovely dark woodwork that made the interior delightfully brooding and ripe for literary urgings.

In 1967, it was the site of a protest lasting almost six hours and involving seventy-five picketers when owner Larry Paoletti posted a list of undesirables who were not allowed in the bar. Rumors about the bar's being "gay" were circulated purposefully by the patrons to keep fraternity and sorority members out. Its landmark status remains in the neighborhood and among those who still hope to see the old Larry's return. The Larry's Bar sign had such a landmark status that the community worked to see it saved and placed in the Ohio Historical Society's archives.

The iconic Larry's sign is now in the archives of the Ohio Historical Society.

LONG'S BOOK STORE/HENNICK'S RESTAURANT AND PIPE SHOP (1836/1814 NORTH HIGH STREET)

Possibly the oldest family-owned bookstore in the United States, Long's was founded in 1902 by Frank C. Long (otherwise known as "the Colonel"). Long enrolled at Ohio State in 1899 and majored in agriculture. He purchased "a student book exchange" in the basement of University Hall from another student, but according to an interview with Long, he was "kicked off campus." His father helped him found a bookstore in a space at Kiler's Drug Store on North High Street at Eleventh Avenue (near the present-day Barnes & Noble bookstore, which has the original Long's Bookstore sign).

Eleventh Avenue was then the main entrance to the university. The entrance to the university later moved north to North High and Fifteenth Avenue in 1909. Long built a two-story building, where his family lived above the store (the wallpaper is still visible inside), and the Cottage Cove in the basement sold bean soup for five cents. The original bookstore was small and had a grocery in an adjacent space. In the 1920s, that space became a Lazarus Department Store for a short time. Frank's son, Robert, built up a rare and first-edition book collection (eventually acquired by Ohio State

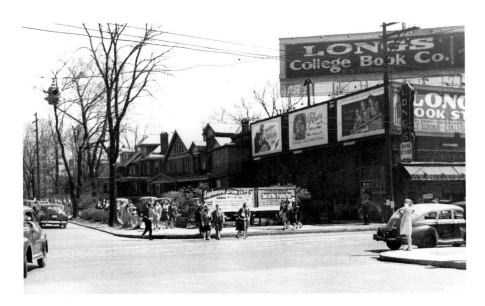

Long's Bookstore, as seen in this 1946 photo.

University). The location became so well known that Long's never used an address, merely saying it was at the gateway of Ohio State.

In the 1940s, Long's was the world's largest bookstore, doing $1,000 a week in retailers' orders from around the globe. However, much of the wealth of Long's came from its own publishing company—from religious tracts to science books, French texts to education treatises. The iconic sign was fabricated in 1948 by the Columbus Sign Company and renovated by the same company to become part of the South Campus Gateway development.

With Robert's death in 1956, another son, Dr. Frank Long Jr., left his medical practice to run the business. He eventually expanded the store to fifty thousand square feet and added clothing and memorabilia. A third generation of Longs ran the business until it was sold to Campus Partners in 2000. Next door, Hennick's was a favorite student hangout from 1922 to 1949 and a popular spot for humorist James Thurber's fraternity brother Elliot Nugent to hang out. Later the pair co-wrote a spoof on Ohio State University life and football called *The Male Animal*. The movie version debuted at the Palace Theater with its all-Hollywood cast in tow and the OSU administration and city officials pulling out all the stops to live in the limelight with them. Nugent also wrote *The Poor Nut*, which was set in Long's, and made into a 1925 Broadway play. Hennick's also had a ballroom above the restaurant.

THE LONG WALK (THE OHIO STATE UNIVERSITY'S WILLIAM OXLEY THOMPSON LIBRARY TO INDIANOLA JUNIOR HIGH SCHOOL, 420 EAST NINETEENTH AVENUE)

The Long Walk is the historic name given to the sidewalk that is the east–west pedestrian route across the Oval, starting at the William Oxley Thompson Library at Ohio State University and continuing east to the main entrance of the university at North High Street and East Fifteenth Avenue.

In 1993, the concept of the Long Walk was extended into the historic heart of the neighborhood that helped to define the University District. The Long Walk's exact origin is unknown, although it may have evolved during the years of OSU president William Oxley Thompson, who was noted for being both the leader of the university and a civic leader in the neighborhood and the city. As a minister at the United Presbyterian Church (see United Presbyterian Church entry) and a mentor and active student life participant,

The Long Walk stretches from North High Street to the William Oxley Thompson Library.

Thompson was frequently called on to marry students, preside over their children's baptisms and, on occasion, preach at an untimely funeral.

Perhaps this is what led to the folklore that a young couple who walked, arm in arm, from the library to Fifteenth and High Street were as good as engaged from that point on and would marry at graduation. It is fitting that the large statue of Dr. Thompson, done by Edwin Frey, was placed directly in front of the library. In his academic robes, he appears to be waiting for a couple to approach him.

The folklore was still strong into the 1970s that one could observe a young couple, romantically walking arm-in-arm on the Long Walk, only to see one of them (usually the young man) suddenly bolt off the sidewalk before reaching North High Street, apparently not so sure in these "free love years" that romance should result in marriage.

In 1993, walking tours of the Long Walk were promoted to showcase historic buildings along the Oval and extended to the historic buildings and districts to the east of the university, including Long's Book Store, Hennick's, the Hillel Foundation, Indianola Presbyterian Church, the Tau

Kappa Epsilon Fraternity, the Kappa Sigma Fraternity, the Phi Kappa Psi Fraternity, Wellington Hotel, Indianola Forest Historic District, Iuka Ravine Historic District and the two Indianola schools.

MIRROR LAKE (NEIL AVENUE SOUTH OF THE WILLIAM OXLEY THOMPSON LIBRARY)

Mirror Lake is part natural landmark, part mecca for Buckeye football fans (and a perfect site for a marriage proposal among Buckeyes) and part explanation for the location of Ohio State University. In 1871, as trustees for the new Ohio Agricultural and Mechanical College were prioritizing their list of potential sites (they were also considering Springfield, Ohio, and Greenlawn Avenue in Columbus), one trustee drank from the lake's natural spring water. He proclaimed it the best water he had ever had.

The decision seems to have rested (at least in local lore) on the idea that the water sealed the deal. Of course, the land was also the right price, and the owner's vast land holdings were being parceled out to William Neil's heirs, all of whom would benefit if their inheritances surrounded the 332 acres

Mirror Lake as seen in the late 1880s.

to become the new land grant college. Mirror Lake was indeed a source of pure water; people came from all over Columbus to fill containers.

In 1891, while installing a sewer line through campus, the city accidentally struck the spring's source. Within two days, the lake was completely dry and remained so for almost a century. In the 1930s, students turned Mirror Lake into a rock grotto as a class gift. Today, Mirror Lake is a manmade lake, but its waters are the source of OSU traditions. The Bucket and Dipper Rock is the site for a colorful initiation ceremony for honorary juniors that is now in its 104th year. Students have jumped in Mirror Lake on the Thursday night before the OSU/Michigan game to ensure victory. While the media makes it seem the tradition has existed for one hundred years, it started in 1990 when the OSU Marching Band members led a Thursday-night parade around the campus that ended in a watery dip.

NEWPORT MUSIC HALL/AGORA/STATE THEATER (1722 NORTH HIGH)

Built in 1914, the State Theater operated as a movie house and theater from the 1920s through the 1960s. In the 1930s it operated as part of the Neth's Theater chain. In 1970, it became a live music venue as the Agora Ballroom and later became the Newport in 1983. As the Newport Music Hall, it is the longest continuously running rock club in the United States.

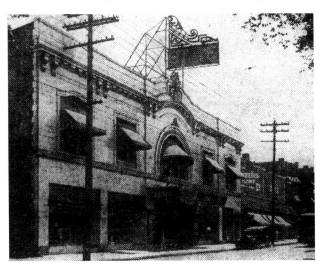

Its white terra-cotta façade has remained unchanged, though a gigantic sign that once hung over the front doors was scaled back long ago to a more modest marquee.

The State Theater, now known as Newport Music Hall, as seen in 1914.

The building continues to evolve. Businesses were always located on the second floor. In 1942, a beauty shop, a doctor and a dentist (Wendell Postle, a name long associated with the neighborhood) were located there. The popular Street Scene restaurant was located on the north side of the building in the 1980s. The building has recently sported a rooftop bar. The 1,200-seat theater retains much of its original interior and has a rich history of famous entertainers, including the last performance of John Lee Hooker, the legendary sharecropper-to-songwriter, blues singer and Grammy Lifetime Achievement award winner, before his death.

North High School (100 Arcadia Avenue)

In 1922, as Central High School in the Franklinton neighborhood was receiving bids for electrical, heating and plumbing work, North High School was in the initial stages of planning for a new school at 100 Arcadia Avenue. Compulsory school attendance laws were greatly strengthened by the Ohio legislature in the 1920s, and this caused Columbus schools to launch a $10 million building campaign for five new high schools. Following a national trend, the new schools had special features for classes in domestic science, manual training and physical education. Because the schools were to be built regionally, they were referred to as Central, South, West, East and North High Schools. However, the Columbus Board of Education had other plans for the names—Central was to become Washington Gladden Senior High School, South would become Abraham Lincoln Senior High School and North would be named Edward Orton Senior High School. North students led the appeal to the board to keep the name of their building as North High School, having already named the yearbook *Polaris* and chosen the Polar Bear as the school mascot.

Controversy over where to build the new North High School started in 1917. More than two thousand high school students lived from Hubbard Avenue to Arcadia. Though the first North High had existed since 1892 at West Fourth and Dennison Avenues, the building was seriously overcrowded. Ohio State University offered to build a $500,000 building on its campus in order for its education department to have a place to practice. The Columbus Board of Education turned them down, and one board member, Ralph Westfall, was adamant in his refusal, saying, "The further away from that college we can put the high school the better. I don't think high schools have anything to do

with colleges. Let those who want their children to go to college pay the expense of sending them to special prep schools."

Yet North's reputation was based on its academic programs that prepared students for college and mimicked other college traditions. Built in 1923 under the direction of Columbus architect Frank Packard and opening in 1924, this new North High was created on the site of the old American Sewer Tile Company on Arcadia Avenue on a fourteen-acre plot.

Charles Disney Everett, principal of North High School on Dennison Avenue and now principal at the new North High School, worked with architect

A detail from the first North High School, built in 1892, near Dennison Avenue and North High Street.

Frank Packard to create interesting additions, like a home economics apartment, completely furnished, where girls could practice the art of decorating a house (just like at Ohio State).

However, a different idea from the university proved to be highly controversial and litigious by the 1950s—high school fraternities and sororities. They not only flourished at North High School—they also ruled the school. The oldest ones (the Link Club fraternity, the Scioto Club sorority, the Waikiki sorority) had started at the first school, but now the Arro Club sorority, the Okay fraternity and the New York Club fraternity, while lauded by many parents as providing leadership opportunities and keeping high academic standards, were, by the 1950s (under the leadership of principal Edgar House) forbidden.

House saw the dark side of institutions that were, at best, pretentious and, at worst, highly discriminatory, demoralizing to students of middle- and working-class families and very undemocratic. Most of the school's other clubs were run by less than 10 percent of the students, all members of these social clubs. Though the Ohio legislature barred high school sororities and fraternities, they did not dissolve but lingered in lawsuits from parents who

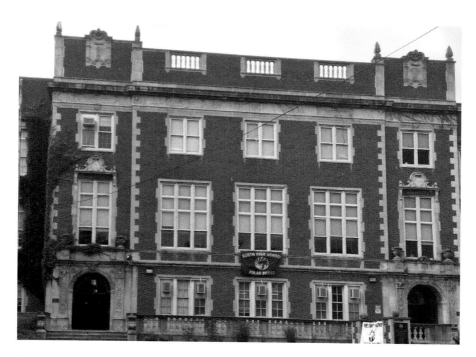

The second North High School was designed by Frank Packard.

brought the Columbus Board of Education to the Court of Common Pleas, saying the ban removed the right of parents to control the activities of their children. The parents lost and lost again at the Franklin County Court of Appeals, where the tradition of social clubs that began in 1889 died on April 17, 1962.

The first North High became Everett Junior High, named for beloved principal and administrator Charles Everett, who served the Columbus schools for over fifty years. North High School is an excellent example of Jacobethan Revival architecture, which was a popular choice for educational buildings in the early twentieth century, and North's addition was done years later by the noted firm of Brooks and Coddington. North High School, like the four other buildings from the 1920s (see COSI/Central High School entry), remains a neighborhood landmark because it was a significant cultural focal point with a commanding architectural presence—and continues to be with the new International High School, which now occupies the building.

STUDENT UNION (WEST TWELFTH AVENUE) AND NEW OHIO UNION (1739 NORTH HIGH STREET)

Because much of the "front door" to the University District's neighborhoods is the Ohio State University, a number of the buildings are easily identified as landmarks of the neighborhood, even by people who are only familiar with OSU football and the stadium. The Ohio Union has always been one of these buildings, even before it was located on North High Street.

The Ohio Union was the first student union at a public university and only the fourth student union in the country. Students themselves led the effort to have a student union—working for years to obtain funding and finally, in 1907, succeeding in approaching the state legislature for an appropriation of $75,000. Constructed in 1909 on West Twelfth Avenue in a Jacobethan architectural style, the building boasted dining rooms, reading rooms, billiard tables, a ballroom, paneled woodwork and stone fireplaces—all for male students. Women could enter only as guests, though they supposedly had the use of Pomerene Hall, a building that housed women's athletics.

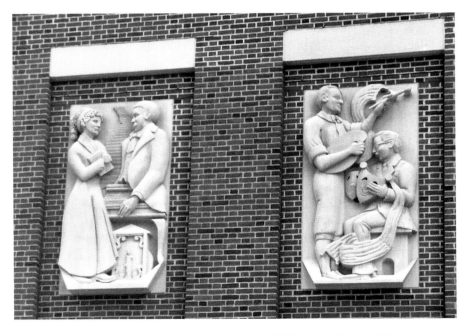

The south facade of the new Student Union, built in 2012, depicts famous Ohio authors and artists.

In World War I, the student union served as the dining hall for the aviation corps, which was in Hayes Hall.

The student union served until the 1950s, when a student campaign started to raise funds to build a sophisticated coed union to serve the growing post World War II student population and the many more student groups. When the university decided to demolish the building on Twelfth Avenue, students succeeded in having it placed on the National Register of Historic Places. Renamed Enarson Hall, in honor of President Harold Enarson, in 1996 the "old" student union became a visitor center.

In 1951, the "new" student union opened on High Street, financed largely by students' fees and lasting until 2007 when the site was cleared for a "newer" student union. This newest Ohio Union incorporated the bas-relief panels from the exterior of the previous Ohio Union and added two new panels that continued the tradition of honoring famous Ohio educators, artists, inventors, and innovators. In addition, the new Ohio Union used student focus groups to help design the interior spaces for study, student offices, relaxing, shopping and dining.

OHIO STADIUM, THE JESSE OWENS MEMORIAL (411 WOODY HAYES DRIVE)

For residents of the University District who are coming by way of Olentangy Road or West Lane Avenue, the Ohio Stadium is a landmark building, showing the way home. The shape of the building created its original nickname, "the Horseshoe." Only more recently has this been shortened to "the Shoe," courtesy of sportscasters. However, because of dramatic (and controversial) renovations in 2001 to facilitate luxury skyboxes and more women's restrooms, the original Howard Dwight Smith design no longer has an open horseshoe end, and the original "shoe" building appears to be encased in an oversize shoebox.

Howard Dwight Smith was awarded a gold medal from the American Institute of Architects for his design of what was, at the time of its construction, the largest reinforced concrete structure in the United States. The building required a massive earthmoving project to relocate the Olentangy River. At the time of its construction, debate raged over whether sixty-five thousand seats were too many to be filled, given the size of Columbus. By the end of the 1920s, one game recorded ninety thousand fans. Before the building of the Ohio Stadium, OSU football was played at many locations, including

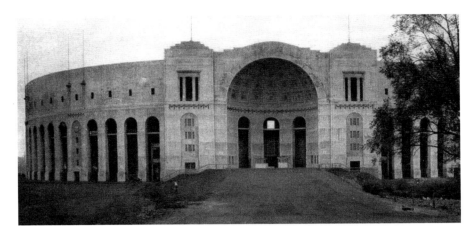

Noted architect Howard Dwight Smith designed both the Ohio Stadium, Orton Memorial Laboratory and Indianola Junior High in the University District.

a field on South Campus, a field in present-day German Village and the original Ohio Field on High Street near Woodruff Avenue. The popularity of Chic Harley swelled the size of the crowds, and talk of a larger stadium soon followed. (See Chic Harley entry.)

The 1920s stadium also lost the original Jesse Owens track in the renovation, but the spirit of Jesse Owens is celebrated in public art with a large pyramid-shaped bronze memorial. Each part represents a pinnacle of Owens's life. The sculpture can be entered and includes quotations from Owens, who is best remembered as the OSU student who won four gold medals in track and field in the 1936 Olympics in Nazi Berlin and broke three world records and tied in a fourth in less than an hour at a Big Ten track meet in Ann Arbor in 1935. Sculptor Curtis Patterson overcame many racial barriers and was the first African American to receive a masters degree in visual arts in sculpture from the University of Georgia.

OLD NORTH COLUMBUS COMMERCIAL DISTRICT (NORTH HIGH STREET BETWEEN HUDSON AND ARCADIA AVENUES)

North Columbus (1842) was a town separate from the City of Columbus, existing as such for more than three decades before it was annexed into the city. David Beers, the original settler to the area who had a business

and residence in the area of West Dodridge Avenue, had been a child captive of the Indians. His language skills and hard work as a miller and father of a large family of sons with ambition secured North Columbus's future.

Solomon and George Washington Beers, David's sons, laid out the town along the Sandusky Pike (North High Street), which was conveniently located midway between two growing places—Columbus and Worthington. Stagecoach and wagon traffic always in need of a blacksmith, the eventual location nearby of a Union Civil War camp with six thousand hungry men, the discovery of a good sewer clay ready to be turned into a

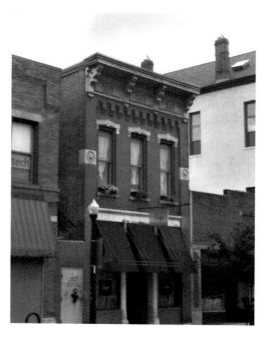

Sage Restaurant is located in Old North Columbus, a town founded in 1842 that was annexed to Columbus in the late nineteenth century.

manufactured product (see North High School entry), the lucrative contracts with the state to build and then rebuild the pike and the coming of the streetcar that culminated at Olentangy Park all helped to make North Columbus boom.

From the mid-nineteenth century through much of the twentieth century, the character of the town was reflected in the prosperous-looking buildings with over-the-top Italianate cornice work. North Columbus had its own locally owned banks, established schools and numerous churches. When North Columbus was annexed into the city in 1871, the city (in the Short North) already had named streets, duplicating the names in North Columbus. Therefore, in North Columbus, First through Fourth Streets became Tompkins, Hudson, Duncan and Dodridge Avenues. Front Street (or Mill Street) became Neil Avenue. Columbus schools purchased a twenty-seat schoolhouse for $3,620, indicating respectable property values, even if next to a slaughterhouse. In the 1920s, nine speakeasies can be documented. They flourished because the town was just south of "dry" Clintonville.

Today the history of the area is still visible in the commercial architecture and the numerous residences from the mid-nineteenth century. The small shops that once supported the community now are music venues, restaurants and specialty shops.

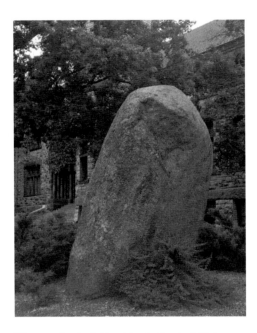

The erratic glacial boulder in front of Orton Hall came from the Iuka Ravine to honor Dr. Edward Orton.

ORTON HALL (SOUTH OVAL DRIVE) AND ORTON MEMORIAL LABORATORY (1445 SUMMIT STREET)

One of the university's most recognizable buildings is Orton Hall, built in 1891–93 by the highly creative architectural firm of Yost & Packard. It is a physical and a symbolic monument to Dr. Edward Orton Sr., who was the first university president of the Ohio Agricultural and Mechanical College (later Ohio State), as well as the first state geologist for Ohio. The Romanesque style complements the building designed to be a lesson in geology, constructed in forty different types of Ohio stone that are arranged in stratigraphic order (just as they are found in nature), with the oldest rocks closest to the core of the earth at the foundation and subsequent layers stacked on top.

At the crown of the tower, extinct animals are portrayed as gargoyles (though the debate rages as to whether they are really dinosaurs). The geology museum (complete with a mastodon skeleton) and related departments are housed in the building. The original library for the university is here and contains over three hundred thousand volumes and maps and notable nineteenth-century paintings showing American landscapes.

The large erratic glacial boulder that serves as a memorial marker near the front façade came from the neighborhood near North Fourth Street and Iuka

A landmark such as Orton Hall is a perfect place for a photo op.

Ravine. The story is told that after finding the boulder (which turned out to be much larger than anticipated), Dr. Orton's students physically dragged, tugged and labored to bring it to campus to please their beloved professor (or perhaps grades were due).

The Orton Memorial Laboratory on Summit Street was designed by architect Howard Dwight Smith, who did the Ohio Stadium and Indianola Junior High, and built by Orton's son, Edward Orton Jr., in honor of his father's work in the field of ceramics. The building was the third location for his work, selected because the lot was available, it was close to the university, and the City of Columbus allowed a departure in its zoning code to permit an industrial building into a residential neighborhood because the building was beautiful. The laboratory experimented with making pyrometric cones, a way to accurately measure the temperature of the heat in a ceramics oven. Dr. Edward Orton Sr. created the first ceramics department on a university campus, and from his work, the American Ceramics Society was founded in Columbus.

Phi Kappa Psi (124 East Fourteenth Avenue)

Probably one of the most beautiful houses in the University District, the Phi Kappa Psi house was originally the home of Alfred Litton, a candidate for Ohio governor, in 1908. He sold this Georgian beauty in 1912 to the fraternity to settle campaign debts.

Phi Kappa Psi helped to save Columbus's favorite literary native, James Thurber, who lived at the fraternity. The first years of Thurber's college life left him despondent and adrift. He was rejected by a fraternity, self-conscious about his lack of money and unfashionable clothes and struggled in ROTC under the tyranny of Captain Converse, who took no pity of Thurber's lack of coordination (mainly due to being blind in one eye). Thurber's later collaborator and life-long friend, Elliott Nugent, got Thurber into Phi Kappa Psi, encouraged his writing and helped him to achieve campus recognition in his literary endeavors.

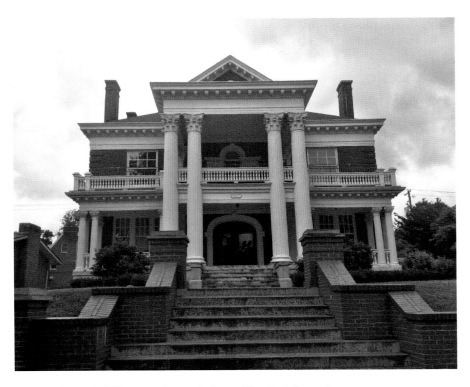

The Phi Kappa Psi House was humorist James Thurber's fraternity.

Thurber's bedroom windows are on the southeast corner of the second floor. In keeping with Thurber's often humorous personal life and eccentric family, he also lived at home (the current Thurber House at 77 Jefferson) and never told his family that he had stopped attending college—and they never asked. Thurber wrote for the student humor magazine and the literary magazine, but he left Ohio State in 1918 still a sophomore.

Thurber became a leading writer at the *New Yorker* from 1926 until his death in 1961 and a member of the famed witty chatter at the Algonquin Hotel's Round Table. Perhaps Phi Kappa Psi's most celebrated moment came on March 12, 1942, when Thurber's story, *The Male Animal*, debuted at the RKO Palace Theater as a Hollywood blockbuster, starring Henry Fonda. The movie featured hometown Columbus and all of Thurber's connections to his college and fraternity. The plot was a not-so-thinly-disguised spoof on Ohio State's obsession with football and athletics over academic excellence. It did not seem to bother many residents of Columbus that their values were being mocked (if indeed they saw this) since Columbus turned the town scarlet and gray in honor of Hollywood. The Phi Kappa Psi house has been undergoing an extensive renovation under the direction of the Lincoln Street Studio and the vision of architect Frank Elmer.

ST. STEPHEN'S EPISCOPAL CHURCH (30 WEST WOODRUFF)

The only non-university building on Ohio State University's property, St. Stephen's was designed by the Columbus firm of Brooks and Coddington and completed in 1953. An earlier church stood on the site since the 1920s, but before that, the corner of West Woodruff marked the site of the Indianola Woods, where lovers strolled among violets.

The building is an outstanding example of mid-century modern architecture, and the courtyard space between the sanctuary and the community center is reminiscent of a medieval garden. St. Stephen's also stands as a landmark and testament to the residential and commercial neighborhood that once stood on the west side of North High Street between West Woodruff and West Lane Avenues. In the 1960s, large homes and well-kept yards were replaced by North Campus dormitories as the university grew, and the City of Columbus "blighted" properties to access some of the first federal urban renewal funds. One large Victorian home on North High near the church was the original home of the Library Bar.

SULLIVANT HALL/GRADUATES' GATEWAY (1813 NORTH HIGH STREET)

Sullivant Hall was built in a neoclassical revival style to be the Ohio State Archaeological and Historical Society (the Ohio Historical Society) in 1913, opening in 1914. The trustees for the university contracted with the society to locate its new building on campus, and the building was the first to be designed by the first university architect, Joseph Bradford. Originally, the building only faced North High Street, but three additional wings were added over time. The wing that faces the Wexner Center was added in the 1920s and contained Ohio's official memorial to those who served in the Great War (World War I).

The memorial contained four large bronze panels that depicted four phases in the war, and they were set in a specially designed lobby space. The large bronze statue of the *Victorious Soldier* that stood on the front steps of the building was also unveiled at the time. They were two years in the planning and four years in the making. All were the work of Bruce Wilder Saville, a former instructor of Ohio State's Fine Arts Department who enlisted the help of Harold Sands, a returning veteran and graduate student who donated his own World War I helmet in the casting of the Victorious Soldier.

OSU's entrance at Fifteenth Avenue started as a memorial and later became Graduates Gateway.

When the museum moved in 1970 to its present site on Seventeenth Avenue and I-71, the *Victorious Soldier* was also relocated. Most recently, the bronze panels have also been relocated to the Ohio Historical Society. The building was renamed Sullivant Hall to honor Joseph Sullivant, son of Lucas Sullivant, founder of Franklinton. Sullivant is largely credited with securing the old Neil Farm as the site for the building of the Ohio State Archaeological and Historical Society.

The refurbished building will be home for the OSU Dance Department and the Billy Ireland Cartoon Library and Museum. Sullivant Hall is set off by the Patriarch's Gateway, named after the group of early graduating classes who started the memorial project in 1912. It is also known as the Graduates' Gateway and the Alumni Gateway. Other graduating classes contributed to the large curved benches. The gateway was dedicated in 1941 to symbolize the "front door" of the university. It is here that OSU posted the mounting casualty list of its fallen students and faculty members during World War II. The gateway was also the backdrop for many 1970s student demonstrations.

Tau Kappa Epsilon Fraternity House
(234 East Seventeenth Avenue)

This fraternity is one of the most outstanding examples of English Tudor Revival architecture in Columbus. The gable has intricate bargeboards carved in a grape motif, and the building features medieval-style windows. In 1930, William Alfred Fowler, winner of the Nobel Prize in physics (1983), lived here, as did war hero John Blackburn, who left his class of 1942 to join the United States Navy. Blackburn died defending his post on the USS *Utah* at Pearl Harbor. Ohio State's Blackburn House on north campus is named for him. President Ronald Reagan, who had joined Tau Kappa Epsilon at Eureka College, made several visits here.

University Baptist Church
(50 West Lane Avenue)

There is the physical landmark of the building—with its prominent site on West Lane Avenue across from Ohio State and its extremely tall

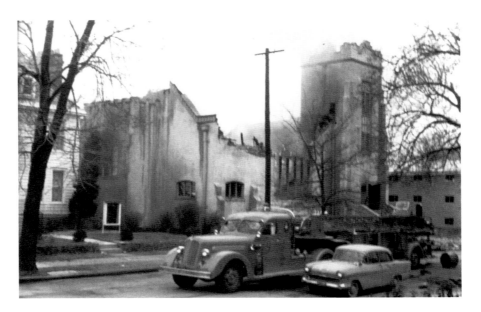

The burning of the Tenth Street Baptist Church in the 1950s created the opportunity for a new University Baptist church.

spire—and then there is the spiritual landmark of the contributions of its members. The church began in an extraordinary way. Abigail Bunker, a native of New England, was a well-educated woman who graduated from a women's seminary in 1845, married and became a farmer's wife, raising eight children. She and her husband moved to London, Ohio, in 1856 and then into Columbus when two of her daughters became Columbus school teachers. From her home at Neil and Fourth Avenues, she began to worship at Russell Street Baptist Church. She recognized the need for outreach to OSU students and opened a storefront church, which became the Tenth Street Baptist Church. When the church burned, much of what she had modeled to other congregants took root as they planned for a new location directly across from the university in a greatly expanded church with spaces for ecumenical programming. Bunker was no longer there when the church opened one hundred years later, but her spirit still inspired.

Alvin Haley, a fifty-year member of University Baptist, was described by his peers as being "in the front line of interdenominational work." He was recognized by whites and blacks as a social activist, in addition to his work as executive director of the Columbus Metropolitan Area Church Council and deputy director of Franklin County Children's Services. Even after retirement,

he maintained a full schedule of church-related activities. He was not a minister, but he was engaged on no fewer than sixteen statewide and national church boards and social services agencies that worked on behalf of victims of domestic violence and substance abuse. When he died in 2009, the social justice award of the Columbus Metropolitan Area Church Council was named in his memory.

Mary and Bill Riley, also members of the church and contemporaries of Haley, were forces for neighborhood social justice, from food pantries to educational policies that supported keeping neighborhood schools open. Modest and unassuming, Bill, a retired OSU scientist, was a zoning watchdog; Mary formed the International Wives Club to help integrate women into the life of the community at a time when women were often isolated when their husbands took on university jobs. The club gave women a chance to practice English, form friendships and bring preschool children, and all cultures and religions were respected. Mary Riley's connections were amazing. When teachers at Indianola Junior High called to see if she could find a translator for a child from China who had come to live with her grandfather and knew no English, Mary was sure she could not. She called back within an hour, having found several people, and asked only, "Which dialect?"

Both Bill and Mary are now gone. Mary's wish was to leave her body to medical research; even in death, she gave.

UNIVERSITY HALL (SOUTH OVAL DRIVE)

Though the original building was torn down over forty years ago, University Hall (perhaps due in part to a somewhat look-alike replica) continues to be a landmark in the University District, which is often thought of by outsiders as defined only by its proximity to Ohio State football. University Hall was the first building of the Ohio Agricultural and Mechanical College, opening in 1873 to be the entire university under one roof. The original Ohio State campus was laid out with the help of Captain Herman Haerlin, a Cincinnati landscape gardener, and University Hall, viewed as an "English manor," was integral to the plan, laid out to face the City of Columbus, on the edge of an old orchard.

The building occupied the highest point. Bricks were made of clay dug in the nearby woods. Stone was cut by a sawmill served by water from Neil Run. The east wing of the basement was student housing (sometimes called "Purgatory" by its residents), and the first floor was faculty housing. Across other parts of the building were a chapel, classrooms, laboratories, an auditorium, a museum

of sorts, a cafeteria and the president's office (and a basement with students' rifles, though heavy artillery was kept outside on the lawn).

By the 1960s, there were serious concerns about the safety of the building. One history professor kept a rope in his desk drawer in case he needed to escape from an upper window during a fire. Yet the old building had both charm and deficiencies.

Throughout the building, in addition to original nineteenth-century chalkboards and a lecture dais in every room, there were wooden stairs, railings and elaborate newel posts. Completely detailed, paneled tiny wooden doors (with properly scaled hardware and moldings) were found on all the floors and stairways and hidden around corners. The eighteen-inch doors appeared to have been crafted purposely for another species of Hobbit-like students who took night classes since all the doors were locked in the day. They were the source of wonder and sometimes amusement when a few periodically sported the nameplate of a fictitious faculty member. The doors were actually utility doors.

The theater continued to host productions of the Strollers, the drama program, to the end of the building's life, despite being interrupted by bats moving across the top of the auditorium. Patrons and actors learned to duck or ignored them. The building was torn down in 1971, despite student and alumni attempts to have university officials reconsider.

An agreement (of sorts) was reached when the university assured all that a replica of the building's exterior would be re-created in its place. Sadly, it is hardly a re-creation and lacks the detailed charm of its predecessor. However, it is far better than the many student-housing towers (like Lincoln and Morrill) proposed to line South Oval Drive during the administration of one OSU president.

WELLINGTON HOTEL
(1932 NORTH HIGH STREET/22 EAST SIXTEENTH STREET)

A handsome Tudor Revival–style building, the Wellington Hotel or Wellington Hall opened in 1928 as a fashionable residential hotel with modern private baths and showers for male Ohio State students. Close to campus and across from the university president's home on North High Street, the Wellington was well positioned to appeal to wealthier students.

Two elegant tailoring shops, tobacco shops and gathering places were nearby. At the corner of the hotel, Jim's Place, a restaurant, was started by future Ohio governor James Rhodes to help pay his way through college during the

The Wellington Hotel opened in 1928 as a fashionable hotel for male OSU students.

Depression. He was far from being wealthy, but with a sense of humor, he created a pseudo fraternity complete with fraternity pin (a crushed beer bottle cap), perhaps to spoof the "swells" who could afford to live at the Wellington.

North High Street saw many new buildings in the 1920s—courtyard apartments, theaters and build-outs in front of older residential homes as the street turned commercial. Across Sixteenth Avenue and south of the Wellington, a large grape arbor graced the area for seventy years, a shady spot and favorite gathering place for students and community members. Now gone, the arbor did not die easily with new development on the corner. Local legend has it that the vines still come up under nearby buildings and have even traveled across (under) High Street, where they come up in the Wexner's prairie plantings.

WEXNER CENTER (NORTH HIGH AND EAST FIFTEENTH AVENUES)

Opened in November 1989, the Wexner Center was conceived of as a research laboratory for the exploration, display and advancement of all contemporary forms of art. From its inception, the Wexner Center supported

the commission of new works, artist residencies and multidisciplinary programming—all cutting edge and drawn from a variety of cultures.

The building was designed by the late Richard Trott of Columbus (who walked by the old armory everyday) and famed New York architect Peter Eisenman (who also designed Columbus's Convention Center). The Wexner Center's design includes two themes: (1) a play off the angles at twelve-and-a-quarter degrees, representing the degree to which the on-campus street grid varies from a true surveyor's north/south axis and (2) the castle-like ramparts of the old Ohio State Armory that once stood on the site.

The imposing Romanesque armory was a landmark building that stood on the site from 1898 until it burned in 1958. Designed by Yost & Packard, architects known for their distinctive building styles, the armory building was one that Richard Trott was very familiar with, and its memory inspired his design. The prairie-grass installation designed by Laurie Olin was first viewed suspiciously by many in the community, but it has become its own landmark, changing with the seasons. In order to build the Wexner Center, a corner of the Mershon Auditorium had to be clipped out. The Mershon building was built in 1957, a three-thousand-seat facility named in honor of Ralph Mershon, class of 1890.

WOODY AND JO'S
(NORTHEAST CORNER OF NORTH FOURTH AND EAST FIFTH AVENUES)

For a time in the 1980s, two of Columbus's best-known black-owned and black-operated barbecue pits stood next to each other on "barbeque corner," at North Fourth and East Fifth Avenues—Javan's and Nassau Daddy's (later it would become Woody and Jo's House of Ribs), sharing a parking lot and a clientele who could get their fill of ribs until 4:00 a.m. (along with sides of baked beans, greens and sweet potato pie). It is believed that Woody and Jo's was originally a small pizza place, but records indicate that if it was, it was just one of many businesses on the corner.

In the 1920s, the site was a small service station. Nassau Daddy's Pit Barbeque was owned by the late Bill Moss, a disc jockey at WVKO and a lightning rod as a member of the Columbus Board of Education. The name "Nassau Daddy" was given to him by a coworker who noticed he came to work at the radio station everyday wearing a wide-brimmed West Indian hat. Moss had experience running a barbecue in Miami, Florida, and sought to

re-create first-class food in a place that never had a wood-burning open-pit barbecue. Though he wanted a chimney, city inspectors made him settle for an exhaust fan. Located close to Ohio State and on a prominent corner (and with commercials on WVKO pumping up barbeque lovers), the barbeque showed almost $2,500 worth of business in three days of its opening.

In 1969, Moss closed the business because the exhaust fan tended to cause pit fires, which, in turned, created expensive repairs and frequent closings. The business continued as Shank's. But it reached landmark status when it became Woody and Jo's, owned by Woody and Joann Helm. Woody was a truck driver who had found his niche in backyard barbequing; his wife created the sauce, and the daughters also worked in the business. When the pit caught fire (as it had for Moss), the ribs were made offsite and brought in.

The neighboring pit, Javan's (now gone), started on Mt. Vernon and Taylor Avenues before it moved to East Fifth Avenue. Jimmy Croskery, the owner, regularly turned out more than five hundred batches of ribs. At the original location, Javan's was a must for touring musicians and celebrities, including Stan Kenton, Nancy Wilson, Louis Armstrong, Arthur Godfrey and Issac Hayes, and did catering for touring companies of *The Wiz* and *Bubblin' Brown Sugar*. The severe Columbus winters took their toll on Javan's second location, a frame building; eventually, the building was condemned and burned down by firemen. However, Woody & Jo's continues, at least for the time being.

York Masonic Temple (1276 North High Street)

The dedication of the Masonic Temple's cornerstone in October 1914 followed a week of activities from representatives of all the 540 lodges in Ohio, sixty children from the Springfield Masonic home for children providing entertainment and special lodgings for the ladies who came from all parts of Ohio. When it was finished at the cost of $70,000, it had dining rooms, a gymnasium, ladies' parlors, assembly rooms, a stage, a fifty- by eighty-foot ballroom, libraries, smoking areas and balconies. The temple took its name from York, England, a famous home of Freemasonry. By 1914, there were over one thousand members. Today, the imposing building on North High Street has been redone and repurposed as condos.

GERMAN VILLAGE

Book Loft (631 South Third Street)

This bookstore—with more than thirty rooms in a labyrinth of up-and-down spaces that stretches a full city block—is a bibliophile's dream. It is easy to get lost, but somehow good thematic groupings and signage help to guide one back to the checkout counter—though it is easy to lose the restroom, even after one has just exited it.

Originally a business and a second-floor living space built in 1877 by Amelia Maurer, the building from the 1890s was known as Maurer's Saloon and was associated with the Schlee Brewery, one of the Big Four breweries located on South Front Street. With the coming of Prohibition in 1919, what was once a saloon turned to other purposes, including a decorating company, a theater, a church, a doll hospital, an art studio, an antique shop and an indoor golf course. In the 1950s, it was Mrs. Keller's Doll Hospital/Variety Store, which attracted a diverse clientele of neighborhood youngsters. It sold the basic eight-pack of crayons, scrapbooks for a favorite sports team's clippings, comic books, penny candy and lead soldiers. With two elementary schools on its doorstep, St. Mary's and Third Street Schools, there was constant afterschool foot traffic. Mrs. Keller was a direct descendent of Nicholas Schlee, one of Columbus's most well-known nineteenth-century brewers, who came from Germany to help the Schlegel Brewery when its owner, George Schlegel, died unexpectedly. Within three months of arrival, Schlee had stabilized the brewery and married the widow, adopting her four young children. The Book

The Book Loft has been a residence, a variety store, a saloon and a "doll hospital."

Loft, the present occupant, is now a tourist destination in German Village and one of the largest independent booksellers in the country.

BURKHOLZ SALOON AND BOWLING ALLEY (351–355 EAST SYCAMORE STREET)

The apartment complex at 351–355 East Sycamore Street was once a thriving saloon and bowling alley. Burkholz Saloon began in the early 1900s at two successive locations on Livingston Avenue, but by 1905, it was at its final location on Sycamore, and the owners, Mary and Michael Burkholz, lived in the apartments above the bar.

Like many saloons, Burkholz changed in 1917 with the Eighteenth Amendment and the 1919 Volstead Act, which enforced the prohibition of intoxicating liquor containing more than 0.5 percent alcohol. Saloons became groceries, confectionaries and/or restaurants. Burkholz became

Burkholz Confectionary and Bowling Alley. With the Twenty-first Amendment in 1933, saloons once again blossomed in the south end, where it can also be assumed alcohol never entirely disappeared during Prohibition among the large immigrant and Catholic population.

However, Burkholz was never just a "beer joint," and the bowling alley saw some serious rivalries. The Plank's Café on Parsons Avenue participated in some fierce matches with the cousin-owned Plank's Bakery to the south on Innis Avenue. Walter Plank, the owner of Plank's Café team, also bowled leadoff for Mike Burkholz's specials team. Walt would be considered a ringer in a friendly bowling match today, having bowled a perfect three-hundred

Burkholz Saloon and Bowling Alley was a fierce competitor with Plank's Cafe on Parsons Avenue.

game. In the late 1940s, Burkholz became Sycamore Recreation, and the traditional euchre games, cold fishbowls and bowling continued unchanged through the 1950s and 1960s.

Neighbor Frank Wickham remembered the night in the early 1970s when the bar, then known as Jits Bar and Bowling Alley, was firebombed (though no real motive was discovered). A police helicopter circled the building, warning the people living in the apartments on the second floor to get out. The property was subsequently sold and renovated and stands as an apartment complex today, though the bowling lanes are said to exist still under the new flooring.

City Car Barns/Old World Bazaar (555 City Park Avenue)

The block-deep building at 555 City Park was built in 1891 by the Columbus Street Railway Company as a car barn for streetcars. In 1922, the company became the Columbus Railway Power and Light Company garage. Tim

Originally built for streetcars, this building is best remembered as the Old World Bazaar.

Cook, a young man who lived next door to the garage at 555 City Park in the 1940s, has fond remembrances of the opportunity it presented since he and his friends used to sneak under the overhead doors at night where, by pushing a button, they could move the electric street cars back and forth inside the building.

In the 1950s, the garage became the Walkers' Car Wash, purported to be the first automatic car wash in the area. The automatic car wash was mesmerizing to one newspaper carrier who spent long periods of time transfixed by the mechanical wonder at work, though fortunately, he allowed himself to be put into a trance only at the end of his route, and no customers suffered delays.

In the 1960s, the building was again converted and became a retail mall called the Old World Bazaar, a destination spot for visitors. Nancy Auer, a neighborhood resident, fondly remembered the ten small shops laid out in a winding path inside the building with a central plaza; rough-hewn timbers, tile and wrought iron gave the retail area an Old World look. Gifts, pastries, flowers, woodcarvings and woodcrafts, antiques and toyshops lured a variety

of customers and were part of special tours from the Columbus Convention Bureau. Currently, the building has been converted again—into office spaces—and is an excellent example of adaptive reuses (many times).

COLUMBIA THEATER (281 EAST WHITTIER STREET)

Originally, the Columbia Theater was the Schiller Theater, built in 1912 on what was then Schiller Street (now Whittier Street). During World War I, a number of the neighborhood streets and alleys that carried German names were renamed. The famous German poet Friederich Schiller was traded out for another poet—popular American poet of the nineteenth century John Greenleaf Whittier.

In this era, all neighborhoods had their own movie theater, though many were little more than storefronts with chairs set in rows. Within walking distance of the Schiller were the Thurmania (Thurman Avenue and Jaeger Street), the Markham (South High Street at Moler Street) and the Victor (Livingston Avenue and Dixon Avenue). The Schiller was renamed the Steelton before becoming the Columbia in 1923. This three-hundred-seat theater was part of the Rowland Circuit and remained a theater until the 1960s.

Currently, it is empty but was most recently occupied by the 4S Club (Knights of St. John, St. Paul, Catholic Order of Foresters, and St. Francis Xavier Society), which had formerly been in a building at 581 South High Street. These organizations today are closely associated with the nearby Catholic parishes of St. Mary's, St. Leo's and Corpus Christi.

DAS MAUS HAUS (225 EAST COLUMBUS STREET)

A garage at 225 East Columbus Street had a previous life as a converted gift and antique shop called Das Maus Haus, very popular with strolling tourists since it was one block north of the Schmidt's Sausage House and Restaurant. Neighborhood girls tell of an afternoon in 1989 when actress Whoopi Goldberg stopped at Schmidt's Sausage House for lunch. Kelly Quickert, an employee who lived a block from Schmidt's, put out a celebrity alert to her sister Colleen and friends Beth and Helen Wickham,

who all arrived en masse at Schmidt's. But Goldberg had disappeared down Purdy Alley in the direction of Das Maus Haus, where she was tracked down by the girls. Goldberg was in hiding from the public eye while she waited for her limousine, but she invited them to take a picture with her.

The girls were thrilled to have met a real star, and even years later, they think that Das Maus Haus is a landmark for the encounter, though Patrick, Colleen's youngest brother, felt Das Maus Haus's landmark status rests solely on its being a source of collectible lead soldiers. (Brothers!)

ENGINE HOUSE NO. 5 (121 THURMAN AVENUE)

Built in 1894 as the Fire Company, Pump Company, and Engine House No. 5, Engine House No. 5 was located on the corner of Thurman Avenue and Mozart Street (Fourth Street) as part of the systematic expansion of fire

Engine House No. 5 was a popular restaurant for many years.

services for Columbus. Manned by eight men, four horses, a steam engine and a wagon, the firehouse was commanded by Captain W.A. Couch and Lieutenant John Veiths. The building would later include Police Substation No. 5, but after almost seventy-five years of service, the station closed in 1968.

In 1973, the building was purchased by the C.A. (Chuck) Muer Corporation of Detroit, Michigan. The multimillion-dollar company owned more than twenty seafood restaurants, and Engine House No. 5 became a fine-dining seafood restaurant, described by Brian Cook, current chef of the Columbus Brewing Company, and his wife, Stacy Auer Cook, former server at Engine House No. 5, as having a Manhattan-style chowder from pollock and haddock; a Martha's Vineyard salad of Bibb lettuce, gorgonzola cheese, pine nuts and maple raspberry vinaigrette; and a Charley's Bucket of steamed lobster, crab, mussels, shrimp, clams, redskin potatoes and corn on the cob in a steamy metal bucket.

Delicious food aside, Engine House No. 5 was memorable because special occasions were marked by a cake with sparklers presented by a server who came down the fire pole upside down and, on occasion, two upside-down servers, one on the shoulders of the other.

In 1993, Chuck Muer and his wife, Betty, and two friends were lost at sea in a storm with gale force winds as they returned from the Bahamas to Florida. No bodies were ever recovered. Subsequently, the restaurant was closed, and the building sold. The former firehouse is an office building today. No word on whether the shadowy figure that floated through one of three dining areas in the restaurant, called out employees' names or produced banging noises is still there.

THE FAIRY HOUSE (793–795 JAEGER STREET)

Tucked into the base of the stone wall between 791 and 795 Jaeger Street is the house of the fairies. The stone retaining walls are not uncommon in German Village, but sadly, many have disappeared as the ravages of time and the rarity of replacing the stonemasons have taken their toll. Many front yards that once featured beautiful stone walls now sport grassy slopes to the sidewalk. But at least one wall has survived on Jaeger Street, perhaps under the protection of the fairies.

Generations of neighborhood children have been introduced sooner or later, be it on walks with their parents or explorations with siblings or

friends, to the fairy house. Much like Santa Claus and the Easter Bunny, the fairy house became a part of the storehouse of childhood fantasy for the neighborhood children. Attempts (by adults) to coax the fairies to come out and wave (usually by gently kicking the wall) end in futility. Little ones look up knowingly and observe that the fairies must be sleeping because, "As you know, Grandpa, fairies only come out at night."

FRANK FETCH PARK/BECK STREET PARK AND LANG STONE COMPANY (BECK STREET, 206 JACKSON STREET)

For many years, the lot where Frank Fetch Park is located served as a stone storage yard for the Lang Stone Company (located at the corner of Jackson and Fifth Streets). The lots for Lang Stone had been purchased in 1869 and used well into the twentieth century as both open surface storage and as a warehouse. Many of the stone stoops, steps and foundations on the South Side came from this company.

The Lang Stone Company eventually moved its operation, including the storage yard, to the Brewery District next to the Columbus Brewing Company. In the 1950s, before the move, the storage yard was considered a prime—but forbidden—playground for the neighborhood children. The stacks of marble, sandstone and granite—some of it weighing tons—were perfect for hiding over, under and around while playing cowboys and Indians, war, cops and robbers or Flash Gordon, depending on what serial was playing at the neighborhood theater, the Victor on Parsons Avenue, that month. The piles of stone were exactly what Columbus children could image the deserts and the buttes must have been like for the wagon trains and the train robbers of the Wild West.

After Lang Stone moved, the lot was vacant until 1964, when the City of Columbus's Park Commission authorized city workers to build Beck Square Park. In 1977, the current owners of the warehouse created a French country–style home that has been featured nationally for its adaptive reuse. To purchase the land for the Beck Square Park, $4,000 had been approved, and the total cost of $6,000 to $8,000 was appropriated for materials and labor to construct the park.

Douglas Strang, the park's architect, told the Park Commission the park would be like a beer garden minus the beer. The city's Park Commission voted approval in March 1964, and Beck Square Park was born. The park was

renamed Frank Fetch Park, after the founder of the German Village Society, in 1985. It is the site of concerts and cultural events, despite its nickname of Dog — Park by the neighbors, in honor of the negligent dog walkers.

There is a beehive tucked into the southeast corner of the park. Despite the concerts and the dog walkers, the park is also filled with the childhood ghosts of Hopalong Cassidy and the Lone Ranger, who continue to haunt the park at night.

FRANKLIN ART GLASS (222 EAST SYCAMORE STREET)

Henry Helf started the Franklin Art Glass Studio in 1924. Helf was the son of German immigrants and a former foreman at the Von Gerichten Art Glass Company, founded by Theo and Ludwig Von Gerichten and located on South High Street. Von Greichten Art Glass was world renowned, and the brothers had studios in Columbus and Munich. The studios on Sycamore were acquired in 1966 by a later generation of the Helf family in a building that had been the Sycamore Theater in 1915 and a United States armory in 1922. In the 1950s, the building was the Sharp & Dohma Chemistry Laboratory. Franklin Art Glass has, for generations, produced commissioned pieces and done expert repair for churches, universities and residences.

GAMBRINUS STATUE (SOUTH FRONT STREET)

The statue of King Gambrinus that stands prominently on Front Street in the Brewery District is over one hundred years old. August Wagner, a beer brewer, immigrated to the United States from Bavaria with the expectation of one day establishing his own brewery. He originally arrived in Cincinnati, where breweries were one of the largest industries in the city, producing over a million barrels a year estimated to be worth $8.6 million.

Wagner became a brewmaster at the Knecht Brewing Company in Chillicothe, and three years later, he was a brewmaster at Hoster Brewing Company in Columbus. But in 1904, he reached his dream, starting construction of the Gambrinus Brewery and serving as its president until his death in 1944, despite Prohibition, the deaths of three sons and changes to the name of the company (called August Wagner Breweries, Inc. after the death of his third son).

In 1904, Columbus and much of the Midwest were dealing with a typhoid epidemic, a waterborne disease that was prevented by not drinking untreated water. Another, simpler approach for some to avoid the disease was to drink beer. Business was very good.

It is believed that at this time another German immigrant, Peter Toneman, was commissioned by Wagner to be the sculptor of the symbolic statue of King Gambrinus. Wagner opened the Gambrinus Brewery in 1906 at the corner of West Sycamore and Front Street, placing the statue above the main entrance to the brewery. The icon of Gambrinus has several legends. Gambrinus, the ruler of Flanders, was regarded by many as the patron saint of beer brewing. Others believed that

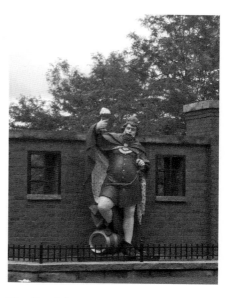

The Gambrinus statue is reported to have been modeled after August Wagner, a legendary beer brewer.

Gambrinus was John the Fearless, a fourteenth-century ruler who was credited to be the creator of malted beer; and another legend claimed Gambrinus was the royal cup bearer in court of Charlemagne. Regardless of who Gambrinus was in legend, it is widely believed that the statue was modeled on August Wagner himself, a large and mirthful man.

Following World War I, Congress enacted the Volstead Act to enforce Prohibition, and the name of the Gambrinus Brewery was changed to August Wagner and Sons Products, which resumed brewing beer in 1933 and survived as the August Wagner Brewery until 1974. He survived Prohibition by manufacturing soft drinks and "near beer," requiring an unusual method by which beer was first made and then dealcoholized.

It is said that on one occasion when he was in court to testify on behalf of a friend's son who had been arrested for consuming two beers, Wagner was asked how many bottles he drank in one day. He took his time to answer as if he was counting in his head—two with breakfast, another dozen or so with customers at the brewery's bar in the morning, two with lunch and another dozen in the afternoon at the brewery. When the lawyer asked if it were possible for a man to get drunk on beer, Wagner answered with a smile that it was possible if one made a hog of oneself.

Wagner was active in perfecting new techniques to improve brewing by attending brewery schools across the United States. He served as director of the United States Brewers Foundation and was president of the Ohio association. He owned six farms in three states (Ohio, Michigan and California) totaling a 1,000 acres, of which 250 acres became Lockbourne Air Force Base, and another 55 acres near Bellefontaine he donated to the U.S. Air Force for radar installation. At one point in his life, he was heavyweight champion wrestler of New York.

As a member of St. Mary's Catholic Church (see St. Mary's Catholic Church entry), he provided for his workers not only by heavily supporting the church but also by having special deliveries of beer for Father Burkley. Older families in the now German Village neighborhood recalled that the heavy Wagner brewery trucks left cuts in the brick that can still be seen today. Wagner supported all churches and hospitals of all faiths. He donated $10,000 for a Columbus zoo building and owned a realty company and a hardware company. After he died, his daughter Helen continued the company.

The site was purchased by the *Columbus Dispatch*, which preserved and restored the statue, though the brewery buildings were demolished.

HARRY TURNER BANANA HOUSE (726 CITY PARK AVENUE)

Every year, the German Village Society holds a Haus and Garten tour, and 2012 was the fifty-fifth tour. One house that was deserving of a place on any such tour was "the Banana House." It was not in San Francisco, Osaka or Bankok, but on the South Side of Columbus. Harry Turner Sr. and, before him, his father-in-law, Ed Dauer, created the landmark corner of City Park Avenue and Sycamore Street—a yard full of banana trees.

The trees had been planted by Mr. Dauer in the mid-1940s and lovingly tended for more than forty-five years. When Harry and his wife, Agnes, inherited this plantation, Harry continued the tradition with the help of a husky grandson. Thirty trees, some the height of twelve feet with a girth of six inches, would have been impossible for the retired bus driver to wrangle on his own. Harry would dig and move the plants to the basement before the first frost in October. Over the years, Harry also provided plants to visitors from Canada, Michigan, Pennsylvania and a homesick Cuban woman who lived in Worthington.

In response to the usual question of "Why?" Harry would reply, "They are fat little devils, but they are real sweet." (Assume he was referring to the

bananas.) The yard is now gone, and a beautiful new house was built where each year the trees emerged from the basement. A banana tree remains on the northeast corner of Griggs and Sycamore Avenues and at the Thibaut house on Mohawk Street, where many exotic plants (including delicious figs) and banana trees grace the landscape.

HEY HEY BAR AND GRILL (361 EAST WHITTIER STREET)

This location has housed a saloon since it was constructed around 1900 for the Hoster Brewing Company. A.C. Ebner was the first proprietor of the saloon and was said to have established the first beer garden in the area (a claim that might lead to a few heated discussions in the early 1900s on the south side of town). The bar was managed by a number of people until 1915, when Andy Fisher purchased it from the Hoster Brewery.

Tim and Sue Gall, the current and longtime owners, can relate the history

The Harmony Milk Sign was recently revealed on the building next to the Hey Hey.

of the landmark—especially its unusual name. With the coming of Prohibition in 1919, the saloon became a "lunchroom." The windows were covered over, and officially, card players filled the space. Of course, as with most liquor establishments in the area, bootleg liquor was readily available to the customers. Tim and Sue Gall pinpoint the hayloft in the adjacent barn to the south as the hiding place for prohibited alcohol, probably brewed in the neighborhood. The "lunchroom" kitchen was on the second floor, and a dumbwaiter device connected this space with the kitchen. It does not take much imagination to suggest other uses for the dumbwaiter. During Prohibition, bootleggers

supplied the beer, quietly knocking on the door and saying, "Hey, hey, the beer is here." When the Eighteenth Amendment was rescinded in 1933, the bar was renamed the Hey Hey.

A noteworthy event at the Hey Hey was the end of the *Columbus Dispatch* printers union. The final meeting to dissolve the union was presided over by the union leader, Gus, whose favorite saying was, "I'd rather see a church burn down than a beer left on the bar." He was kidding, of course. The favorite gathering spot for many occasions, the Hey Hey is famous for its sauerkraut balls. Currently, the Galls are in the process of uncovering an old wall sign next door. Ironically, it is not for beer but for Harmony Milk and is in pristine condition.

LINDEY'S/THE LINDENHOF/THE PALMER HOUSE/THE KING'S ROSE GARDEN (169 EAST BECK STREET)

The two-story brick building at the corner of Mohawk and Beck Streets is now Lindey's, a restaurant known for its fine cuisine. However, the building has not always been a restaurant. Since 1884, the building has held a grocery (Art Daeumler's Grocery), a saloon (Daeumler and Oldhausen) and, in the early 1900s, a bar named the Tide House Saloon (owned by the Gambrinus Brewery Company).

Later it became the King's Rose Garden, a neighborhood bar with a tough reputation. In the 1950s, the saloon was notable for the bloodstains on the limestone steps at the front door. The bloodstains were reputedly the results of knifings. Pat Phillips, a student at St. Mary's High School, two blocks to the south on Mohawk Street, remembers the day the bus driver stopped the school bus because of a gunfight outside the bar. Reportedly, over thirty shots were fired.

Phillips also remembers playing euchre in the Rose Garden. Euchre playing was a standard activity in the neighborhood bars in the 1950s and 1960s, whether it was at the Beck Tavern, where the booths had slates glued to the tables and the bartender supplied the chalk; Deibels; or the Hey Hey. At the Rose Garden, Phillips and his friend Joe Grispino were playing cards (and probably cheating) with two West Virginia men who had come to Columbus to find work when a woman entered and shouted to a man at a nearby table, "Losing your paycheck again?"

He replied, "Aw, go away." She pulled out a gun and shot him dead.

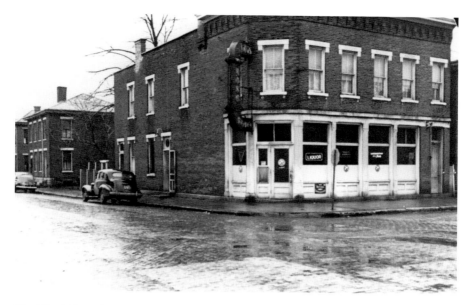

The King's Rose Garden, now Lindey's, was once known as the "Bucket of Blood."

Lindey's, opened in 1981, is one of the finest restaurants in German Village.

The King's Rose Garden, also nicknamed the "Bucket of Blood," transitioned from a local bar to the Lindenhof, then to the Palmer House and to Albert P. Grubble's in the 1970s. In 1981, it became Lindey's, though not without controversy. Expansion plans, like those of many businesses located in residential neighborhoods, were often contentious—business expansion at the detriment of the residents' enjoyment of their homes and neighborhood. Neighbors' complaints include limited parking, noise, 4:00 a.m. trash pickup, litter and semi-trailer delivery on narrow streets, but the merchants insist it is money to the community.

MARKHAM THEATER (1320 SOUTH HIGH STREET)

Neighborhood movie theaters were an important part of the life of the community. The South Side had several landmark theaters, but perhaps the grandest was the Markham on South High Street at Moler Avenue. The gala opening on October 11, 1937, saw lines of people fifteen deep around the entrance. The *Columbus Dispatch* described the interior as "done in dubonnet and cerulean blue with touches of silver and dusty pink." The men's and women's restrooms had fireplaces, and on either side of the projection booth were "crying rooms," smoking rooms and a room for the hard of hearing. Each room seated forty-eight people.

The 1937 opening featured *Artists and Models*, starring Jack Benny. Perhaps more important to the men in the audience were the newsreels that covered the Yankees-Giants World Series. It was the second year for Joe DiMaggio, and the last year for Lou Gehrig (who died of ALS). It was also the final World Series game for Carl Hubbell, the Giants' Hall of Fame player who also gave up Lou Gehrig's last home run. The newsreels included the Ohio State and Southern California game where OSU lost by one point.

Pat Phillipps considered the Markham Theater a landmark for an entirely different reason. Early in the 1940s, big brother Ray was told to take his five-year-old brother Pat to the movies with him. Pat remembered the feature was a Frankenstein film, though Pat did not recall which Frankenstein film. Ray became so frightened that he ran home, entirely forgetting his five-year-old brother in the theater. By the 1970s, the theater had developed into an X-rated movie theater, and it was eventually demolished and replaced by a funeral home.

MAX AND ERMA'S/ ANNIE KAISER'S/ LAMPRECHT'S HALL (739 SOUTH THIRD STREET)

Lamprecht's Hall was built in 1889, named after Tobias Lamprecht. The first floor held a saloon, the second floor was the family's living quarters and the upper floor was used as a hall suitable for banquets, lectures or simply as a "fest" hall for good times. Tobias's niece Annie Kaiser later owned the building, and even into the 1950s, the saloon's first floor was known as Annie Kaiser's.

The original Max and Erma's restaurant opened in 1972.

There were many tales from the locals that it was a comfortable spot where the television was generally tuned to soap operas or wrestling. The clientele that lived across the street sometimes went out their own back doors as if they were heading elsewhere, only to circle around a number of blocks to head into the back door of Annie Kaiser's to take up their spots at the bar. Their disappearance was obvious to their wives. Small neighborhood boys were sent by fathers and uncles to the bar to pick up a bucket of suds. During Prohibition, the downstairs was converted to a grocery store.

In 1958, Max and Erna Visocnik purchased the building, working six days a week to carry on the saloon, while living upstairs. In 1972, German Village resident Barry Zacks bought the business, creating a trademark family-friendly restaurant that featured gourmet burgers, an ice cream self-service in a claw-footed bathtub and an interior filled with stained-glass lamps and Columbus-themed nostalgia. This was the flagship for the more than one hundred Max and Erma restaurants in the country.

MOHAWK RESTAURANT (819 MOHAWK STREET)

A large number of commercial establishments in what is now German Village started as saloons. Many became groceries, restaurants or confectioneries during Prohibition, and when Prohibition ended, they returned to being saloons. The Old Mohawk (also known as the Olde Mohawk, the Mohawk Grill or the Olde Mohawk Grill) was no exception. At times, the building held two businesses simultaneously. Ferdinand Thomas, the great-grandfather of the current neighborhood mailman, Ed Thomas, started a grocery in half the building (819 Mohawk Street) in 1905 and started a saloon in the other half (821 Mohawk Street).

For a time, the building was vacant in Prohibition until U.S. Stores opened a grocery, reportedly selling liquor out of the backroom, as did most of the converted saloons during Prohibition. In the early 1930s, Spencer's Malt and Hops Shop and Saunder's Confectionary operated out of the building. Malt and hops sales were perfectly legal, and Columbus seems to have developed quite a taste for "near beer." Wasserstrom's Restaurant Supply Sales (located in the Brewery District) made a name for itself by selling beer-making apparatus during Prohibition. Though it makes a colorful story, gangster Al Capone did not hang out at the Mohawk.

With the end of Prohibition in 1933, Myles Elk, a five-hundred-pound giant of a man, rented the storeroom at 821 Mohawk, opening Elk's Tavern and selling beer and hard liquor. John Sauer, a neighborhood kid, remembered hearing his father say he was going to the Elks, and assumed at the time, his father meant to Brotherhood of Protective Order of Elks lodge. Elk enlarged the tavern in 1936 when he took over 819 Mohawk Street and installed a horseshoe-shaped bar that is there to this day. The tavern was known throughout the city for its Friday specials: fried snapper and turtle soup. Even children who were not allowed in the tavern by their parents lined up at the backdoor with a cooking pot, money wrapped up in a tissue, to buy turtle soup for Friday-night dinner.

Doral Chenoweth, restaurant reviewer for the *Columbus Dispatch*, recalled a trip to the Mohawk for turtle soup with his friend and *Columbus Citizen Journal* columnist Ben Hayes. Hayes went into the basement where the turtle meat was scooped from the shell, taking the shell back to his office. The shell became a pencil and paper clip holder on the desk of the bureau chief of the United Press International. There was live entertainment at the Mohawk on weekends, and Ed Thomas remembered his young cousin Michael Thomas singing the "Wiffenproof Song," accompanied by another neighbor, Faris (Bob) Edington in the 1950s.

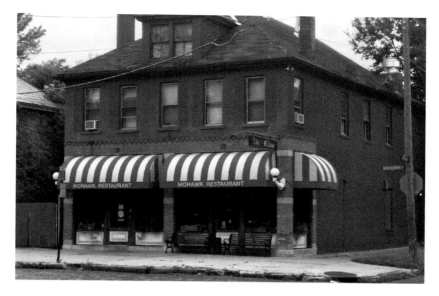

The Olde Mohawk Grill was open during Prohibition and secretly served alcohol.

The much-beloved Blarney Stone of the Irish community was originally found in the backyard of Jack Dempsey, who lived in what is now German Village. According to Mark Dempsey in the book *Transplanted Shamrocks*, his uncle Jack grew tired of ruining lawnmower blades on what he thought was a small rock in his backyard used as a home plate. But when he and his brother Edward (Red) Dempsey (Mark's father) began to dig, they unearthed a four-hundred-pound rock. They celebrated their find at the Olde Mohawk Grill, taking the dirty boulder with them on a dolly and putting it on the bar. Word spread quickly about the "miracle" find, and many came to see it for themselves. However, after several days of sitting on the bar, the owner offered free drinks for those who would remove it.

Someone actually lifted the rock off the bar, but it slipped, crashing through the floor to the basement below. The Mohawk's owner had it removed, painted it a disgusting shade of green and the Columbus Blarney Stone (an icon of the Shamrock Club) became official, dedicated in 1968 to the Irishman of the Year. Each subsequent Irishman of the Year must maintain the rock (at an office or favorite establishment) during his year of service. Thus did turtles give their lives for a German rock that became an Irish tradition—all at the Mohawk.

Plank's on High Street, also known as Plank's Bier Garten, opened in 1939.

PLANK'S (888 SOUTH HIGH STREET)

In 1920, the land on the corner of Whittier and South High Streets was owned by the August Wagner Realty Company (see Gambrinus entry), and the building was constructed in 1930. Walter had started the Plank's Café on South Parsons in 1939, and at some point, he gave the business to sons Walter and Willy. Willy purchased Grundy's on Whittier and High Streets and renamed it Plank's Bier Garden.

The Plank family also owned Thurn's Bakery, which would become Reiner's. Willy's wife was Marilyn Thurn. Mary Plank, a family member who still helps out in the kitchen on Parsons Avenue on weekends, recalled, "I was one of eighteen first cousins, so holidays at my grandmother's home on Oakwood Avenue were incredible."

Confused as to who is connected historically to which Plank's? Suffice to say that the Plank's restaurants are family owned. Plank's on Parsons is sometimes called "the Corner" (though both are on corners). Plank's Café is extensively chronicled in the book *The Corner*, by Walter H. Plank and Nancy Plank Kelley. Plank's on High is the softball players' mecca (as if the other one was not?) and is known for its outstanding pizza.

PLANK'S CAFÉ (743 PARSONS AVENUE)

Since 1866, the building on the corner of Sycamore Street and Parsons Avenue has always been (in one form or another) a saloon or restaurant, except for the years 1919–33 when Prohibition forced such pretenses as Manns' Ice Cream Parlor, which served soft drinks. There have been a series of owners with names familiar to south siders—Thum, Deibel, Wolf, Winkler, Elbert, Manns (the current family), Lieb and finally Plank. In 1939,

Walter and Loretta (Manns) Plank purchased what was then Manns' Café from Loretta's brother Ed after Ed's partner, Frank, died.

Plank's Café is and was the quintessential neighborhood bar where "everybody knows your name." Clientele included the mailman, who was also the coach at the local elementary school; the attorney who insisted that legal papers were best signed at Plank's (because Plank's had the best blue ink pens in town); an owner with major sports credentials; sports broadcasters as bartenders; and the family of waitresses and bartenders, many of whom had worked at Plank's for thirty-five years or more.

Walt Plank was himself a well-known athlete, bowling a three-hundred game in league competition in 1915. There have been family-and-friends euchre tournaments and meetings of numerous clubs, like the Agonis, the Optimist and Kiwanis clubs. Classes (South, St. Charles, Aquinas, Wehrl and Hartley High Schools, as well as Corpus Christi grade school) still meet there. Sports, in general, and Ohio State football, in particular, take center stage in the fall. The pep rally before the Michigan-Ohio State game draws in the Buckeye Boosters, the Ohio State Marching Band and the Ohio State cheerleaders. The Big Red Ohio State Bus provides rides from Plank's to the home games at the Ohio Stadium. At various times, over the years, Ohio State coaches Woody Hayes, Jim Tressel, Thad Matta and Eldon Miller all enjoyed the atmosphere. Even Michigan fans are welcome.

RECREATION PARK (NORTHSIDE OF EAST WHITTIER STREET BETWEEN JAEGER AND KOSSUTH STREETS)

The original Recreation Park was located in the Parsons Avenue/Mound Street neighborhood, an area that is now part of the I-70/71 interchange. The Recreation Park was the home field of the Columbus Buckeyes, a major league franchise (American Association) in 1883 and 1884. The team was remarkable for its pitcher, Ed (Dummy) Dundon, a deaf player who was a resident at the Ohio School for the Deaf (see Ohio School for the Deaf entry). The school was the first residential high school in the United States to have a baseball club.

The Ohio School for the Deaf team, the Columbus Independents, contributed several players to the majors, each usually carrying the nickname "Dummy," which in those days was considered descriptive, not pejorative.

In 1879, the touring school club had a 44–7 record against major league clubs, including Cleveland and Cincinnati. While in the majors, Ed Dundon was credited, along with others—including William (Dummy) Hoy, also a major leaguer from the Ohio Deaf School—with developing the umpire hand signals that are used today.

With the demise of the Columbus Buckeyes in 1884, the stands at the original Recreation Park were dismantled and the wood was used to rebuild the stands at Recreation Park II, at the corner of Schiller (Whittier) and Jaeger Streets. Here the park was simply known as "the Recky." The original Recreation Park would have been in the backyard of author James Thurber, who was an excellent athlete at East High School and also a huge baseball fan. His short story written in 1941, "You Could Look it Up," was about a midget on a major league baseball team. The story is said to have influenced Bill Veeck, owner of the St. Louis Brows, to insert Eddie Gaedel, a three-foot-tall man, into a game in 1951.

Though Thurber did not have a chance to play ball in Recreation Park II, the park did have a ball-eating horse that could have come from a Thurber short story. Joe Santry, Columbus Clippers historian, relates the story of the horse, the Columbus Buckeye Team mascot, which lived in a stable at Mound and Monroe Streets behind center field. The horse would mistake any ball hit his way for an apple, chomping down on it and preventing the opposing outfielders from retrieving it. Fortunately, Columbus outfielder Fred Mann (see Plank's Café entry) was known to the horse, which allowed Fred to take it out of his mouth.

Unfortunately, the memories of the original Recreation Park are buried under the Interstate Highway System, and Recky II has more recently become a Giant Eagle grocery store and parking lot. However, a historic plaque notes that the first OSU football game was played on the site on November 1, 1890. OSU lost to Wooster, 64–0.

SALLY'S FLOWERS (246 EAST SYCAMORE STREET)

Beginning in 1910 and continuing through the mid-1950s, 246 East Sycamore has housed a grocery, a confectionery and the Sycamore Kraut Pickle Company (located in the rear of Fleshman's Grocery). In the 1950s, there was a TV repair shop, a venetian blind cleaners, a flower shop and a gift shop. The parade of businesses ends with a series of offices to the present time.

The enterprise that stamped "landmark" on this fine example of post-and-lintel architecture was Sally's Flower Shop, owned and operated in the 1960s by local television personalities Sally Flowers and Jerry Rasor. The noted columnist the late Ben Hayes described Sally as "by far the biggest happening in Columbus TV during the small screen era."

The size of her following was extraordinary. Her most popular show was *Meetin' Time at Moore's* on WLWC, Channel 4 in Columbus in the 1950s. Moore's was a general store/hardware store that served as background for a country western theme. Billy Scott was the featured performer, accompanied by Charlie Cesner on the organ. The show lasted until 1958 and would feature special guests, like Roy Rodgers and Dale Evans. Sally's second popular TV show was *Bowling for Dollars*, co-hosted with Gene Fullen. Her immense popularity caused a tremendous buzz in the neighborhood where her flower shop was located. Sally (Lillian Nixon) died in 1989 at the age of eighty-one and is buried in Green Lawn Cemetery.

SCHWARTZ'S CASTLE (492 SOUTH THIRD STREET)

Built by a pharmacist in 1880, the castle-like house is prominently located close to Livingstone Avenue on South Third Street. Contrary to urban myth and popular opinion, Dr. Frederick William Schwartz (1836–1914) was not crazy, not a recluse, not an astrologer, not a mystic and not in mourning for a long-lost love, but he may or may not still be around as a ghost.

He may have built the house in a style that reminded him of his native Germany. He was, however, a man ahead of his time—a naturalist, a vegetarian (always viewed suspiciously by carnivorous nineteenth-century Germans), a sun worshipper, a walker for health (really suspect in the nineteenth century) and a pharmacist who appreciated a healthy lifestyle. His drugstore was at Main and Fifth Streets, and one of his assistants was George Karb, who would become mayor of Columbus, originator of the slogan "Good Old Columbus Town" and guardian and executor of Schwartz's will when Schwartz died on May 11, 1914.

Schwartz lived with his sister in the house, but they did not entertain, so when people occasionally caught a glimpse inside through a partially opened door, they judged Schwartz on what they saw (or what they thought they saw). The walls were covered in quotes from literature and song,

inspirational sayings and pieces of poetry in German, the language that obviously reminded him of home. The house did have several basements, but they were used to store and dry herbs.

Contemporaries and later generations would translate this as the house was filled with hidden panels, trapdoors and secret passages. He drank only rainwater (quite wise considering Columbus's cholera problems) and ground his own grain (since wheat was often mixed with alum at this time to cheat consumers, Schwartz was wise not to trust grain). In time, after Schwartz's death, the house became a maternity hospital for a short time and then a rooming house.

By the 1960s, with freeways and urban renewal plans nibbling near German Village, the house became more decrepit, the roomers more down on their luck and the rumors of ghosts, murder and mayhem more rampant. It did not help that the murder of a homeless man in the house and a second murder between roomers remained unsolved. Neighborhood scalawags, especially those who knew from their grandparents that Schwartz was known to sunbathe in the nude in his glassed-in-tower, believed it all and made up more. Today, the lower three floors are law offices and the upper floors are a condominium. If indeed there is a ghost that roams the ramparts, it might perhaps be the only nighttime-appearing, sun-bathing apparition in the country.

St. Mary's Church (684 South Third Street)

St. Mary's parish was formed in 1865 when the Catholic population of the South End had outgrown the Church of the Holy Cross at Rich and Fifth Streets. Holy Cross started in the 1830s for "a few German and Irish residents and farmers living in the vicinity and laborers on the National Road," according to diocese history. Father Specht, who was ordained in 1864, was an assistant at Holy Cross and was assigned the task of organizing the new parish of St. Mary's.

Father Specht formed the new St. Mary's Church in a four-room building in what today is called the Specht Center, built to house the church and an elementary school in the first-floor rooms and the priest's quarters in the two second-floor rooms. The cornerstone of the new church was laid in 1866, and the dedication ceremony began with a procession from Holy Cross led by bands from Dayton, Newark, Zanesville and the local Hemmerschaft's band.

St. Mary's was designed in Gothic Revival style by architects Blackburn and Koehler at a cost of $40,000. The building was 140 feet in length, with side and front buttresses to reinforce the Gothic style. Three bells were added in 1870, a pipe organ in 1875 and a spire in 1893, bringing the total height to 193 feet. A year later, a clock was added to the tower. Frescoes were painted by Wencelaus Thein and William Lamprecht, and oil paintings were added to the side altars in 1867. In 1874, the school was staffed by two Sisters of Notre Dame. The next year, the long association with the Order of Saint Francis of Mary Immaculate in Joliet, Illinois, began. Father Specht was the pastor of St. Mary's until his death in 1913.

In 1906, he asked Bishop Rosecrans to assign a young priest, Father Edmund Burkley, to be his assistant "for a little while." Father Burkley would stay until his death in 1972. Father Joseph Wehrle was pastor from 1913 until his death in 1924. One of his significant acts of pastoral ministry was the founding of St. Mary's High School in September 1914. The high school was housed in the Ohlnhausen home, just north of the church. A one-story addition, affectionately known as "the bungalow," was added to the rear of the original building in 1921. A new school building was added in 1887 on Mohawk Street, doubling the capacity to nine schoolrooms.

Father Edmund Burkley was a son of the parish, having a relative, Anton Brun, who was a founding member of the parish. Father Burkley, born in 1880 on Front Street, was baptized and schooled at St. Mary's. As a young priest, Burkley was struck with typhoid, and death was so certain that they measured him for a coffin. Having served the parish for almost seven decades, he was foremost the spiritual leader of the community, as evidenced by his Mass schedule. Parishoners Ray and Terry Thomas recalled the 3:30 a.m. Mass on Sunday to accommodate the odd work shifts of the newspaper printers, followed by the 5:00 a.m. for railroaders and other workers who had early Sunday shifts. Assistants who helped with the early Sunday schedule would hang a white towel from a second-floor rectory window to mark an early Mass, and if the church wasn't opened when servers arrived, they were to throw stones at the window to wake up the assistant but never, under any circumstances, tell Father Burkley the assistant had overslept.

August Wagner, the brewer, also made sure that Father Burkley had a steady supply of Gambrinus beer, delivering it right to the rectory on the playground (see Gambrinus entry). Having married, baptized and buried generations of families, Father Burkley also coined the phrase "Grand Old St. Mary's," based on the similar phrase of Mayor George Karb's, "Good Old Columbus Town," but his real legacy was St. Mary's grade school and high school.

The steeple of St. Mary's Catholic Church is a landmark for all of German Village.

Father Burkley's influence is inextricably linked with the school. Every child has seen the home movies taken by Father Burkley at every important church and school function. Sister Miriam Joseph recalled, "His interest in the school children was unique…The year-by-year stacks of movies attest to that. I recall how the graduating seniors chuckled and laughed at themselves as Father Burkley showed them movies of important events from tot to young adulthood while at St. Mary's." Every year there was a production for Father Burkley, on his name day, in the school auditorium.

Each class performed, usually a religious hymn or small play. One particular year, Ed Quickert was chosen to sit on the stage in a great chair and play Father Burkley. The program always ended with the whole school singing a song to the tune of "The Bells of St. Mary's," and the last line was "…and so Father Burkley once more, happy name day, St. Mary's bells ring out, ring out for you today." It was a pleasant memory for Ed Quickert, who also remembered a not-so-pleasant memory surrounding the new elementary school.

On July 31, 1955 the first spade of ground was turned over for the construction of a new $400,000 elementary building on South Third Street. On April 26, 1956, Quickert was serving for the blessing of the new ten-foot marble statue of Mary that was being fixed to the front of the new grade school building. Father Burkley had traveled to the quarry in Carrara, Italy, to select the stone and choose the design for the statue. The statue was on the bed of a truck. A harness was put around the statue, and the crane started to lift the statue into position in preparation to fasten it to the building.

There was a cracking sound. The statue broke in half. Father Burkley's eyes glistened with a tear. Quickert said he never walks by the school without remembering that day.

The high school was the first four-year parish high school in the city, closing in 1968 after graduating fifty-one classes. The grade school remains the oldest parochial elementary in the city. The Sisters of the Order of Saint Francis of Mary Immaculate of Joliet, Illinois, the teachers in St. Mary's, said of Father Burkley, "He admonished, 'Sisters, love your classes.' We went forth….We simply worked on it, never questioned what the reward." Father Burkley, the gentle soul of Grand Old St. Mary's, passed away in 1972.

SCHILLER PARK (BOUNDED BY DESHLER AND CITY PARK AVENUES, REINHARD AND JAEGER STREETS)

Once known as Stewart's Grove, a privately owned land that was often used by the German community for picnics and shooting "fests," Schiller Park is Columbus's second-oldest park (see Goodale Park entry). The twenty-three acres of park grew from a wooded area on the fringe of the city's limits to an official park purchased by the city. From here, the first July Fourth celebration was organized in the 1830s, and Captain Zirkle prepared a regiment to fight in the Mexican War in the 1840s.

The grounds were the site of the city's first *saengerfest* (singing celebrations or singing contests) in June 1852. Saengerfests were very popular in German communities, as were all things to do with literature, poetry and the printed word, since the German language was a common denominator among the German-speaking communities across Europe that had no country of their own until the late nineteenth century. In the 1860s, Schiller Park was the site of the Ohio State Fair.

In 1867, the city purchased twenty-one acres, much still in woodland, for $15,000 from the Deshler and Thurman families, christening the land City Park on July 4, 1867. It would be another two decades (1891) before the Johann Christoph Friedrich von Schiller statue made its appearance. Completed by a Munich bronze firm for $6,500, the statue has been considered to be one of the most important bronzes in Columbus, and subsequently, the park became Schiller Park.

In the 1870s, City Park had a zoological garden of an eagle, buffalo, bears and foxes in the southwest corner. A smaller zoological park remained into

An early photo from the 1890s showing the rustic bridge over the pond in Schiller Park.

the early twentieth century. A romantic-looking bridge spanned a pond where fishing was allowed. In 1871, Prince Alexander von Lynar and a small retinue of German imperial officers, in town for the German prince's wedding to local May Parsons, planted a peace oak tree to honor the end of the Franco-Prussian War or perhaps his coming marriage. Versions vary depending on how romantic or militaristic one wishes to be.

The choice of Fourth of July for both the park dedication and the dedication of the statue are significant because Germans truly saw the holiday (and its non-religious connotations) as significantly in sync with why they came to the United States; a lack of freedom of religion had kept Germans divided since the Reformation into more than two hundred small principalities, imperial cities and sectarian kingdoms.

St. Mary's students annually decorated bicycles and paraded to the park in May for games, each student wearing a small tin cup on a chain around his/her neck to be able to participate in the three lemonade offerings when volunteers rang a hand bell. Children swarmed the big wooden barrels of lemonade with large blocks of ice floating in them. The day began with Mass at the church and a procession of the entire school down the middle of South Third Street led by a police escort. In addition to the bicycles, mothers pushed baby carriages. Games were played, but Sister Eudora was hard to

beat in the softball throw. Father Burkley was always in the background with a movie camera.

In World War I, the name of the park was changed to Washington Park in an act of patriotism, but the Schiller name resumed in 1930. In the Depression, WPA workers also built the caretaker's home, and over the years, active neighbors and Friends of Schiller Park helped to create and maintain the large perennial flower beds, the recreation of a historic *Umbrella Girl* statue, tree plantings and the performance area where Shakespeare in the Park is staged.

Schmidt's Restaurant (240 East Kossuth Avenue)

Today visitors to Schmidt's eat dinner in the 1890 building that was once the livery stable, processing plant and meatpacking business for German immigrant Fred Schmidt, who started the business in 1886. The animal pens were across the street (Schmidthoff condominiums now occupy the site). Into the 1950s and early 1960s, an occasional escaped steer or pig careened around the corner seeking freedom.

The livery stable was one of the few parcels not liquidated when the packing business closed in the early 1960s (seems as though having animals—especially those that escaped—was no longer permitted within the city limits). Schmidt's opened a stand at the Ohio State Fair as early as 1914. The restaurant that is known today on East Kossuth opened in 1967. The business grew greatly under the supervision and vision of George Schmidt, Fred Schmidt's grandson, who was also a navy pilot in World War II. He is credited with being a major advocate for the Octoberfest festivities, and many of the paintings in the restaurant were done by him.

Schumick's Market/Hausfrau Haven (765–771 South Third Street)

The landmark building with the landmark business, Hausfrau Haven was a gift and wine shop founded by the iconic team of Fred Holdridge and Howard Burns in 1960. In addition, a laundromat occupied the northern section of the building (presumably wine and soap suds helped to give it the name "Hausfrau Haven").

The site had many tenants before Fred and Howard, as they were known to most of the city. In the 1890s, Adam and Joseph Sauer's Meats was side-by-side with saloons owned by Martin Heimann (1891) and Conrad "Coonie" Bauer (1911). They were the first in a long line of businesses. Sauer's Market became Schumick's Market in the late 1950s—and even if there had never been a Hausfrau Haven, Schumick's Market deserved the title of "landmark" because of its proprietor, Anton (Tony) Schumick.

Schumick was the quintessential nice guy, a great family man and a tireless worker for his church, schools and community. But he also had a little bit of the devil in him. One of the neighborhood urchins (Larry Wolfe) related the times when he and his mischievous friends would open the front door of the market, yelling, "Tony baloney, Tony baloney," and run out the side door to Columbus Street.

Tony, in his bloodstained butcher's apron, grabbed a meat cleaver and gave chase. According to Wolfe, "And when he caught us, it was straight back to the meat counter for a fresh piece of liver held within an inch of our noses until we promised never to do that again. Of course, we promised and, of course, we did it again and again. It was our way of saying, 'We love you, Tony.'"

On other occasions, Larry Wolfe (again) came in with a meat order for his mother—a meat order that required the use of the band saw. Tony, and his equally ornery sidekick, Herb Brooks, would team up to scare the daylights out of an unsuspecting child. Starting the band saw, Tony would then scream in pain, Herb would run over with a small piece of liver hidden in his hand that he then dangled off the tip of Tony's supposedly missing finger and come close to the unsuspecting child as they could to give maximum terror.

Wolfe summed up these adventures when he said, "Growing up on the near south side, in what is now German Village, during the 1960s was a real treat. It was a different time and place in many ways, and the charm that is now 'the Village' is no match for the closeness of the neighborhood we experienced then. Everyone seemed to know one another, and don't dare 'embarrass' your family name for fear that message would reach home. The neighborhood had real characters with real jobs and real families, and if you were 'one of us,' it was special."

STEWART AVENUE SCHOOL (40 STEWART AVENUE)

Despite the fact Ohio claimed to support free public education in the early nineteenth century, public schools struggled because the Ohio legislature

Originally, the Stewart Avenue School was called the New School.

had used money from the sale of lots to be put into the general fund. In 1821, the legislature permitted local communities to establish public schools, but with no money. Public schools were compelled to charge tuition. In 1845, the first school board in Columbus was established, and Dr. Asa Lord, a nationally recognized educator, created a graded school system of primary, secondary, intermediate, grammar and high schools (actually, just one high school: Central, located on East Broad at Sixth Street).

All of the historic mid-nineteenth-century buildings have been demolished over the years. Stewart is one of two of the oldest remaining buildings (Second Avenue School in Italian Village is the other). Stewart was built in 1873 at a cost of $21,074 with an addition in 1893, costing $12,700. When it opened in 1874, there were fifteen rooms to be used by 444 students and thirteen teachers. Classes were taught in German (see Third Street School entry). Stewart's design reflected the preference for Italianate style in a rectangular form with an E-shaped floor plan to create light wells for maximum light and ventilation. At this writing, the building is under extensive renovation.

TEEZ BEAUTY SHOP (764 MOHAWK STREET)

In 1898, the building at 764 Mohawk was the tailor shop of Max Neugenbauer, who was also the manager of the Columbus Battalion Band, located at the same location. In the latter part of the nineteenth century, bands such as his were in high demand. Visiting dignitaries would be met at

Unlike most neighborhood businesses, this 1898 building was never a saloon.

the train station and escorted to their destination by one or more bands, depending on the religious, civic or cultural nature of the visit. Most functions, public and private, had a band as a main source of entertainment, and concerts in a park were a regular Sunday activity.

A daughter of St. Mary's Parish, Sister M. Rosella Girard O.S.F. remembered an occasion in the 1920s: "The Max Neugenbauer [Columbus Battalion] Band still sends chills up my spine when I recall the sound and volume as it vibrated the whole church interior."

Since the early twentieth century, the structure has seen many businesses pass through, but unlike most businesses that existed in the neighborhood prior to Prohibition, the building was never a saloon. It has been the Clover Farm Store, Orra's barbershop, Mohawk Street Grocers, Mike's Market, Antiques Emporium and, presently, the TEEZ beauty salon. Eddie Quickert, a child in the 1970s, fondly remembers the store as a source of penny candy, pop and camaraderie, and he recalls the owner, Mike, who gave him the nickname, "Fast Eddie." It is funny what will stick in one's memory to create a landmark from a past time and bring a smile, whether it was a blaring band or a silly nickname.

THIBAUT'S GARDEN (668 MOHAWK STREET)

In the 1940s, Henry Thibaut moved from a farm near Grove City to Mohawk Street in what is now German Village. Mr. Thibaut had a garden in the 1940s and 1950s that would certainly qualify for a contemporary

German Village Haus and Garten tour. Mr. Thibaut, whether it was from his farming background or because of the size of his family, had a garden to put present gardens to shame. On his lot were three hundred tomato plants and assortments of other vegetables. But even a garden of this size and this impressive would not linger long in memory if it were not for an epic battle that erupted on that site one hot summer day in the early 1950s—"Chief Victorio's Apache Massacre," subtitled "The Bloody Ambush at Macon"—a neighborhood children's battle of rivals.

Some say it was the fault of the dreaded Beechy gang (rumored to be troublemakers) who descended from the north near Livingston Avenue and passed through Macon Alley on their way to Schiller Park. Perhaps it was taunts from them cast at the innocent young boys playing cowboys and Indians in the Thibaut backyard. However it started, it was meaningless once the first tomato was thrown.

Then another flew by, and another, and another. The resulting barrage and the counter barrage continued, pillaging three hundred tomato plants. The wrath of Mr. Thibaut caused the Beechy boys to scatter and left Chief Victorio, the boy who lived closest to the Thibauts, to face the music alone. According to him (and he still lives nearby), he was not allowed in that yard until 2006, five decades later.

THIRD STREET SCHOOL (630 SOUTH THIRD STREET)

The Golden Hobby Shop is the current resident in the building that began as the German-American School in 1866 for a cost of more than $15,000 on a site that cost $1,400. There were eight rooms for 287 students and nine teachers. Charlotte Olnhausen was the principal (see St. Mary's Church entry for a connection to Olnhausen), and it drew students from an area bounded by Liberty, Hoster, Jackson, Sixth and Frankfort Streets.

By the end of the nineteenth century, the German lobby in the Ohio legislature was strong enough that legislators conceded to the demands of Cincinnati and Columbus Germans and radically altered public education in Ohio. All school subjects in German communities from primary through high school could to be taught in German. (The Ohio legislature also agreed to publish all laws and ordinances in German, as well as English.) Four schools in Columbus, including Third Street School, taught in German until World War I, when German became an elective subject rather than a requirement.

The Third Street School was one of four schools on the south side that taught exclusively in German.

By 1937, the school became the Third Street School for Crippled Children. Later in the 1940s and 1950s, the school was designated for girls with learning disabilities. The school closed in 1976, and the building was used as an arts center until it was sold to the City of Columbus. Columbus Parks and Recreation Department maintains the building as the popular Golden Age Hobby Shop, accepting consignments from older artists and craftsmen and staffed by volunteers.

THURMANIA THEATER (210 THURMAN AVENUE)

The Thurmania Theater opened in 1912 and was one of the earliest movie houses in the city. In 1926, the marquee declared, "Showing the Very Best of Photoplays…First Run in the South End." The 525-seat theater was, at one time, run by Johnny Jones, noted *Columbus Dispatch* columnist and pundit whose "Now Let Me Tell You" column was a favorite for *Dispatch* readers for four decades. Jones also managed the Majestic and Southern Theaters. Miss Zoe Fogg, one of the very best vaudeville and silent picture piano players, played regularly at the Thurmania.

Since closing in 1944, the theater has been a pharmacy, a doctor's office and an art gallery/gift shop. The Latvian Supper Club was located in the basement. Part of the building has been converted to apartments, and neighbor Frank Wickham reported seeing an area that may have been part of the original theater covered with what might have been Remington tile. Current plans call for a 26,000-square-foot emporium with several vendors, a wine and cheese shop in the basement and apartments in the back.

NEAR EAST SIDE, KING-LINCOLN, BRONZEVILLE AND OLDE TOWN EAST

ALPHA HOSPITAL SITE (893 EAST LONG STREET)

It was a coffee shop with a bright future and a little-known past. When Urban Spirits Coffee Shop opened, its history came tumbling out. The renovated building at the corner of East Long and Seventeenth Street had been, for many, hiding a secret past as the Alpha Hospital created by Drs. W.A. Method and R.M. Tribbitt as a private institution in 1920. It was the first of its kind, a hospital in which an African American doctor could fully practice his professional skills, and it was therefore named "alpha" by a contest conducted in the African American community. No hospital in Columbus at that time would permit an African American physician to do so.

African American doctors could practice only privately with fee rates set by the Columbus Academy of Medicine (office calls ranging from one to five dollars) but were not allowed to practice surgical skills in hospitals. Doctors took chickens for fees and saw patients at the Isabelle Ridgway Old Folks' Home and the Phyllis Wheatley Home (once known as the Mary Price Home) for unwed mothers for free. The Drs. Method (who married Isabelle Ridgway's daughter) and Tribbitt purchased an old residence of six rooms and a bath with the intention of remodeling it but soon realized it made more sense to purchase the adjoining property.

The result was offices, consultation rooms, operating rooms, a small laboratory, separate small women's and men's wards, nurses' quarters, baths,

Alpha Hospital was the first hospital where an African American doctor could practice his skills as a physician.

a diet kitchen to prepare special meals, a dining room, a clinical laboratory and a heating plant—all within two stories and a basement.

During the first thirteen weeks of opening, the Alpha Hospital received forty-two cases, thirty-two of which were operative, and many emergency cases. The timing of its opening was critical to the community—flu epidemics were rampant, and many in the community were newcomers from the South. Those on the Great Migration during World War I did not come equipped to deal with Ohio winters. In addition, the hospital provided employment in the community. An art gallery and bookstore now occupy the site.

BROAD STREET

Broad Street, growing eastward from downtown, was the city's "Street of Dreams," where the middle class and working classes hoped one day to live. In the mid-nineteenth century, a few homes were already established. Some were spectacular, like the Kelley homestead, a Greek Revival–style mansion (mentioned in the Introduction). Others were more modest but venerated for their history, like the Taylor mansion, built by the Taylors, who acquired their land as part of the Refugee Tract (land donated by the United States

government to help compensate residents in Nova Scotia and Canada who lost property for siding with the Americans during the American Revolution). The name "Broad Street" seemed most fitting since a wide street with tree-lined inside carriage lanes was said to be the inspiration of William Deshler, prominent Columbus businessman, who visited Havana, Cuba, and marveled at the broad, tree-lined streets and brought the idea home. The carriage lanes lasted until the twentieth century and the age of the automobile, though there are periodic discussions about bringing them back.

The fine residences reflect the prosperity and civic mindedness of the later nineteenth-century Columbus families, like the Queen Anne–style Shedd-Dunn (965 East Broad Street), the Hanna home (1021 East Broad Street), the Godman home (1031 East Broad Street) and the Lindenberg home (1234 East Broad Street). Respectively, these homes were owned by families who helped to found Players Theater; founded a paint company that specialized in ready-mixed paint colors; built a shoe empire and the city's oldest settlement house (that still exists); and made a fortune in manufacturing regalia and paraphernalia for organizations, secret societies, fraternities and lodges. The latter building, the Lindenberg home, became an Ohio governor's residence in 1919 (ten governors lived there over a thirty-six-year period) and is the home of the Columbus Foundation today. From downtown to Franklin Park, the street is a study of architectural styles from neo-Classical Revival to the art deco Royal York Apartments and a lesson in urban history and social changes.

Broad Street Presbyterian Church (760 East Broad Street)

In the early 1880s, downtown churches (those between High and Fourth Streets) wrestled with the matter of members moving out of the increasingly commercial city core. First Presbyterian, the oldest congregation in Columbus, decided to stay in its 1830 edifice facing the Capitol, but it opened a mission on Long Street, east of Garfield in 1884. In 1887, 104 people from the mission organized as Broad Street Presbyterian Church, with 85 percent of them living within walking distance between Washington and Ohio Avenues.

They began a permanent edifice with plans by Elah Terrell—a chapel finished in 1888 and the sanctuary in 1894. In less than twenty years, the congregation was much larger than originally anticipated, and Frank Packard was engaged for plans to expand the sanctuary and to change the interior

appearance from Romanesque to Classical Revival. The expanded sanctuary opened in 1908, and expanded social facilities were completed in 1923. Later additions and remodeling were required as the congregation grew to 2,200.

By the 1960s, though there were many residences surrounding the church, houses had become offices, and fewer members lived close. Membership diminished somewhat. The mission was broadened to serve those both near and far in their particular need. Alterations to the church in 2004–05 more effectively addressed the change of people entering the building from the parking lot in the rear.

BROAD STREET UNITED METHODIST CHURCH (501 EAST BROAD STREET)

Joseph Warren Yost, a well-known Columbus architect, designed the exterior of the church in 1885 in High Victorian Gothic style, a style that was very popular for religious and public buildings in the late nineteenth century. The church used polychromatic masonry materials, contrasting textures, pointed arches and complex gable roofs with dormers, but it is the green serpentine stone that is notable enough to have people often refer to it as the "Green Church." When the original stonework was badly deteriorating, the church undertook the Herculean task of finding replacement artificial stone used along with Columbus limestone and Berea sandstone to mimic the original look of the church.

Victorian woodwork and art glass (some of which was saved from the older Central Church located at East Broad and North Fourth) dominate the interior. The east window was designed and installed in 1908 by the Von Greichten Studios of Columbus, memorializing one of the church's founding members, Mrs. David Gray, who lived in the former Snowden Mansion (now Kappa Kappa Gamma) on East Town Street. President William McKinley was a member, and after his assassination, the memorial funeral service was conducted here. The church is noted for its outreach to the disenfranchised, such as "Bethlehem on Broad Street," a program of shelter and services for homeless families.

BRYDEN ROAD (BETWEEN PARSONS AVENUE AND NELSON ROAD)

Bryden Road starts with a name change at Parsons Avenue: on one side, it is Town Street as it leaves downtown; on the other side is continues as Bryden Road. The same street with two different names supposedly

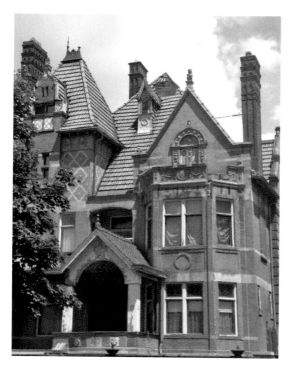

Bryden Road's spectacular homes have given it historic designation.

came about to thwart the expansion of the streetcar. Just as the mansions of Bryden Road were being built, new homeowners found out that the city had signed a contract to expand a streetcar line eastward on Town Street and into their neighborhood. They felt the presence of such a contraption would devalue their properties, but the contract clearly stated the streetcar was to be built on Town Street. Therefore, the residents had the name of the street changed. Both sides are known for their spectacular homes from different eras of prosperity. Original homes on Town Street reflect Columbus's prosperity from the 1840s through the 1870s. Bryden Road's homes reflect the later nineteenth century, an age of prosperity and opulence, housing the former "Silk Stocking District," built on increasingly well-established fortunes. Bankers, architects, manufacturers and politicians chose to showcase their wealth with castle-like homes on Bryden Road. It is said that nearby Broad Street was Judges' Row, but lawyers lived on Bryden Road. Alice Schille, the watercolor artist; James Thurber's grandfather; and Joseph Yost, famed architect, lived on the street. Wealth was gradually moving east.

More than fifty architectural styles can be found along Bryden Road, and many exhibit French, German and Renaissance detailing. The Myers house (1330 Bryden Road) is perhaps the most ornate nineteenth-century home in Columbus, built in 1896 on the fortunes of buggy and carriage manufacturing. The homes have third-floor ballrooms, dining rooms to seat more than thirty people, elaborate entranceways, tall chimneys and taller turrets, meticulously detailed stone and woodwork (both interior and exterior) and the ever-requested French-influenced conical roof (especially if the house

was at an intersection). Though some houses do have sizeable front porches, many exteriors were designed to impress—the fruits of one's labor was in the showcase effect for passersby—not to suggest lemonade on the porch.

The street appears to have been somewhat more democratic than middle-class neighborhoods, in the sense that only wealth mattered and there were apparently no deed restrictions for Jewish families. As wealth continued to move eastward from downtown by the 1960s, the large homes were occupied as rooming houses, nursing homes and businesses. For the past two decades, the preservation of the street's architectural heritage by its neighbors has taken precedence over the social growing pains of a past generation's preoccupation with racism, homophobia or classism.

CARTER SCHOOL OF MUSIC (199 HAMILTON AVENUE)

Helen Carter, an active member of Shiloh Baptist Church, as well as an accomplished pianist, organist and composer of spirituals and choral music, opened a school in 1929. In the 1940s, the Carter School of Music boasted a program of "interracial cooperation" and offered lessons in piano and violin, as well as voice—and lessons in language, history, chorus, conducting and more. Carter died in 1973, but near the corner of East Spring and Hamilton Park, a historic marker tells of the music heritage of the schools, places of entertainment, music shops and music studios of this neighborhood that Helen Carter helped establish as a center of the musical arts in the area once known as Bronzeville.

COLUMBUS URBAN LEAGUE (788 MT. VERNON AVENUE)

In 1910, the National League on Urban Conditions among Negroes was formed to create, in the words of the league, "Not Alms, but Opportunity" for African Americans migrating north. The northern branch in New York and the southern branch in Nashville were committed to emphasizing cooperation with social welfare agencies, training and employment skills specifically for urban life and securing playgrounds and boys' and girls' clubs to help curb delinquency. By 1917, editorials in New York said the group had made significant progress.

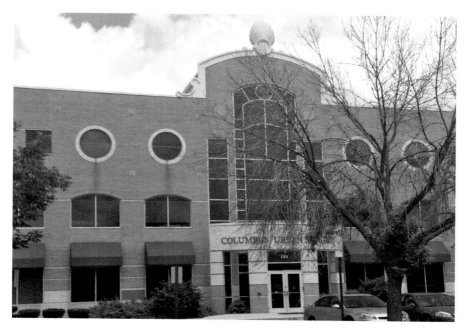

Built in 1994, the Columbus Urban League was founded in 1918.

The following year, the Columbus Urban League became a branch of the National Urban League at the request of R.H. Bondy, secretary of the social service bureau of the chamber of commerce, who noted that the National Urban League was created because "far-seeing white and colored people observed in the great influx of Negroes in cities North and South, the creation of serious social problems which required the study and attack of sympathetic individuals."

The Columbus Urban League is one of the oldest branches in the country. Its first board was composed of Columbus leaders with well-known surnames like Beatty, Jeffrey, Method and (King) Thompson, who focused on finding employment for the unemployed, reducing turnover in workers and providing schools for adults. By 1926, Nimrod Allen, the executive director of the Urban League, reported that the first presidents of the Urban League board were ministers from First Congregational Church and Indianola Methodist Episcopal Church, followed by the chairman of the Race Relations Committee at Ohio State.

Not merely an organization that coordinated social services, in 1924, the Urban League conducted an investigation of the Columbus Police

Department and the City Workhouse and studied three Columbus newspapers and the 1556 articles in them that reported African American news (39 percent of the total space of the papers was devoted to only negative and often highly sensationalized reports). From this study, the *Columbus Citizen* and the *Columbus Dispatch* newspapers pledged themselves to fairness, eliminating the words "Negro" and "Colored" from their headlines. In 1925, it began monitoring the number of African American men and women who served jury duty. The Urban League's most persistent problem was always housing, monitoring uses of Land Contract Agreements, covenants that stipulated against property being transferred to African Americans for twenty-five years unless all owners in the covenant agreed.

First started in a storefront on East Long Street, the present Columbus Urban League was built in 1994.

EAST HIGH SCHOOL (1500 EAST BROAD STREET)

Originally constructed in 1922, this historic building has been equipped for twenty-first-century learning and was the first newly remodeled building in the Columbus City Schools in 2008, part of the campaign to preserve and reuse the district's historic school buildings. The building was originally designed by Howell and Thomas, a Columbus architectural firm that later relocated to Shaker Heights, Ohio, and helped to plan and design Shaker Square. The previous East High School had been built in 1899 on Franklin Avenue.

The building was one of five new high schools (Central, South, North, East and West) that were needed as two important pieces of legislation affected education. The Smith-Hughes Act provided federal funding to offer training in agriculture, domestic sciences and industrial arts and required additional and specially designed spaces; the Bing Act made high school attendance mandatory. Between 1921 and 1929, sixteen new school buildings were built in Columbus in a $10 million dollar building campaign, and East High was one of them, initially planned to be called Joseph Sullivant Senior High School.

As soon as the building opened, it was featured in a Billy Ireland cartoon in the *Columbus Dispatch* as a "silk stocking school" (one whose students were wealthy), but the architects had not counted on just how wealthy—they forgot to provide a parking lot for students' automobiles.

The twenty-first-century renovation work included restoring numerous skylights throughout the building, refinishing the solid woodwork and

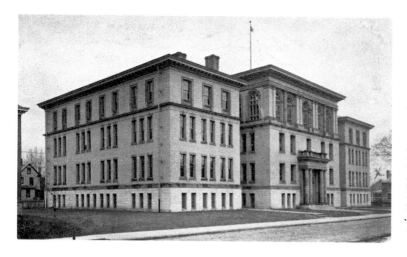

The first East High School was on Franklin Avenue, becoming Franklin Junior High in 1923.

wrought-iron railings and installing new energy-efficient lighting fixtures. In addition, the beautiful library was completely redone, and a 34,000-square-foot gymnasium was added, featuring three full-sized basketball courts to seat 1,850 spectators.

East High School's historic restoration was important because of the landmark status of the school to the east side neighborhoods and to the African American community of Columbus. Notable graduates have included actor Philip Michael Thomas of *Miami Vice* fame; Bernie Casey, NFL player and actor; Granville Waiters, NBA player and local businessman; Chuckie Williams, college basketball All-American and NBA performer; Bill Willis, College Football Hall of Fame and Ohio State lineman; Bill Agnew, artist; and Kevin Boyce, Columbus City councilman and State of Ohio treasurer. Their fame is part of the East legacy that has also included (in the early part of the twentieth century): Mary Campbell, two-time Miss America in 1922 and 1923; James Thurber, writer and humorist; Gardner Rea, cartoonist; and Chic Harley, the famed Ohio State football player whose popularity and career was the inspiration for the building of the Ohio Stadium (often called "The House that Chic Built").

ELDON AND ELSIE WARD Y.M.C.A (130 WOODLAND AVENUE) AND WARD HOME AND STORAGE FACILITIES

The Spring Street YMCA, founded in 1919, was one of the first YMCAs in the United States to specifically serve the black community. It was a much-

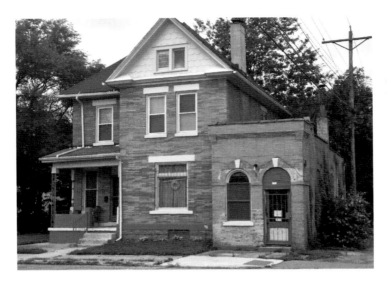

The E.E. Ward Moving Company is the oldest African American–owned continuously operated business in the country. Mr. Ward's home, pictured here, is located on Champion Avenue.

used and beloved historic institution for many years. In 1962, this YMCA moved to the Woodland Avenue location and was renamed the East Side YMCA. In 1997, the YMCA was rededicated as the Eldon and Elise Ward YMCA to honor the Ward family's lifelong support of the community and unique place in the history of Columbus.

The late Eldon Ward was head of the family-owned E.E. Ward Moving and Transit Company from 1945 until his retirement in 1996. When he died in 2004, Columbus lost not only a well-honored businessman but also one of the city's great historians. He was a Sunday school teacher, civic leader and humanitarian with an almost photographic memory, and he was a product of a long line of achievers. Artist Aminah Robinson called him "the historian griot of Columbus" upon his death in 1904.

His great-grandfather John T. Ward was one of a number of black Columbus conductors on the Underground Railroad. As a farmer, (old) city hall janitor and hauler of goods through Columbus, John Ward was in the perfect place (though at great personal risk) to help move fugitive slaves through Central Ohio, sheltering fugitives on his own farm (Whitehall) and working as a conductor to safe stations in Clintonville, Worthington and Westerville from 1848 to 1858. It was said by his contemporaries, "He could easily overpower five ordinary men and was in a bad mood to be tackled when hauling Negroes seeking escape."

John Ward's son, William S. Ward, founded the Ward Transfer Line in 1881 with two helpers and a team of horses. In 1899, the company's name became

E.E. Ward Transfer & Storage Company. William's youngest son, Edgar Earl (from which E.E. Ward Company gets its name) continued the business, which has been recognized by the United States Department of Commerce as the oldest continuously running African American business in the United States.

An exclusive contract with the Steinway Piano Company helped to solidify the recognition that the Wards could move anything and do it well. Between 1903 and 1959, it is estimated that they moved over 900,000 pianos. Whereas movers in other cities moved pianos for only one or two dealers, Ward moved pianos from seven Columbus stores into homes (of the mostly wealthy), and word-of-mouth and constantly moving wagons were the best advertisement.

What is perhaps less recognized and worthy of research is the number of homes, offices, barns, sheds and stables associated with four generations of the family. By 1909, a number of stables and barns on the near east side (especially in the vicinity of Champion, Mt. Vernon, Bryden, Franklin and Sherman Avenues) were rented or purchased for storage and as transfer stations for the rapidly expanding business. The Wards used only fireproof and spotlessly clean buildings. The general offices in the early twentieth century were in a home on Champion Avenue.

EMERSON BURKHART HOME (223 WOODLAND AVENUE)

Columbus in the 1940s was home to many artists of regional and national stature, including Will Rannells, Alvan Talmadge, Robert Gattrell, Robert Chareayne, Harriett Kirkpatrick, Carolyn Bradley, Hoyt Sherman, Mark Russell, Ray Kinsman Waters, Lydia Reeder and two of the most prominent who were residents of the east side—Alice Schille and Emerson Burkhart.

Emerson Burkhart (1905–1969) was an American scene painter who often depicted urban panoramas and African American life in Columbus. He mentored African American artist Roman Johnson, and the large front room of this house was Burkhart's studio. Known for his portraits and murals, many in a "gritty realist" style, Burkhart's larger pieces done during the Depression as part of the WPA programs can still be viewed—a mural at Stillman Hall at Ohio State University and his controversial mural *Music*, which was painted for downtown Central High School (now the COSI building).

Music made national headlines when it was covered over by Central's principal in the 1940s because he considered it to be "too risqué." *Music*

featured young women in evening dress swaying to (presumably) jazz music. The cover-up was noted in *Time Magazine* because it came at a time when Adolf Hitler was censoring the arts in Germany. The mural was unseen for more than fifty years, taken down in anticipation of the removal of the Central High auditorium during the conversion of the building, rolled up and stored in ten large sections at the Ohio Historical Society. It was rescued by high school students at Fort Hayes Metropolitan Education Center. The mural sections came to Fort Hayes, and over one thousand students worked over the course of six years to painstakingly remove the whitewash covering them. Because of its size, the mural found a home in one of the few places with room to house it—the Convention Center—and even then the mural had to turn a corner.

E.T. PAUL COMPANY (123 PARSONS AVENUE)

What began as a blacksmith shop in the late 1890s quickly transformed itself to fit into the new automobile age. Within ten years of opening (but still with plenty of horses on the streets), E.T. Paul began to sell tires from this location. It is now the oldest tire dealership in the United States.

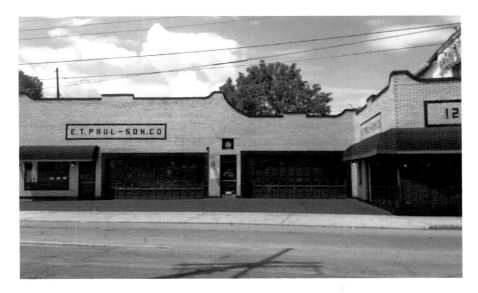

The E.T. Paul Company started as a blacksmith shop.

First Church of Christ Scientist (457 East Broad Street)

Dedicated in 1925, the church's neoclassical revival style is very different from its Gothic and Romanesque neighbors on East Broad Street but blends well with them and with the classical façade of the Columbus Museum of Art across the street. Christian Science began in 1866 with the spiritual teachings of New Englander Mary Baker Eddy, who encouraged better health with a return to a more basic belief in Jesus as a healer. Her ideas spread to Columbus by the 1890s. The Columbus congregation grew so rapidly that within three decades, the church moved into four buildings to accommodate the crowds. The 1925 building is on the site of an older 1914 church.

Golden Barbershop and Billiards and Lemmons Drugstore (1533–1537 Mt. Vernon Avenue)

The large green abandoned building at the intersection of Mt. Vernon and Taylor Avenues is frequently the inquiry of passersby. Its impressive size and configuration suggest a building of great importance. The building appears to have been built circa 1915 for storage and first-floor retail, with

apartments on the second and third floors. On the first floor was a druggist, J. Guthke, and on the upper floors were apartments where an electrician and a printer lived. Guthke lived close by on Taylor Avenue.

Throughout the 1920s and 1930s, some of the same residential tenants remained. In keeping with the changes the new automotive trade brought to the landscape, the Accurate Measure Oil Company opened

Lemmons Drugstore was *the* place to get a lemon-lime phosphate or, in today's jargon, an Italian soda.

in the rear of the building (and later a tire company occupied the space). The building was always occupied. In the 1920s, Ben Golden, who owned a barbershop and billiards room, was established in the building and would remain through 1958 (when the drugstore also changed to the Elijah James Pharmacy). However, in the 1920s, Hubert Kanmacher was the druggist, and in the 1930s, Clifton Workman owned the drugstore.

Howard Lemmons, who established Lemmons Drug Store #1 on the first floor in the early 1940s, seems to have been the best remembered, generally for his soda confections. Lemmons lived on Broadleigh Avenue, and there is no indication that additional stores were opened. By 1958, other changes were appearing. Golden's space was now occupied by George Jameson, barber, and Robinson Insurance was a new tenant. Elijah James Pharmacy replaced Lemmons Drug Store #1 and remained into the 1960s. Speedy's Janitorial Service occupied the rear of the building.

Across the street (330 through 344 Taylor Avenue) were row houses (flats) that were continuously occupied by anywhere from ten to nineteen working-class families (seamstresses, repairmen, toolmakers and salesmen) and occasionally a small restaurant (Knotts Grill). A landmark building and corner? Absolutely. In a neighborhood that has seen many teardowns and is burdened with vacant lots that remain for decades, a neighborhood corner—much less one with a building of commanding size—that retains its urban character is a rarity.

HAMILTON PARK (HAMILTON PARK AVENUE, BETWEEN EAST BROAD AND EAST LONG STREETS)

Hamilton Park was one of four late nineteenth-century residential streets built around park-like boulevards. Today only three remain because of the construction of the interstate highways. Homes and a few well-appointed apartment buildings for wealthy owners were constructed and remained exclusively white into the twentieth century, when African American families of means began to settle onto the street. Long Street had been a center for African American settlement for some time.

A study done in the late 1920s showed that the African American community had been attracted to Long Street because of the proximity of the railroads for work and the willingness of white real estate people to make "secret deals" with whites on behalf of black families, who were willing to pay higher rents

An early twentieth-century photo of unidentified young children playing in front of Hamilton Park homes.

to live there. In addition, Long Street grew as an African American neighborhood because the white residents of East Broad Street, one of the wealthier streets, desired to have "help" nearby. Long Street was near enough for convenience and far enough away to keep Broad Street exclusive. Lastly, Broad Street and the residential boulevard streets were already changing with the rapid expansion of the city's commercial area. Having been built rather late in the nineteenth century on large tracts of land vacated by the state, wealthy homeowners moved eastward, and homes were rented to upper-middle-class families. It was natural that Hamilton Park became a street desired by wealthy and upper-class African American families. The 1919–20 *Columbus Illustrated Record* lists thirteen African American households along Hamilton Avenue, mostly centered near Long Street and extending to Mt. Vernon Avenue; however, that would change within the next two decades.

The historic district has significant architecture and stories connected to prominent Columbus families and businesses. Distinctive conical turrets, ironic columns, frieze windows, projecting bays, contrasting stone trim and tall chimneys make walking the street an architectural scavenger hunt. Of note are the Hoster (Brewery) family house (43); the home of Andrew Denny Rodgers Jr., married to Eliza Sullivant, granddaughter of Lucas Sullivant (65); the Hardesty home (91); former headquarters of the Columbus Call and Post (109); and the former Bernadine Apartments (102–128).

The former Robert Jeffrey Mansion became the third location of the Isabelle Ridgway Home for the Aged.

ISABELLE RIDGWAY CARE CENTER (1520 HAWTHORNE AVENUE)

In 1912, Isabelle Ridgway and her good friend Dottie Whitaker, the wife of an undertaker, founded a facility to take care of African American elderly, poor and disenfranchised. Founded as "an old folks' home," it was incorporated as the Ridgway Home for the Aged in 1916. Ridgway, a native of Van Wert, Ohio, was fifty-eight years old when she started her mission and worked to the age of ninety-seven.

The story of Isabelle Ridgway is the story of many houses: the Ridgway cottage at 190 Jefferson Avenue, where the idea was born; a house at 157 North Champion that was the first home; another at Champion and East Long that expanded the idea (the present site of a firehouse); and the mansion at 71 Winner Avenue. The first recipients of Ridgway and Whitaker's good intentions were three women. The friends simply thought of the project as an extension of their church work. Fifty years later, thirty-five elderly people lived in the Jeffrey mansion, the former home of Robert Jeffrey, mayor of Columbus in 1903.

The modern and well-equipped Isabelle Ridgway Care Center (1980) is named in her honor. The facility was known for many years as the only facility that would take care of African American elders living on the near east side and is a landmark for its longevity and service to the community.

JONES MANSION (731 EAST BROAD STREET)/CENTRAL ASSURANCE INSURANCE (741 EAST BROAD STREET)/JONG MEA RESTAURANT (747–751 EAST BROAD STREET)/OREBAUGH HOUSE (675 EAST BROAD STREET)

A grouping of four buildings on the south side of East Broad Street represents over a half century of distinct architectural styles. What is unusual is that they sit, for the most part, cheek to jowl (or perhaps more accurately, foundation to foundation) as if they were game pieces on an urban Monopoly board. They form a landmark from Parsons to Garfield Avenues, signifying changes all of East Broad Street faced from a wealthy nineteenth-century residential world of mansions and carriage lanes to early twentieth-century apartments and then to midcentury modern commercial. (The four buildings also had a neighbor to the west that made the grouping distinctive—a Kentucky Fried Chicken fast food restaurant.)

From west to east, the Jones Mansion is the first and the most striking of the group. Its eclectic style in red pressed brick sits on a high ashlar stone foundation. A hip slate roof has steep-pitched dormers. Gables are set above a circular tower with a flat roof and flanked by tall, decorated chimneys. But what most passersby notice first are the stone works of animal, plant and somewhat human motifs and the ironwork on the tower, the porch and the roof. There is symbolism in the number of twists in each piece of ironwork and in each face in stone. The Jones family home had a duplicate in Barnesville, Ohio (now gone). The Barnesville mansion was constructed, as the story goes, for a family with a critically ill child who believed the child could regain her health through architectural protective forces, especially through numerology. The ironwork was twisted in configurations of threes, sevens and nines, and a grotesque stone face scared away illness. At the rear of the house is probably the largest and most ornate remaining carriage house in Columbus.

The house was built in 1889 for William and Josephine Jones, who supposedly knew of the Barnesville house and had their house copied from it. Born in 1839, Jones came to Columbus from Zanesville after the Civil War and was a partner in Jones, Garner & Co., a jobber of notions and dry goods. From 1877 to 1881, Jones was in business for himself as wholesaler, and four years later, he founded Jones, Witter, & Co, a wholesale dry goods firm. After his death on December 10, 1922, Josephine continued to live in the house for another year. After that, the building was used for a doctor's office and then Schorr-Ketner Furniture Company into the 1970s. The house was a decorator's show house in 1987.

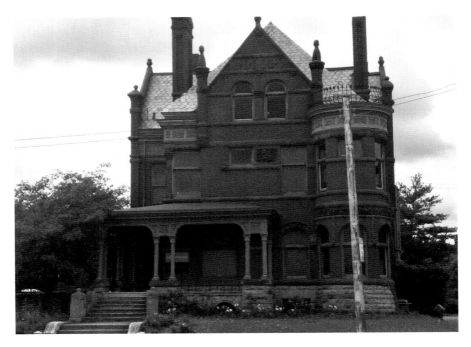

The Jones Mansion on East Broad seems to have been modeled after a home in Barnsville, Ohio.

The elaborate and eclectic architecture of the Jones Mansion sits a few feet from a 1940s streamlined and modernistic commercial building constructed for the Central Assurance Insurance Company (later becoming state offices for taxation). The insurance company had been on the site since the 1930s, first occupying an 1867 house owned by Henry Knight and his family before constructing the present building. Knight and his wife came from England, and it is speculated that Knight, a sewer contractor, arrived to help direct what would become the American Sewer Tile factory (see North Columbus entry). Knight appears to have owned the land from his home to Garfield Avenue.

The sleek, almost Art Deco insurance building is shoved against a Tudor Revival half-timbered 1920s apartment and commercial building, purchased by Henry Kohn, a real estate investor, who may have built the commercial structure on the site of a preexisting building. In 1930, the Golden Lotus was a first-floor tenant, and several members of the Yee family who ran the restaurant lived upstairs, continuing to do so for many years. By 1951, the Golden Lotus became Jong Mea restaurant, which lasted into the 1980s and is still remembered by many Columbus residents.

Finally, the Tudor Revival building is bookended by the last distinctive building, an 1880s Italianate home with a large L-shaped front porch, frieze windows and brackets under the roof line and hood molds surrounding the windows. Built by Ephraim Orebaugh in 1886, he sold it to Henry Miller. It appears to have been rented to Samuel Palmer, a minister from Broad Street Presbyterian Church (located across the street). In 1915, James T. Miller purchased the home (though he may not have lived there) from James Niswonger. The house was still in the Miller family in the 1970s; however, the house had long since been a rental. In the 1960s, it was the Pratt rooming house. The James T. Miller family was connected to the development of Upper Arlington, having sold their family farm to King Thompson, who developed the suburb.

In addition to being architecturally interesting, the buildings also represent the history of Columbus through the stories of the houses and owners—post–Civil War wealth, entrepreneurial immigration, streetcars to the automotive age, working-class rooming house, growth of Ohio government, early twentieth-century commercialization and even suburbanization.

KAPPA KAPPA GAMMA FRATERNITY/SNOWDEN AND GRAY MANSION (530 EAST TOWN STREET)

East Town Street between Washington Avenue and Parsons Avenue and the neighboring streets form the Town Franklin Neighborhood, the city's first "suburb," which began before the Civil War and continued to fill in during the prosperous decades following the war. Beginning in the 1840s, developers began subdividing house lots, and by the 1850s, many fashionable residences filled in the Town and Rich Streets area. The construction of the Ohio Deaf School added to the wealth and importance of the area (see Topiary Park/Ohio Deaf School entry).

One of the homes was built for wealthy silk importer Philip Snowden around 1850 and is considered to be the most beautiful example of Italianate Villa architecture in Central Ohio with carved hood molds and a belvedere tower ("beautiful view") rising from the center of the house. The style was said to have been a favorite of wealthy vineyard owners, who protectively guard their lands from the uppermost vantage point. Though Mr. Snowden lost his fortune soon after he moved in, the very large home became the governor's mansion during the Civil War for Governor David Tod and his very large family.

In the following decade, the mansion was owned by the Gray family, and Mrs. Gray, who was considered to be the most beautiful woman in Columbus, often gave parties, using the vantage point from the tower to observe what her female guests were wearing. She had time to change clothes before guests arrived if someone wore a gown that might rival or mimic hers. By the 1930s, the mansion had fallen on hard times—serving as a rooming house and later home to the Woman's Club of Columbus before passing into the hands of the Kappa Kappa Gamma Fraternity, a national sorority and the first such institution of its kind.

KELTON HOUSE (586 EAST TOWN STREET)

The well-known Kelton House was the home of the Keltons for three generations before being saved by the Junior League of Columbus when Grace Kelton, noted interior designer, died in the late 1970s. Many know it as a spot on the Underground Railroad and its connection to two little girls who were found in the shrubs, presumably dropped off on their travels to freedom. Today, the house has a well-designed interpretive center in the basement to explain the role of the Keltons and other conductors on the secretive journey to help escaping fugitive slaves. Others know the Kelton House and lovely gardens as a wedding site, while many are awed by its complete and all-original house furnishings, artifacts and ties to Columbus history (the pall bearer armband of first-generation Fernando Cortez Kelton is preserved with a color lithograph of President Lincoln's funeral cortege at the statehouse).

The house and the Junior League were instrumental in making the first plans for the preservation of the Town Franklin District, just as Grace Kelton had done years before when she insisted in the 1950s that the approaching interstate highway to the east be relocated away from her house and be constructed below the sightline of the street.

KING ARTS COMPLEX/PYTHIAN THEATER AND MAYME MOORE PARK AND AMOS LYNCH PLAZA (867 MT. VERNON AVENUE)

The complex is deeply rooted in the history of the near east side. The Pythian Theater was one of a number of movie houses and vaudeville theaters in the area. The Pythian and the Lincoln Theaters (on Long Street) are the only two

that remain. The Pythian is the only known building to have been designed by African American architect Samuel Plato and was constructed in 1925 for the Knights of Pythians. The famous local Cotton Club, named for Harlem's Cotton Club, occupied the fourth floor of the building. The main auditorium featured jazz arts and jam sessions from the 1940s through the 1960s.

The complex opened in phases. In 1987, a $2.7 million dollar renovation of the Pythian Theater and the old Garfield Elementary School next door was completed. In 1989, a $1.8 million dollar addition created a sixty-thousand-square-foot facility, and in 1989, the renovations were renamed the King Arts Complex. The complex hosts educational programming and special events, but it is also known for its Elijah Pierce Gallery and a permanent art collection. Two murals depict the African American journey from slavery—Ron Anderson's *Cargo, the Middle Passage* and Onye Lockard's *Behind the Bars*. Nearby is the Mayme Moore Park, the first park in Columbus named after an African American woman. Moore was a civil rights activist and grandmother of Otto Beatty Jr., a former state representative and community activist. Amos Lynch Plaza, adjacent to the park, is an amphitheater for concerts and community performances named for Amos Lynch, founder and editor of the Columbus *Call & Post*, a well-known African American newspaper that was distributed statewide.

LINCOLN THEATRE (769 EAST LONG STREET)

In Columbus, vaudeville reigned in the early part of the twentieth century. Acts were booked by the Theater Owners Booking Association, known as TOBA, and black actors said it stood for "tough on black artists" because they were often passed over for white actors. Acts were booked into the Dunbar Theatre (Champion and Mt. Avenues), a popular venue. The Empress, the Pythian and the Ogden Theaters also used TOBA entertainers, in addition to showing movies. In the black community, there was also midnight vaudeville called "midnight rambles." Bessie Smith; Willie Bryant; Buck and Bubbles; Butterbeans and Susie; the Brown Skin Models, who danced in perfect syncopated rhythms; and a four-year-old Sammy Davis Jr. appeared on stage. (According to the late Dr. Anna Bishop, Butterbeans was the stage name for Thomas Sellers, who died in 1989 in Poindexter Village. He was known in vaudeville for his dance, "the heebeejeebies.")

The design of the theater was Egyptian-Revival with large columns, painted ornamentation and decorative plaster cornices. In addition, there

were stencils of roosters, ostriches, ducks, urns and palms. The Lincoln opened as the Ogden on Thanksgiving 1929 by Al Jackson. The building was developed by the Grand United Order of Odd Fellows, and the architect was most likely Carl Anderson, an African American who owned a construction company in Dayton and was responsible for St. Paul A.M.E. Church. Not just a theater, the building had four storefronts, offices for the lodge and a ballroom. It is said that people arrived by taxicabs or elegant cars, dressed in evening gowns and tuxedos. A red carpet led from the street to the theater, and elegantly dressed ushers in silk trousers and gold satin shirts escorted people to their seats—all in keeping with an exotic Egyptian palace interior.

However, the Ogden changed from Al Jackson's hands to the Keith Theatres, which had a policy of prohibiting blacks from its theaters. With the sale, the name "Ogden" changed to "Lincoln."

MACON LOUNGE (366 NORTH TWENTIETH STREET)

The Macon Lounge was a landmark of the famed jazz club scene on the near east side.

Located in the area known as Bronzeville in the 1930s, the Macon Lounge is one of the remaining landmarks of the famed jazz club scene of the near east side. Musicians from around the country were able to stay in the hotel upstairs and play downtowns. At the time, the Macon was in good company with other clubs— the Yacht Club, Jamaica and Skurdy's—where live jazz was performed and supported by the community. The building was constructed in 1888 and in 1915 was known as the Hildreth Block. In 1942, it housed Earl Foley's billiards parlor and the Macon Hotel. Like other cultural landmarks,

the Macon's decline came with the building of interstate I-70, which cut off the neighborhood from downtown. In the 1980s, the one-hundred-year-old building was renovated and historically listed, and owner Geraldine Barnett vowed to keep the new bar operating. It is still owned by the family.

Mansion Day School/Miller Mansion (72 Woodland Avenue)

One of the largest residences on the near east side was built as a home for William Miller, president of the H.C. Godman Shoe Company, probably the most successful and well known of Columbus's many shoe companies that flourished in the early twentieth century. The striking mansion is set on four acres of landscaped grounds and contains twenty-four rooms with fifteen fireplaces.

The Miller Mansion remained in the Miller family until 1932, when it was owned by the Glenmont Home for Christian Scientists. By 1942, it had also

The Mansion School on Woodland Avenue was originally the estate of the president of the H.C. Godman Shoe Co.

remodeled the large stable and carriage house to expand the number of guest rooms to twenty-five.

For most Columbus residents, the landmark building is best remembered as the Learning Unlimited Mansion Day School, owned and operated as a successful private school from 1988 until 2006 by Dr. Pouneh Alcott and her husband, Bill. It is a point of pride to the African American community that for two decades it operated as an elementary school serving many African American children and drawing students from Gahanna, Dublin and Pickerington. In 1904, when the mansion was built, African Americans were restricted from moving into the neighborhood.

Mt. Vernon Avenue/Long Street/Bronzeville

It is virtually impossible to talk about the history or importance of Bronzeville, Long Street or Mt. Vernon Avenue without referencing the late Dr. Anna Bishop, poet, educator and local historian of the near east side and the Columbus African American community.

She quoted Dr. W. Sunni Jones, who wrote:

Every city and town, north, south, east, and west, having an appreciable Black population has its "Avenue" which is considered the center of Black commercial, social, sporting, and entertainment life…these are the streets, the avenues, the environments that nurtured the ambitions, the disillusions, the hopes, fears, happiness, sadness, good times, bad times, high living, bread lines, God fearing, church going Christians, prostitutes, thugs, dope addicts, gambling joints, bootleg houses, churches (store front and edifices), bars, taverns, night clubs, chop suey joints, Greek restaurants, barbecue pits, lodge halls, doctors, dentists, and lawyers' offices that all prospered or suffered together…The "Avenues" were the nurseries of all Black progress in every field of endeavor.

Mt. Vernon had that and more. It also had artists, musicians and Jewish merchants, as detailed by Wil Haygood, *Boston Globe* journalist, in *The Haygoods of Columbus*, and by Marvin Bonowitz, for the Jewish Historical Society, who compiled oral histories in *Mt. Vernon Avenue: Jewish Businesses in a Changing Neighborhood, 1918–1999*. Bonowitz's book depicts the interaction of the Jewish and African American business community, one he compared to the Lennox Avenue of Columbus. He paints a world of Halloween street

Mount Vernon Avenue was the center of commerce for the African American community, with many buildings dating to the nineteenth century.

The Williams Building on Long Street is the home of the King-Lincoln Bronzeville Neighborhood Association.

parades, Easter Sunday's finely dressed community (who also dressed up to celebrate whenever boxer Joe Louis was victorious) and an epicenter of nightclubs and theaters that drew whites and blacks alike.

Some of Columbus's most well-known Jewish families can trace connections to the area: the Glicks, Blanks, Wasserstroms, Romanoffs, Margulieses, Schottensteins, Shamanskys and Krakoffs, in addition to the Bonowitzes. Amos Lynch, editor of the *Columbus Call and Post*, described Mt. Vernon as "more than a location, it is a state of mind." After Lynch printed those words, in 1988, the "Comin' Home Festival" drew twenty thousand people to a celebration on Mt. Vernon.

The neighborhood also had East Long Street and a community whose identity was defined as Bronzeville. By 1938, the term "Bronzeville" was well recognized in the community, and this concept of a "city within a city" had already been modeled by Chicago. The community of the near east side elected a mayor, and he, in turned, selected a cabinet that mirrored the city's administration. This helped to bring one community voice to the mayor and city council when negotiating for city services. Columbus was only the third city in the United States to try to experiment with this grassroots democracy.

The term reflected the amalgamation of metals that go into making bronze, the hardest of substances. But in addition to having political clout, Bronzeville also built community spirit by sponsoring festivals, including the election of a Miss Bronzeville, and community gatherings. With the coming of the public transit streetcar system in post–Civil War Columbus, the city expanded into streetcar suburbs along Long, Broad, Main and Mt. Vernon Streets. The near east side now became a definable wealthy community, and farmland turned into subdivisions by the 1870s. From the 1920s to the 1940s, the near east side was a diverse community with identifiable pockets.

Hamilton Park between Long and Broad Streets became a wealthy African American community. Within a short distance, there were five move theaters (the Dunbar; the Pythian, now the King Arts Complex; the Ogden, now the Lincoln; the Empress; and the Cameo). The Cameo prohibited blacks. The area around St. Dominic's on Twentieth Street was home to Italians, African Americans and Irish, with families who were often associated with work to be found from the nearby railroads.

The "Blackberry Patch" (see Poindexter Village/Blackberry Patch entry) was where poor African Americans lived, many if not most of whom had come north during the Great Migration. It disappeared in the building of Poindexter Village in 1940.

By 1919, Long Street African Americans owned and operated two printing offices, an insurance company and several real estate agencies. In

the 1930s, Long Street (sometimes referred to as "the Block" to distinguish it from Mt. Vernon, "the Avenue") was home to the Columbus Urban League in the Williams Building (681), the Belmont and the Waiter's and Bellman's Club (689), Blue Triangle YWCA (690), P.O.R.O. School of Beauty (660), Columbus Baptist Printing (705), Whittaker and Son undertakers (720), Krogers (736), the Plaza Hotel (738), Novelty Bar (741), the Community Pharmacy (740), Cokolis Billiards (742), the Chauffeurs Club (742½), Jackson billiards (748), Jackson-Logan Apts (750), Oscar Allen and Thomas Owens Barbershop (758), Bobbins and Burke Cigars (760), Majestic Restaurant (764), Goins Confectionary (766), the Empress Theatre (768), Interstate Motorist Auto Club (768½), the Empress Soda Grill (772), the Crystal Slipper Dancing Academy (771½), Ogdeon Theater (773), Charles Holmes Barbershop (774), Duvall Grocery (790), Bryco Gas & Oil Company (791), Lowe's Cut Rate Drug Company (775), Metropolitan Temple (773), Ogden Fruit Shop (771), Caliz Beauty Parlor (769), Order of Old Fellows Building (767–779), Harold Dickinson dentist and Emma Benton beauty parlor (761), Truesdall confectionary manufacturer (747–755), Hughes Dry Goods (731), Adelphi Loan and Savings and Colored Ohio National Guard headquarters, Frank's Place (barbershop) (922), Long Street Market/O'Caine's Market (1032) and the Long-Mason's Lodge (1108).

A 1933 OSU thesis noted that Long Street was lively during the day but still rather sedate later, primarily because of the number of offices of doctors and dentists, real estate agents and restaurants—the author commented that it might be said the people were "uppish." He saw Mt. Vernon Avenue as the workhorse street and the heart of the business district. Here were drugstore after drugstore, restaurants with "girls frying fish in display windows," an Ohio National Bank, a home building and loan, the Cameo Theater, a Masonic Hall, the American Legion Post, offices for the *Columbus Sentinel*, East Market (a farmers market that opened at 5:30 a.m.), pool shops and tailor and shoe shops. The author characterized Mt. Vernon Avenue as having the atmosphere of an "open-air parlor," commenting that Mt. Vernon is alive earlier than Long Street, but Long Street stays awake longer."

Marvin Bonowitz chronicled the unrest in the neighborhood on September 21, 1967, over racial segregation, lack of employment (especially at the city level) and fair housing. Broken store windows followed days of picketing. However, Bonowitz put the change to Mt. Vernon Avenue squarely on later city policies and the city planners, who, following a national trend, razed the street's stores, theaters, nightclubs and small businesses. Others, like Haygood, said it was the building of the freeway that isolated the neighborhood.

OHIO SCHOOL FOR THE BLIND/COLUMBUS HEALTH DEPARTMENT (240 PARSONS AVENUE)

Originally located downtown, the institution for the education of the blind was the first publically supported school for the blind in the United States. Educating any blind child residing in Ohio, the school started in 1839 with a maximum capacity of sixty students. Residential schools for children with handicaps were considered modern and revolutionary in the nineteenth century. Ohio's commitment to serving these children brought international visitors to study the Ohio model.

In the 1930s, people marveled at what the children could build and accomplish. However, today, residential schools for children that take them from their home environment seem extreme. Construction for a larger building started on the Parsons Avenue site in 1869, and when completed five years later, the massive Second French Revival–style building opened with three students. Located on a prominent street in a wealthy residential neighborhood, the building was noted for its beauty and spacious lawn.

In the nineteenth and early twentieth century, famous residents of the surrounding streets included the Parsons (from whom the street gets its name), whose daughter married into German royalty; the Hartmans, who made a fortune in patent medicine; the Battelles, whose legacy was the

The Ohio School for the Blind started in 1839 and was committed to educating any blind child in Ohio.

Battelle Foundation that exists to this day; the Kilbournes, whose fortune was made in manufacturing and who are associated with the founding of Worthington; and the Thurbers, whose grandson James, probably much to the chagrin of his strict Methodist grandfather, became a famous humorist and cartoonist.

Between 1830 and 1901, it is estimated that more than three thousand children were enrolled. The original building was built in the footprint of the letter *E*, with boys' and girls' dormitories on either side of a main building, but when the building was renovated to house the city's public health department, new spaces for clinics and offices were built within "the legs" of the wings. In addition, historic areas like the auditorium, covered by a false ceiling, were revealed and restored. Between the closure of the school and the renovation by the City of Columbus, the building was the home of the Ohio State Highway Patrol.

POINDEXTER VILLAGE/"BLACKBERRY PATCH"

Blackberry Patch, a corner of the near east side memorialized by the late Dr. Anna Bishop, was roughly an area bound by Mt. Vernon Avenue on the north, East Long Street on the south, Ohio Avenue on the west and Mink Alley on the east. Crossing through it were Hawthorne and Champion Avenues.

Blackberry Patch was a shanty town where southern blacks lived when they first arrived in the north and a place where Anna Bishop's mother did not allow her to venture near or into. If Bishop's writings and poems about "the Patch" made the area come alive in literature, the visual storyteller Aminah Robinson gave it color and movement in her mixed-media work. She depicted the many interesting residents and entrepreneurs of the area— the crow man, the elephant man, the rag man, the brown skins man, the sock man and others. The residents of the Blackberry Patch are celebrated in Robinson's books and live on in a large mural at the Columbus Metropolitan Library on Grant Street.

Most residents had settled in the area as little more than refugees from the Great Migration that brought an influx of African Americans north prior to and during World War I. Homes were constructed from pieces of scrap wood. The area had outhouses and potbellied stoves for heating. (On the other side of the railroad yards near Joyce Avenue and the American Addition, migrants lived in abandoned boxcars.)

Poindexter Village was built on the former site of the Blackberry Patch, a "shanty town" where many African Americans lived after arriving in Columbus from the south.

In 1941, Blackberry Patch was no more, and President Franklin Roosevelt came to Columbus to dedicate Poindexter Village, the nation's first public housing projects, named for Reverend James Poindexter on its site (see Second Baptist Church entry). The location of the freeways that isolated the near east side and misguided public policy and housing programs that destroyed housing stock and mature trees and paved over the character of the neighborhood were powerful "push" factors as disinvestment, vacancies and arson in the area drove families away.

These occurred at the same time other powerful "pull" factors drew families to other areas—the mobility provided by the automobile, the end of legal segregated housing and areas of new housing opportunities such as Berwick and East Gate. Today, the near east side is working to retain a fraction of the former Poindexter Village, an important historic landmark for the history of the city and the community in particular.

SECOND BAPTIST CHURCH (186 NORTH SEVENTEENTH STREET)

Second Baptist Church was born from First Baptist Church in 1824. Three of the seven members of First Baptist were African American: Patsy Booker and George Butcher from Petersburg, Virginia, and Lydia Jones, from Kentucky, petitioned the church to form their own African American branch and transact business and meetings for themselves.

Second Baptist Church's most famous minister was the Reverend James Poindexter.

After a series of buildings, the church on North Seventeenth was constructed in 1907 (in 1990, an educational and administration wing was dedicated). Perhaps the most well-known member of the church in the nineteenth century was Reverend James Preston Poindexter. Highly respected in the Columbus community, he was the first African American elected to the Columbus School Board and to the Columbus City Council. In the 1840s, he left the church over a split in slavery. Forty members of the church went with him, pushing for a stronger abolitionist voice. Together, they were secretly instrumental as conductors in the Underground Railroad, especially John T. Ward, who operated a moving company (see E.E. Ward entry). However, the other members of the church continued to support their antislavery Baptist brethren, and in 1858, the two arms of the church reunited. Poindexter was the pastoral leader of the church from 1858 to 1898.

Second Baptist is known as the "Mother Church" because in some way or another, each of the African American Baptist churches in Columbus has been formed from it, including Shiloh Baptist, Union Grove, Bethany Baptist, Pilgrim Baptist, Oakey Baptist, Union Baptist in Urbancrest and Good

Shepherd Baptist. The Reverend Leon Troy, a successor to the trailblazing set by Reverend Poindexter, also served on the board of education. He also served on the board of Franklin County Children's Services.

ST. CLAIR HOTEL (ST. CLAIR AVENUE)

The St. Clair was one of a number of hotels in the near east side that catered to African American visitors and was especially popular with vaudeville and big band entertainers in the 1940s who were playing the Pythian, Empress and Ogden Theaters. However, the St. Clair did not start as a hotel, but rather as a hospital and a school for nurses. It was built in 1911 by noted eye, ear, nose and throat surgeon Dr. William Sloss Van Fossen. Designed to be a private general hospital with twenty-five beds, it increased to fifty beds in seven years. With the Depression, the hospital became a registered hospital, meaning it was only able to provide internships. By 1940, the hospital was a convalescent home and transitioned to an African American hotel eight years later. Today it is a senior assisted living residence.

ST. DOMINIC CATHOLIC CHURCH (453 NORTH TWENTIETH STREET) AND SCHOOL (1056 DEVOISE STREET)/ST. CYPRIAN'S CHURCH AND SCHOOL (1385, 1399, 1413 HAWTHORNE STREET)

The story of St. Dominic's Catholic Church is really the story of two churches, three schools, the convents, two neighborhoods in the midst of change, a remarkable act of good will, segregation, integration and—despite or because of intertwined circumstances—a new outreach.

St. Dominic is the older parish, organized in April 1889 by Right Reverend John Ambrose Watterson, the Bishop of Columbus who saw a need for a church to serve the Irish and Italian families who lived and worked near the railroads. Organized by Father Thomas O'Reilly, St. Dominic began with a first Mass at Benninghoff Hall on Twentieth Street and Hildrecht Avenue. Within six months, a school had been organized under the direction of the Sisters of St. Joseph. The school and church occupied the same large room

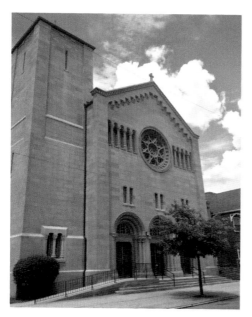

St. Dominic's Catholic Church began in 1889 to serve the Irish and Italian families who lived and worked near the railroads.

to the "cheerful" inconvenience of all, as has been described in church records.

Knowing that a nearby new public school, the Twenty-third Street School, would be underutilized, Father O'Reilly took the extraordinary and unheard of step of approaching the Columbus School Board for the use of three rooms. The large and commodious public school had just opened with twelve rooms, anticipating future growth because of the streetcar lines, and the public school was using only three of the twelve rooms. To the surprise of everyone, the school board president and all members of the board "heartily" agreed that the school could be rented to the Catholic church.

Then a backlash came in the form of indignation from anti-Catholic protesters. The heavy weight of Columbus's early twentieth-century moral conscience weighed in. Dr. Washington Gladden, minister of First Congregational Church and founder of the nationally known social gospel movement (that essentially called upon Christians to act like Christians) stopped the opposition, denouncing any who opposed a friendly and justifiable act of the board of education in an "age of enlightenment and civilization."

Within three years, St. Dominic's school was in its own building, a parsonage and convent were built and the parish was growing. An innovation in convent construction was introduced with each sister having her own room, abandoning the usual dormitory setup. In an age of rampant infectious flu and tuberculosis, the new arrangement was far more desirable. In 1911, ten lots were purchased from the old Anderson estate, creating a space of two acres fronting Twentieth, Devoise and Medill Streets (the latter two having since disappeared in new construction). Five years later in 1916, the large Basilica-style church of pressed brick and Bedford stone, with interior granite columns, was dedicated, and over three hundred children attended the school.

At the same time, and reflecting the segregation mentality that followed the fears of the Great Migration in northern cities, the site for St. Cyprian's Church was being purchased by the diocese in 1912 for apostolic educational outreach to African Americans (and non-Catholics) in the neighborhood near Hawthorne Avenue and Burt Street.

A combination two-room school and a chapel were built (now gone), and in 1914, a second building with school rooms and a hall was built, as well as a convent (1413 Hawthorne). By 1918, the school had over one hundred students (nearly all non-Catholic), and the church had a few African American Catholic congregants who had migrated to Columbus from the Raleigh-Durham, North Carolina region. By 1943, over 650 people had been baptized at St. Cyprian. The area around St. Dominic was also changing. By the 1950s, Irish and Italians were moving into other parts of the city, as were African Americans who were now accepted into white Catholic churches and schools.

St. Cyprian's school and church closed. St. Dominic's in 1980 had a congregation of 225 members and was 90–95 percent African American. Today St. Dominic's is open to all and has a number of unique programs, including a dance ministry, a rite of passage ceremony for graduating high school seniors and a gospel and traditional choir.

St. Paul's AME Church (639 East Long Street)

In 1814, the first Methodist Church in Columbus was constructed as a log church. The city donated a lot, and the members, both African American and white, named it the Town Street Methodist Episcopal Church. In less than a decade, Moses Freeman, one of the charter members, left with twelve followers to organize an African American Methodist Church, meeting in rented rooms.

On Straight Alley (now Lazelle Alley) just north of Spring Street (which was really a spring at that time), they organized a church they named Bethel that was set up for less than $160. When the General Conference of the African Methodist Episcopal Church met in Columbus, the members took steps for the creation of St. Paul A.M.E., the new name for their church in 1871.

In 1905, lots were purchased for $6,000 at 639 East Long Street, and it was one of the first churches to install a pipe organ (one that cost more than the lots). It established the first school for the education of African American youth, and the first African American high school graduates of Columbus schools were members of the church. Isabelle Ridgway was a member of

St. Paul's and a pioneer in providing social services (see Isabelle Ridgway entry). In 2007, the Gateway Wellness Center opened to provide medical care, dental services and health education for the community.

ST. PAUL'S EPISCOPAL CHURCH (787 EAST BROAD STREET)

St. Paul's was established in 1839 with a decision of Trinity Episcopal Church to create a "missionary church," and it began in 1842 at the corner of Mound and Third Streets. By 1880, the church was pushed farther on East Broad "to the outskirts of the city," according to an early church history, and occupied a frame building, but by 1904, the current stone structure was completed.

A group of young women from the church, the King's Daughters, raised $125 that was the start of the first Children's Hospital in 1892. In 1910, the church established Neighborhood House on Leonard Avenue. For years, the church duplicated the annual Festival of Lights, reminiscent of the pageantry of Westminster Abbey, for the Season of Epiphany, the only American recreation of the ceremonies in London, and, over the years, did significant outreach into the needs of the community, sharing space with the Cambodian Mutual Assistance Association, the New Creation Metropolitan Community Church, Project Open Hand, Olde Town East Neighborhood Association and others. The building has seen a number of different tenants since the church was closed by the Episcopal Church, which still owns the property.

ST. PHILIP'S EPISCOPAL CHURCH (166 WOODLAND AVENUE)

The present site of St. Philip's Episcopal Church is the fourth location for the historic church, and the current church was built in the early 1960s. The first site in 1891 was the northwest corner of Cleveland Avenue and Naghten Street. The second site was Johnson's Hall on Mt. Vernon Avenue, west of Eighteenth Street, and the third site in 1895 was at 250 Lexington Avenue, which was appropriated for the freeway construction in the early 1960s. Though the church has moved four times, it has never moved away from the community, operating a daycare center, a food pantry and clothing pantry, and it has been constantly supported by the African American community. In addition, a great deal of its focus is on global and social justice issues.

SHILOH BAPTIST CHURCH (720 MT. VERNON AVENUE)

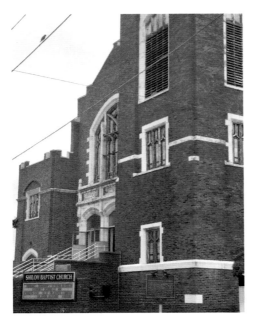

Shiloh Baptist was organized on August 8, 1869, with forty-four members, all of whom had left Second Baptist Church to answer the call to form an additional congregation, meeting the needs of a growing population of freed slaves and the expansion of the east side. They met in a grocery store at the corner of North Fourth and East Gay Streets for two years.

Shiloh was the third African American historic church on the east side, after Second Baptist (1824) and St. Paul A.M.E. Church (1834). The church has been at the present location since

Shiloh Baptist Church is the third historic African American church on the near east side.

1923, moving from previous locations at Long Street and Cleveland Avenue. It was designed by the A.O. Day Construction Company in Indianapolis, owned by a black woman, and Reverend James Burke, a member of the congregation, was the builder. The sanctuary windows were made by the world-famous Von Gerichten art glass studios, located in Columbus and Munich, Germany.

During the Depression in the 1930s, the church faced foreclosure because it was unable to make its mortgage payments. When the Bellefontaine Building & Loan Company began foreclosure proceedings, the church filed an injunction to stop the proceedings. The loan company took possession but agreed to sell the property back to the church.

During these difficult times, Shiloh Baptist Church fed hundreds and has kept the tradition alive with Saturday lunch programs. Shiloh also became the site of many Civil Rights rallies, and during one rally, the Little Rock Nine were brought to Columbus. The late Jefferson Thomas, one of the Little Rock Nine, later moved to Columbus and worked at the Defense Finance and Accounting Services in Whitehall. He often talked about the warm reception he and his fellow students received at Shiloh in 1957 after they integrated Central High School in Little Rock, Arkansas.

The community outreach of the church has included operating a day school, housing flood victims, feeding the poor, opening the first black credit union, transporting workers and children as needed and providing meeting space for educational programs and the NAACP, as well as establishing foreign missions.

THERESA BUILDING/JAZZ LADIES MURALS (821 EAST LONG STREET)

It is appropriate that murals of African American women who are famous in jazz should be in the presence of the Theresa Building. The many jazz clubs of the area hosted female jazz legends, especially Columbus's own Nancy Wilson, who was already hosting her own radio program at age fifteen. Many of the buildings up and down East Long Street are named for women—the wives and mothers of the builders. The Theresa Building was perhaps the first building constructed in Columbus specifically for African American dentists, real estate developers and photographers.

TOPIARY PARK/OLD DEAF SCHOOL SITE (480 EAST TOWN STREET, 400 EAST TOWN STREET)

Begun in 1988 and dedicated in 1992, the topiary garden in the Old Deaf School Park was the creation of sculptor James T. Mason, a Columbus native and graduate of the Columbus College of Art and Design. He and his wife, Elaine, interpreted Georges Seurat's post-impressionist painting *A Sunday Afternoon on the Island of La Grande Jatte* into a groomed landscape of ninety-five yew trees growing in sculptural frames.

The fifty-two topiary people (some as tall as twelve feet, to give perspective to the work), eight boats, three dogs and a monkey are posed in front of a pond that represents the River Seine. A topiary cat, not original to the Seurat work, is hidden in the topiary garden for whimsy. The woman with the watering can behind the gatehouse is a tribute to Elaine. The Topiary Park fills one side of the Old Deaf School Park, which is surrounded by the original fence from the Ohio statehouse, and it is the only park in the world based on a painting.

The Deaf School Park takes its name from the Ohio Institution for the Deaf and Dumb (in 1904, it became the Ohio State School for the Deaf).

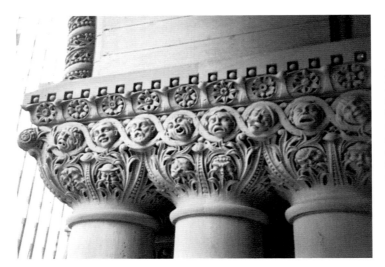

Richards, McCarty and Bulford, prominent architects, designed expressive faces in the stone exterior arches to be seen by children attending the Ohio School for the Deaf.

Ohio was a pioneer in providing education to people with disabilities. As early as the 1820s, the Reverend James Hoge of Columbus petitioned the Ohio legislature to establish programs for "defective children" of the state, and the Deaf and Dumb School was founded by an act of the legislature in 1827.

As the institutions grew (the Ohio School for the Blind is only a few blocks away), fashionable residential neighborhoods grew around them because the institutions were set in park-like surroundings and well maintained by the state of Ohio.

Though the first school was in rented rooms near Broad and High Streets, the second structure was on a ten-acre site outside the city limits (the present site) designed for sixty to eighty students. This was replaced by a French-Second Empire style building in 1868 that used over eight million bricks in its construction.

A second building to house a new school, art rooms and a gymnasium on the site began in 1898 and was designed by Richards, McCarty and Bulford, a prominent Columbus architectural firm. All entrances are marked with Gothic arches, and the major details are in carved stone. Though it has lost its twin towers, the landmark building that provides the backdrop for the Topiary Garden is distinctive with its elements of French, Dutch, Gothic and Jacobethan styles.

By the 1970s, the area and much of the street was going into decline. Plans ended to develop the oldest building into residential housing for the elderly when a suspicious fire devastated the 1868 building in 1981. The second building is currently undergoing restoration for a school and the nearby Main Library of the Columbus Metropolitan Library System.

Union Grove Baptist Church
(266 North Champion Avenue)

Union Grove was organized in a log cabin on the north side of Mt. Vernon Avenue on April 29, 1888, growing out of a Sunday school class that met under a large oak tree at the corner of North Champion Avenue and Granville Street.

Mrs. Cordelia Thompson, a white missionary, met with black children, and soon parents and others joined, creating a sizable group that necessitated a meeting space larger than just a log cabin. A church was constructed at 218 North Champion Avenue, but little more than a decade later, a dispute over doctrinal teachings created a split in the church. Forty-five true believers formed True Union Grove Baptist Church. Eventually they returned, coming back to the original Union Grove.

In the twentieth century, the late Reverend Phale Hale made significant contributions to the local and national civil rights movement. Dr. Martin Luther King Jr. preached the seventy-first-anniversary sermon at Union Grove, and Hale encouraged the church to become a meeting place from which Columbusites organized to join the Poor People's Marches in Washington.

Reverend Hale was elected to the Sixty-third House District in the Ohio State legislature in 1966, serving fourteen years and working on most of the city and Ohio boards that pushed for social justice and the impoverished.

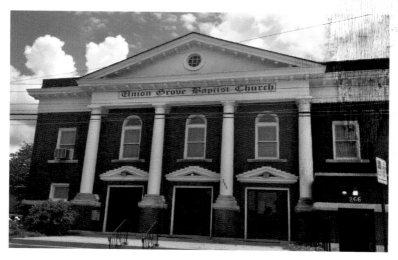

Union Grove Baptist Church began in 1888 from a Sunday school class that met under a large oak tree.

URBAN CULTURAL ARTS FOUNDATION (1270 BRYDEN ROAD) AND KWANZA PLAYGROUND IN ENGLISH PARK

The Urban Cultural Arts Foundation was established in 1978 to run the William H. Thomas Gallery as a place to showcase aspiring artists who did not display in mainstream galleries. It is the oldest black-owned gallery in Columbus, and for thirty years, the house has not only exhibited art but has also been a work of art itself. There are hand-hewn tree limbs that are the "bones" of the house, ever-changing art works and a riot of colors and textures that fill each room.

Almost directly across the street is the Kwanza playground in English Park, believed to be the first African-inspired playground in the United States. Dedicated in 1995 on English Park, a donation from an English family, the park is alive with art because artist Shirley Bowen inspired a new type of place for children to play. Original artworks from professional local artists flow through the space—Bowen's own African Tell-a-Story board, Barbara Chavous's

The Urban Cultural Arts Foundation on Bryden Road is both studio and gallery, a mecca for artists.

Thrones to the Earth and Sky, Bill Agnew's sculptures, fences that feature African adages and the Babobah Tree, where children can hear stories about harmony and culture.

Nearby, the Central Community House, serving the neighborhood in the tradition of a settlement house, was made possible by Walter and Marian English, and is renovating the former mansion of H.C. Godman, founder of the Godman Shoe Company. Godman helped establish Godman Guild, the oldest settlement house in Columbus, now located in the University District.

LIST OF SITES WITHIN NEIGHBORHOODS

FRANKLINTON

Anthony Thomas Candy Company
Ater's Sandwich Shop, Ater's Drive-In, Tommy's Diner
B&T Metals Company
Burger Boy Food-O-Rama
Celebration of Life Statue
Centennial Rock
Center of Science and Industry (Central High School)
Central Point Shopping Center
Deardurff House
Florentine Restaurant
Franklinton Branch Library
Franklinton Cemetery and First Presbyterian Church
Franklinton Firehouses
Franklinton Mural
Franklinton Post Office
Franklinton Sculpture Sign
Franklinton War of 1812 Landmarks: Harrison House/Lucas Sullivant
 Land Office; Fort Franklinton; Tarhe the Crane and William Henry
 Harrison Peace Council Monument
Gladden Community House
Green Gables Drive-In

Green Lawn Abbey
Green Lawn Cemetery
Harley Davidson Motor Co./A.D. Farrow Company Harley-Davidson
Holy Family Catholic Church
Josie's Pizza
Maggie Fager Memorial Library
Marina Restaurant
Milo's Deli and Café
Mount Calvary Cemetery and Jewish Cemetery
Mount Carmel Hospital and Hawkes Hospital of Mount Carmel
National Road
Philipp's Original Coney Island
Pilot Dogs, Inc.
Sullivant Statue
Sunshine Park/Dodge Park
Toledo and Ohio Central Depot and Franklinton Railroads

Short North (Victorian and Italian Villages, Harrison West)

Al G. Field House
Annunciation Greek Orthodox Cathedral
Aston-Taylor-Howe House
Christopher Columbus Square
Cocoa Manor
Ethopian Orthodox Tewahdo Church/Neil Avenue United Methodist Church
Garden Theater
Goodale Park
Graystone Court
Hubbard School
Medical Sciences Building
Michael's Goody Boy Diner
Mona Lisa Mural
North Market/North Graveyard
Sells (Circus) House
St. Francis of Assisi Church
St. John the Baptist Italian Catholic Church

SHORT NORTH GEOGRAPHICAL MARKERS:
 The Arches
 The Cap
 Union Commercial Travelers Headquarters
 The Viaduct
 and The Widening of High Street
 Winders Motor Sales and the Automotive Trade of the Short North
 Wonder Bread Factory
 Yukon Building

UNIVERSITY DISTRICT

Beta Theta Phi Fraternity House
Blue Danube Restaurant
Chic Harley Terra Cotta Sculpture/University Theater
Dick's Den
Fraternity and Sorority Row
Glen Echo Park
Hennick Home
Indianola Elementary School, Indianola Junior High,
Indianola Park
Indianola Presbyterian Church
Iuka Ravine/Indianola and Summit Viaducts
Kappa Sigma Fraternity/Neil Mansion, Iuka Ravine and Indianola Forest
King Avenue Methodist Church, Dennison Place and "The Circles"
Larry's Bar
Long's Bookstore/Hennick's Restaurant and Pipe Shop
Long Walk/William Oxley Thompson Library
Mirror Lake
Newport Music Hall/Agora/State Theater
North High School
Ohio Stadium
Ohio Union
Old North Columbus Commercial District
Orton Hall and Orton Memorial Laboratory
Phi Kappa Psi Fraternity House
St. Stephen's Episcopal Church

Sullivant Hall
Tau Kappa Epsilon Fraternity House
University Baptist Church
University Hall
Wellington Hotel
Wexner Center
Woody and Jo's
York Masonic Temple

GERMAN VILLAGE

Book Loft
Burkholz Saloon and Bowling Alley
City Car Barns (Old World Bazaar)
Columbia Theater
Das Maus Haus
Engine House #5
Fairy House
Frank Fetch Park/Beck Street Park/Lang Stone Company
Franklin Art Glass
Gambrinus Statue
Harry Turner Banana House
Hey Hey Bar and Grill
Lindey's/Lindenhof/Palmer House/King's Rose Garden
Markham Theater
Max and Erma's/Annie Kaiser's/Lamprecht's Hall
Mohawk Restaurant/Old Mohawk Grill
Planks Bier Garden
Plank's Café/"The Corner"
Recreation Park
Sally's Flowers
Schwartz's Castle
Schiller Park
Schmidt's Restaurant
Schumick's Market/Hausfrau Haven
Stewart Avenue School
St. Mary's Church and School

TEEZ Beauty Shop
Thibaut's Garden
Third Street School
Thurmania Theater

NEAR EAST SIDE AND KING-LINCOLN, BRONZEVILLE AND OLDE TOWN EAST

Alpha Hospital Site
Broad Street
Broad Street Presbyterian Church
Broad Street United Methodist Church
Bryden Road
Carter School of Music
Columbus Urban League
East High School
Eldon and Elsie Ward YMCA/Ward Home and Ward Storage
Emerson Burkhart House
E.T. Paul Company
First Church of Christ Scientists
Golden Barbershop and Billiards and Lemmons Drugstore
Hamilton Park
Hannah Neil Mission
Isabelle Ridgway Home for the Aged
Jones Mansion/Central Assurance Insurance/Jong Mea Restaurant/
 Orebaugh-Miller House
Kappa Kappa Gamma Fraternity/Snowden and Gray Mansion
Kelton House
King Arts Complex/Pythian Theater, Mayme Moore Park and Amos Lynch
 Plaza
Lincoln Theater
Macon Lounge
Mansion Day Care-Miller Mansion
Mt. Vernon Avenue, East Long Street, and Bronzeville
Ohio School for the Blind/Columbus Health Department
Poindexter Village/The "Blackberry Patch"
Second Baptist Church

Shiloh Baptist Church
St. Clair Hotel
St. Dominic Catholic Church and School/St. Cyprian's Church and School
St. Paul AME Church
St. Paul's Episcopal Church
St. Philip's Episcopal Church
Theresa Building
Topiary Park/Old Deaf School
Union Grove Baptist Church
Urban Cultural Arts Foundation/Kwanza Playground

ABOUT THE AUTHORS

Tom Betti serves on the board of Columbus Landmarks Foundation and is also chair of the Education Committee, charged with leading the organization's extensive programming. He is dedicated to bringing history to life through entertaining storytelling. He co-leads the Historic Tavern Tours with Doreen Uhas Sauer. Betti founded the Historic Preservation Committee of the Athletic Club of Columbus, and he was instrumental in having the building listed on the National Register of Historic Places for the club's centennial birthday. Betti has co-authored *Historic Columbus Taverns* (2012) and *On This Day in Columbus, Ohio History* (2013) with Uhas Sauer. A native of the Cleveland, Ohio area, Betti found historic roots in Columbus when he purchased his condo in the venerable 1898 Hartman Hotel Building, where he lives with his Boston terrier, Hugo, who also frequently leads Columbus Landmarks Foundation's walking tours.

Ed Lentz has been teaching, writing and exploring the history of Central Ohio for more than forty years. When not doing that sort of thing, he teaches from time to time at various local colleges and universities. He

writes for local newspapers, consults in history and historic preservation and keeps company with his wife, two cats and occasionally resident two children. Lentz holds degrees in history from Princeton University and Ohio State University. He is the author of several books, including *Columbus: The Story of a City* (2003), *A Home of Their Own* (2010) and *Historic Columbus* (2012). Lentz is currently the interim executive director for Columbus Landmarks Foundation.

Doreen Uhas Sauer serves on the board of Columbus Landmarks Foundation as immediate past president and on boards in the University District, where she currently chairs the University Area Commission. A longtime Columbus educator with Columbus City Schools, she currently directs a Teaching American History grant, and she has worked extensively in international civic education. She received statewide recognition for her work in preservation education, developing more than thirty local history/preservation programs, and was recognized by the Ohio Department of Education as Ohio Teacher of the Year. She has co-authored books on local Columbus history and on the University District, where she resides with her husband, John, whose roots are extensive in the German South Side.